Imogen Cunningham Ideas without End

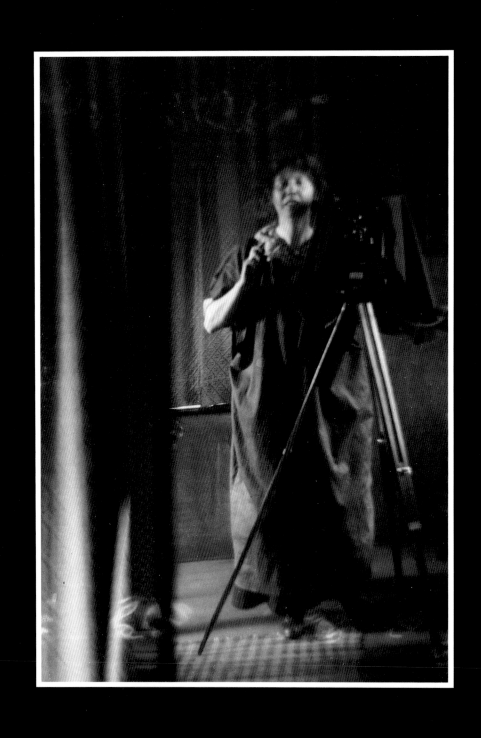

Imogen Cunningham Ideas without End

A Life in Photographs

Richard Lorenz

Chronicle Books
San Francisco

For Mary Hewko Lorenz, my mother

Edited by Suzanne Kotz
Designed by Ed Marquand
Typeset by G&S Typesetters, Inc.
Printed and bound in Japan

Cover: Imogen Cunningham, *The Unmade Bed,* 1957.
Back cover: Henry Swift, *Portrait of Imogen Cunningham,* 1934. Collec-
tion of The Imogen Cunningham Trust, Berkeley, California.
Frontispiece: Imogen Cunningham, *Self-portrait with Camera,* 1912.

Unless otherwise noted, all illustrations reproduced herein are gelatin-
silver prints. All photographs by Imogen Cunningham are reproduced
courtesy of The Imogen Cunningham Trust. All reproduction photogra-
phy is by Rondal Partridge, except as follows: M. Lee Fatherree, figs.
29, 53; Richard Lorenz, figs. 27, 33; Oakland Museum, figs. 15, 42.

Library of Congress Cataloging-in-Publication Data
Lorenz, Richard.
 Imogen Cunningham : ideas without end : a life in photographs /
Richard Lorenz.
 p. cm.
 Includes bibliographical references and index.
 ISBN 0-8118-0390-2. — ISBN 0-8118-0357-0 (pbk.)
 1. Cunningham, Imogen, 1883–1976. 2. Photographers—
United States—Biography. 3. Photography, Artistic. 1. Cun-
ningham, Imogen, 1883–1976. II. Title.
TR140.C78L67 1993
770'.92—dc20
[B] 93-67

1 3 5 7 9 10 8 6 4 2

Distributed in Canada by Raincoast Books, 112 East Third Avenue,
Vancouver, B.C. V5T1C8

Chronicle Books
275 Fifth Street
San Francisco, California 94103

Contents

Acknowledgments

This book would not have been possible without the cooperation and assistance of the entire Partridge family, especially Gryff and Janet Partridge, Padraic and Marjorie Partridge, and Rondal and Elizabeth Partridge. Rondal and Elizabeth, who manage the Imogen Cunningham Trust, and their assistant, Naomi Gardner, have been invaluable in the preparation of this monograph. Meg Partridge, Joan Partridge, Betsy Partridge, and Loren Partridge have also given me valuable insights into their grandmother's life.

My personal thanks go to Robert G. Smith for his support and encouragement. Sincere thanks are due Robert McDonald, who introduced me to the Imogen Cunningham Trust many years ago, and to Judith Dunham, for her assistance in bringing this book to publication. E. J. Montgomery, United States Information Agency-Arts America, was instrumental in funding a Cunningham project whose development instigated the original research for this book. I would also like to thank the following individuals for fortifying my belief in my ability to realize this project: Nona R. Ghent, Louise Katzman Kurabi, Jacque Clark, and Amy Conger. A special thank-you is due Van Deren Coke, former director of the Department of Photography, San Francisco Museum of Modern Art, for inspiring me years ago to believe that I could indeed wear several hats. Suzanne Kotz, my editor, has my greatest admiration for her sensitive refinement of the manuscript as well as for her loyalty and genuine affection for this project. Ed Marquand has produced an exceptionally handsome design to showcase Cunningham's distinguished imagery.

The following individuals have rendered a variety of professional courtesies and contributed significant information to this publication: Joseph Struble, Janice Madhu, and Becky Simmons, International Museum of Photography at George Eastman House, Rochester; Verna Curtis, Library of Congress, Washington, D.C.; Nicole Friedler, Museum of Modern Art, New York; Therese Heyman, Drew Johnson, and Janice Capecci, Oakland Museum; Amy Rule, Center for Creative Photography, Tucson; Francis Wainwright, Seattle Public Library; Sean Kennedy, Cornish School, Seattle; Anna Koster, de Saisset Museum, Santa Clara, California; Katie Crum and Renée Jadushlever, Mills College, Oakland; Diana du Pont, Santa Barbara Museum of Art; John Campbell and David Wirshup, Anacapa Books, Berkeley; M. Lee Fatherree; Barbara and David Meyers; Alice Putnam Breuer Erskine; and the late Billy Justema.

Preface

The gift of age can be a sweet reward for those with the passion and interest to live it. It was especially so for Imogen Cunningham, who was challenged personally and artistically by her long photographic career and, despite economic and emotional hardships, triumphantly endured. Her fearless explorations, through several generations, were always relevant to photographic developments of the time, and she accumulated a multitude of hard-won achievements, all the while indefatigably protesting that her best photograph might yet be made tomorrow. As Hilton Kramer noted, "Her work has a double claim on our attention. It belongs to history, and at the same time it is part of [the] contemporary scene."[1]

Cunningham's life in photography spanned seven decades—half of the relatively short history of the scientific art. Cunningham was admired around the world and, during her later years, revered by her students and beloved by the residents of San Francisco. In a special issue devoted to two centuries of "Remarkable American Women, 1776–1976," *Life* magazine ranked her first in the category of arts and letters—"the creative impulse"—proclaiming her "the best-known woman photographer in America."[2] In a 1974 cover story on the history of photography, *Newsweek* called her "the Queen . . . the blithe spirit of American photography."[3] Yet much of her life's work remained unknown at the time, and despite her status as a popular hero, photo historians were still deliberating. Over the years a cursory selection of just more than one hundred images, a small percentage of the tens of thousands she had made, trickled down to the public eye through successions of curatorial agendas, leaving some critics hesitant to embrace a career they considered too heavily based on the cult persona and the blunt, witty badinage of the sharp-as-a-tack nonagenarian. A 1970 *New York Times* review lauded her "insouciance" and "independent spirit" but unfairly surmised that the work never achieved an "oeuvre" because of the artist's "careless indifference to her reputation."[4] Ironically, some photographic reputations have been based on less work

than Cunningham produced in an average five-year installment, and the critical assumptions and dismay regarding her stylistic changes over seventy years need to be reexamined. Throughout her life Cunningham exhibited a remarkable capacity for challenge, exploration, interpretation, and insight, and she became the West Coast's truest and foremost candidate for an avant-garde. The intellectual consistency and logical evolution of her style and content are propelled by ideas, seemingly infinite, occasionally random, but always in control. As her old friend Shen Yao suggested: "Be Imogen, and remember, ideas are always without an end."[5]

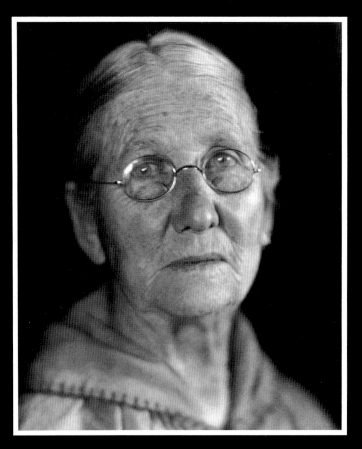

Fig. 1. Imogen Cunningham. *Susan Elizabeth Johnson Cunningham*, ca. 1923.

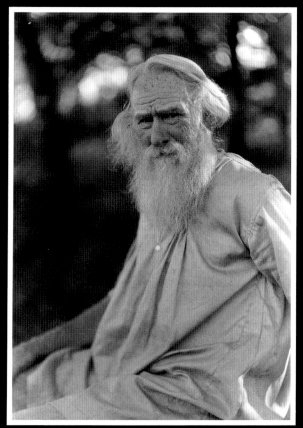

Fig. 2. Imogen Cunningham. *Isaac Burns Cunningham 2*, ca. 1923.

Learning to See

Imogen Cunningham's Scottish ancestors settled in Virginia in the seventeenth century. Her father, Isaac Burns Cunningham,[1] was born in Columbia, Missouri, in 1846 and later settled in Texas. With his first wife, Mary Malvina Mitchell, he fathered two daughters and a son.[2] Mary died in childbirth in 1880 at the age of thirty, and Isaac moved his small family to Portland, Oregon, in search of new opportunities and a supportive community. He wrote to Susan Elizabeth Johnson, a woman he had known in Missouri, and invited her to marry him. Susan,[3] a widow left with one child but no money, may have considered herself fortunate to receive Isaac's proposal and join him in the Garden Home district of Portland.[4] They were married on April 15, 1882, and Imogen was born on April 12, 1883, the first of six children Isaac and Susan would have together.[5]

Isaac Cunningham was a voracious reader, freethinker, and spiritualist as well as a vegetarian. Eccentric in many ways, he was a great individualist who became attracted to the ideals of utopian communities. In the summer of 1887 the family moved to the Puget Sound Co-operative Colony, a commune on the Juan de Fuca Strait at Port Angeles, Washington, a Victorian seaport for the fishing and logging industries.[6] Isaac made a go at farming but failed, and he again moved his family about 1889 or 1890, this time to Seattle.[7] The Cunningham homestead was located in a forest atop Queen Anne Hill. Isaac operated street-grading equipment and started a small wood and coal business. Life was undoubtedly difficult for this family with ten children, and Imogen's lifelong pragmatism was an obvious by-product of her poor and primitive upbringing. She learned at a young age that "you can't expect things to be smooth and easy and beautiful. You just have to work, find your way out, and do anything you can yourself."[8]

Imogen described her mother as a gentle, quiet woman who "never expressed an opinion of any kind"[9] and considered her an unfortunate but not atypical victim of the times (fig. 1). Susan Cunningham's life was one of total devotion and service to the family. Cooking, sewing, milking cows, feeding chickens, and raising children were the center of her world; she remained relatively unread and rarely socialized beyond her immediate home life.[10] Isaac Cunningham was an independent and self-educated man, opposed to organized religion, and well-read in many areas (fig. 2). He maintained a small library on disparate topics including theosophy, mathematics, vocabulary, farming, and plumbing, and even managed to acquire an early set of the *Encyclopedia Britannica*. He was known for taking in abused horses and treating animals with a kindness uncharacteristic for the day. And after his chores were completed, he was an avid checkers player at the nearest social hall.[11]

Imogen was Isaac's favorite child, and he began her education at home, teaching her to read the Bible, Shakespeare (he had, in fact, named Imogen after the virtuous, long-suffering heroine in Shakespeare's drama *Cymbeline*), and Dante's *Inferno*. Imogen did not begin formal education until the late age of eight because of the family's unsettled nature and the remoteness of their Seattle home. Occasional bear tracks, in fact, were not an uncommon sight along the path through the woods to her school. Isaac arranged for his daughter to take art lessons, which were not part of the regular school curriculum, on weekends and during summer vacations. Imogen remembered: "I was always absolutely on my own, going somewhere, doing something, being interested in something, and no one in the family was interested in the same things. . . . I didn't do anything but art every summer, and my father, I must say, was extremely indulgent to me in that respect. I had private lessons every summer."[12] She attended Broadway High School and entered the University of Washington in Seattle in 1903; she learned typing and shorthand, worked as a secretary to her chemistry professor, Horace Greeley Byers, and paid for her own education. Encouraged by Isaac to excel in education and disdainful of the station in life given to Susan—which Cunningham would call "the rune of women"—independent Imogen became the only child in the family to graduate from a university. All her sisters attended nursing

Fig. 3. Imogen Cunningham. *Marsh, Early Morning (Marsh at Dawn)*, 1905–1906. Platinum print.

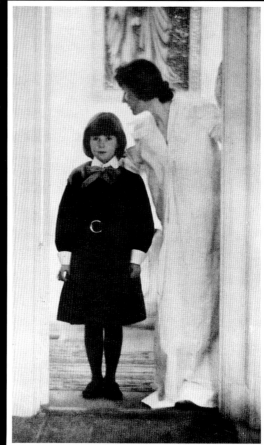

Fig. 5. Gertrude Käsebier. *Blessed Art Thou among Women*, 1899. Reproduced in *Camera Work* 1 (Jan. 1903).

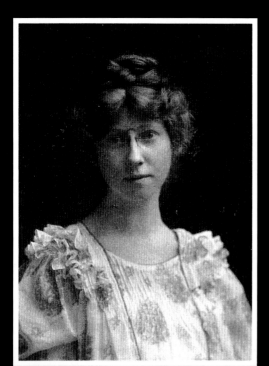

Fig. 4. Edward S. Curtis Studio. *Imogen Cunningham*, 1907. Platinum print. Collection of Imogen Cunningham Archives. The Imogen Cunningham Trust, Berkeley, California.

school, the highest achievement in medicine the times commonly allowed women, and her brothers played professional baseball in minor league teams before entering the printing business.[13]

Cunningham claimed that since childhood she thought she might like to become a photographer, and by her sophomore year she began to plot an appropriate course of study for a career in the field: "I always liked the pictorial. In my second year in college I told one of my professors that I wanted eventually to be a photographer, and asked him what I should study. 'Chemistry, by all means,' he said. 'Learn scientific photography.' And I applied myself in that direction."[14] As adjunct class work, Cunningham made lantern slides for Professor T. C. Frye in the botany department, and from this experience her fascination with botanical imagery might have developed. She majored in chemistry and took additional courses in physics, literature, German, and French.

Imogen bought her first camera during her junior year, 1905–1906,[15] from the American School of Art and Photography in Scranton, Pennsylvania. The 4-by-5-inch format camera came with a booklet describing the "Schreiver System of Photographic Mail Instruction." Imogen took her first photographs on the campus of the University of Washington, and the image she remembered as probably her first is *Marsh, Early Morning* (fig. 3), a misty study of a swamp at the university's edge.[16] She processed her film by candlelight emitted through a red box in the tar-paper-lined darkroom her father had created in a section of their woodshed, a surprisingly supportive gesture considering his disdain for the photographer's craft and his advice to her at the time: "I can't see what all that studying at the university will do if you're just going to be a dirty photographer."[17]

Cunningham completed her course work in three-and-a-half years (fig. 4) and then wrote a lengthy thesis, "Modern Processes of Photography." She devoted the latter half of her senior year to studying the work of Edward S. Curtis, the Seattle-based photographer who chronicled a vanishing culture in his twenty-volume study, *The North American Indian*.[18] Although Cunningham knew Curtis's images well, she never considered them an influence. Nonetheless, one can see certain similarities in Cunningham's later work to Curtis's direct and unsentimental portraits in natural settings. Cunningham did assert that her path toward photography as a profession became clear when she first saw the images of Gertrude Käsebier, and she often recounted the enormous impression that Käsebier's *Blessed Art Thou among Women* made on her (fig. 5).

The image was reproduced in 1907 in *The Craftsman*, a monthly magazine published by Gustav Stickley and devoted to the encouragement of handicrafts in America.[19] Käsebier's pictures were introduced as examples of a new photographic emotionalism and were intended to discredit the prevalent notion that the photograph was limited by its mechanical process. Her study of a young schoolgirl being guided through a doorway by a maternal, draped figure—angel, guardian, or possibly muse—depicted a feminist spirit of liberation and challenge.[20] The accompanying article, ironically, was written by a woman using a male pseudonym.

Public perception of the nature of photography was in transition at the turn of the century. The simplification of photo processes and the introduction of hand-held cameras begat a proliferation of photographers, whose variable results helped create the notion that the camera was a machine that impersonally captured reality. Photography came to be considered a technical craft, not an art form. To overcome this bias, the pictorialist movement developed toward the end of the nineteenth century and prospered until after World War I. Pictorialists argued for the dual role of reality and aesthetics in their photographic works and emphasized the artistic nature of the photograph by selecting subject matter and compositions traditionally employed by painters and graphic artists. Allegorical themes, stylistic tendencies from nineteenth-century painting, and the illusion of emotion became inherent components of pictorialist imagery.

In America, Alfred Stieglitz in 1902 solidified the pictorialist movement's achievement of the serious recognition of photography as a fine art by forming an organization called the Photo-Secession. Gertrude Käsebier was a member of the group, and her images were representative of its goals. The same *Craftsman* article influential to Cunningham commended Käsebier for reproducing "conditions mellowed by the imagination and saturated with the quality of the artist, . . . expressing her own temperament and life as it has reached her through imagination and through her growing understanding of humanity."[21]

From June 1907 to July 1909, Cunningham was professionally employed in the Curtis studio. Under the guidance of Adolf F. Muhr, she learned the mechanics of retouching negatives and printing them on platinum paper. She later noted in her inimitable way: "Edward Curtis was such a big shot in his own mind that he seldom if ever turned up in the studio and if he did, he never spoke to the help. The man who influenced my life at the time was A. F. Muhr,

who has never been heard of since. He was the operator of the Curtis establishment and he was a gentleman from away back; also a fine technician."[22] It was probably while in Curtis's employ that Cunningham became acquainted with *Camera Work*, Stieglitz's exquisite periodical devoted to the Photo-Secession and modern art and culture.[23] She corresponded with Joseph Keiley, the managing editor, who two years later would give her an introduction to Alvin Langdon Coburn. Keiley and Coburn were both important members of the Photo-Secession.

In 1909 Cunningham was awarded a $500 fellowship by her college sorority, Pi Beta Phi, to study abroad. She received a supplemental $250 loan from the Washington Women's Club. She chose the Technische Hochschule in Dresden, Germany, specifically to study in the photochemistry department under the world-renowned Robert Luther. With a three-tiered trunk, a new 5-by-7-inch Century view camera, and a small Kodak camera[24] that was a going-away present from a friend at the Curtis studio, she traveled that year from Vancouver to Montreal on a Canadian Pacific train, and from there by steamer to Liverpool.[25] She was to meet Coburn in London, but their arrangements fell through. Continuing on to Holland by boat and then by train to Leipzig and Dresden, she finally settled into her student quarters at Ostbahnstrasse 27.[26]

Dresden provided Cunningham with the unexpected opportunity to view and compare the work of European and American photographers on display at the unprecedented 1909 International Photographic Exposition, then in progress in the city. Here she claimed to have seen "the best of American photography placed side by side with the foremost work of the European artists, and in technical skill, good taste, and real pictorial values the American work stood first."[27] Imogen later recalled: "I was perfectly conscious of what was going on in the world of photography. . . . There was a big exhibition of photography that was drawn from worldwide sources. It's strange that the person whose work I remember best at that time was Baron de Meyer, who later came to America and worked for the Condé Nast Company. At that time he lived in Europe and was doing all sorts of delicate and beautiful things with table decorations and fancy elegant women."[28]

Imogen studied art history and life drawing at the conservatory of art, but most of her time was devoted to technical work. Her March 1910 thesis for Professor Luther, "About Self-Production of Platinum Papers for Brown Tones," presented a cheaper alternative to platinum printing by proposing the substitu-

tion of lead salts in the sensitizing layer. The paper was published in *Photographische Rundschau und Photographisches Centralblatt* that same year.[29] Luther, by chance, offered Cunningham a lasting approach to her portrait subjects. When she photographed him sitting at his desk, he suggested: "Now I want to do a mathematical problem in my mind, and when you think I've come to the point of greatest intensity of thought, take the picture then" (fig. 6).[30] She remained forever fond of this portrait and its inherent lesson, and later noted: "Sometimes people get embarrassed about being photographed. I tell them to think about the nicest thing they know. I think that makes a difference. Some people don't think it does. Sometimes people think about nothing at all, and it's hard to get an interesting photograph."[31]

Cunningham left Dresden in June 1910 for Paris, where, with her Kodak, she photographed Notre Dame from across the Seine (fig. 7) and one of the elegant pools on the grounds of Versailles. Alvin Langdon Coburn had suggested that she visit French photographer Robert Demachy to investigate an oil-pigment printing process, but no record of such a meeting exists. She finally met Coburn himself at his Hammersmith studio in July. Imogen made photographs of several London sites previously documented by Coburn, who had explored scenic and architectural urban imagery to illustrate his book *London*, published in 1905 with an essay by Hilaire Belloc, a copy of which Cunningham was proud to own. Again using her amateur Kodak, Cunningham photographed the sphinx at the Thames embankment (fig. 8), boats moored along the Thames, and the fountain at Trafalgar Square (pl. 5). She later remarked:

> I still have one of the photographs that I did while walking along the Thames at six o'clock in the morning. I went into Limehouse and walked along and watched the men working. I later discovered that that was a dangerous thing to do. Nobody even whistled at me. . . .
>
> I remember once in Dresden I was walking along with a girl. It was some strange place, I guess. I'd never paid any attention to where I was, as far as taboos were concerned, I mean. A baker boy came along, shouting at us, "Where are you going?"
>
> We just laughed and didn't answer him; he laughed and went on. You can tell by the way in which people say those things whether they have an ill meaning or not. I've never been afraid anywhere.[32]

The journey home took Imogen through Philadelphia, where she later remembered taking pictures of the Betsy Ross House. She also visited New York and Alfred Stieglitz's "291" gal-

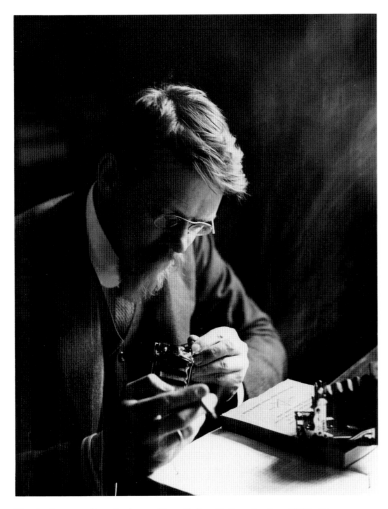

Fig. 6. Imogen Cunningham. *Herr Doktor Robert Luther*, 1909–10.

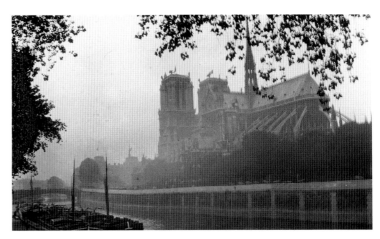

Fig. 7. Imogen Cunningham. *Notre Dame*, 1910.

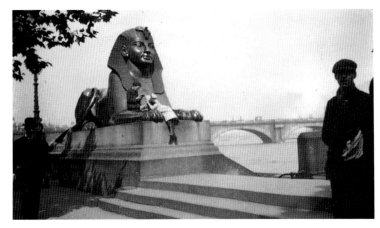

Fig. 8. Imogen Cunningham. *Along the Thames Embankment*, 1910.

lery, the most influential source in America for modern art, photography, and aesthetic ideology. Intimidated by Stieglitz at the time, she remembered: "Of course I was greatly impressed and rather afraid of him. I did not express myself in any way that anyone could possibly remember and I remember that I felt Stieglitz was very sharp but not very chummy. . . . I also looked up Gertrude Käsebier who was most cordial."[33] As for the city itself, she said, "I loved New York on that first visit. . . . I thought it was all very picturesque. I ate my two bananas for lunch every day in something like Union Square and thought nothing of it. . . . I don't think that I was smart enough to think New York needed me, or that I could cope with it. It never occurred to me that I could handle New York. I kept thinking all the time that I had to be near somebody I knew who could lend me this or that. It was financial, mainly. I didn't have any money."[34] Her circuitous route continued through Washington,

D.C., where she visited one of her sisters (and prophetically bought a plant whose blossom would later become her celebrated signature image, a *Magnolia grandiflora*, to take home for her father); she traveled by rail to southern California to meet up with a school friend, and then visited her parents at their new farm in Sonoma County, just north of San Francisco.[35]

Cunningham arrived home in Seattle during September 1910 with a few dollars in her pocket and no place to live, but managed to set herself up in business within a few weeks. For ten dollars a month, she rented a cottage on First Hill that had been refurbished as an art studio by a Mrs. Andrews, a painter, supporter of the arts, and the wife of a banker. An early visitor described it colorfully:

> Walk north from Madison on Terry Avenue for a block and a half on the left-hand side of the street and you will notice a quaint little sign

swinging out over the sidewalk and modestly challenging attention. It consists of a single artistic portrait under glass and the words in German lettering: Imogen Cunningham—Photographs.

Below the level of the street crouches the studio, a little old cottage which was once, no doubt, an ordinary dwelling but which has long since surrendered its soul to art and its body to the overwhelming embrace of the giant ivy that covers it completely. At the rear a few stately old maples afford an effective background for the picture which is in pleasing contrast to the paved streets and modern buildings that surround it.

Lifting the brave brass knocker that adorns the little white door, stooping as you do to avoid the overhanging ivy shoots, you are presently admitted to the most cheerful room imaginable. Tiny paned windows, which were scarcely noticeable from the outside, let in a surprising amount of light and right in the middle of the room is a fireplace blazing merrily. The wall covering and hangings are of faded delft blue, against which the few pictures show to excellent advantage. As Imogen says, "It's all quite primitive." Of expensive furniture there is none. Indeed some of the chairs have been known on close acquaintance to prove weak and undependable, but there is a homelike air about the little place and such a feeling of good-fellowship that I know plenty of persons who would rather have a sandwich and tea in one of Imogen Cunningham's blue china cups than dine in state.[36]

When Cunningham established her studio she claimed to be the only photographer creating expressive portraiture in Seattle. She took pride in offering a different, more naturalistic approach from the rigid poses and stereotypical formats routinely created in commercial studios.[37] She photographed in situ at her clients' homes, to which she carried her camera equipment in a wicker hamper. In her own simple studio, she made every effort to overcome any conventionalities in her work by composing portraits with the addition of props such as floral arrangements or an occasional pet (pl. 6), or by situating her clients within the landscape of her studio garden or other exterior architectural frameworks. "The outside gives me great scope in combining landscape and portraiture," she said. "I use it both summer and winter. The out-of-doors lends an inspiration to my indoor work."[38] Imogen's concern for environment in her portraits would always remain a priority, but most important was the interpretation of the essence of the person. She believed that "one must be able to gain an understanding at short notice and close range of the beauties of character, intellect and spirit so as to be able to draw out the best qualities and make them show in the outer aspect of the sitter. To do this one must

not have a too pronounced notion of what constitutes beauty in the external, and, above all, must not worship it. To worship beauty for its own sake is narrow and one surely cannot derive from it that aesthetic pleasure which comes from finding beauty in the commonest things."[39]

Beyond her professional obligations to the portrait studio, Cunningham maintained ties with the local art world. She was the only photographer to be a charter member of the Seattle Fine Arts Society, a group of painters and printmakers with whom she frequently exhibited.[40] She also showed portraits of artists and writers with the Society of Seattle Artists. An early review of her pictures commends her keen artistic sensibility: "In addition to a thorough technical knowledge of her art, she has a fine imaginative feeling and a sense for the fitness of things which characterizes the true artist, whatever be the means of expression. If she does a landscape it is something more than an accurate, geographical, detailed view of a locality; it is something pleasing and grateful to the eye with a suggestion of the charm and atmosphere that we find in the quiet, restful paintings of Corot. If it be a portrait, it is something more than a correct impression of features and clothes: it is a portrayal of the sitter's personality, spirituality—soul, if you will,—which gives the beholder a sense of actual presence."[41]

The need to promote herself was a practical matter of fact for maintaining a successful portrait studio, and Cunningham ran a simple advertisement in the mid-1910s in a Seattle weekly, *The Town Crier*, to announce her availability, "Imogen Cunningham— Photographs," with telephone number and address. But the emotional desire to share her art and be judged by a more diversified group of colleagues led her to submit work to the leading photographic periodicals and salons of the period. *The Shipbuilders*, for example, Cunningham's pictorialist, centrifugally designed study of three boys and their model boat, dramatically backlit by an open window, was illustrated in the 1912 *Photographer's Association of America Annual, The Camera*, and elsewhere.[42]

Cunningham also published in 1913 a significant feminist manifesto titled "Photography as a Profession for Women," in which she ascribed the lack of "conspicuously strong and individual work" by women in the higher arts to their deprivation of opportunity. She wondered, "Why women for so many years should have been supposed to be fitted only to the arts and industries of the home, is hard to understand. . . . And who shall say from the records women are making every year in their professions that they are

unfitted for them, that they should still be brought up with only the three Ks (Kirche, Küche, und Kinder)."[43] She believed that a career in photography, or any career, should not be predicated by sex: "It is really not so much a matter of suitability to sex as to individuality. . . . Women are not trying to outdo the men by entering the professions. They are simply trying to do something for themselves. . . . Photography is then . . . a craft or trade to which both sexes have equal rights. . . . If photography needs any new recruits, it needs only people of good taste who know the fitness of things and have a sense of the limitations of the medium. And with this good taste should be combined the hand of the skilled mechanic, the eye of an artist, and the brains of a scientist."[44]

During 1913 Cunningham corresponded with Alvin Langdon Coburn regarding a possible exhibition of his photographs at the Fine Arts Society.[45] Coburn gave her an introduction to the pictorialist photographer Clarence White, to whom she wrote to request an exhibition of her photographs in New York as well as their inclusion in Camera Work. White politely but somewhat disdainfully critiqued a group of images she had sent him: "I found your work interesting—not so much probably as photography—but what you are trying to express with your photography. The examples that you show with less ambitious motives please me most.—Such as the portrait of Mrs. Champney. This is not to discourage you in the picture motives, but better photographic values would make the picture more pleasing to me."[46] White suggested that she write Alfred Stieglitz directly to submit photographs to Camera Work, but no correspondence seems to have taken place at the time. White did introduce Cunningham's work to the new management at Wilson's Photographic Magazine and to Edward Dickson, the editor and publisher of Platinum Print, a beautiful yet unpretentious little magazine devoted to "personal expression." Dickson wrote her cordially: "Mr. [Karl] Struss, White and I looked over your prints a little while ago, and what interested me very much is that you are doing new things. Good. Keep up the work. I know how lonely it must perhaps be to be working out there without the impulse of many others who are working along the same lines. Before your prints are shown at Brooklyn, I shall choose one for reproduction in 'Platinum Print' for, as I said, they are new, and we want new things."[47] Wilson's Photographic Magazine ran a well-illustrated appreciation of Cunningham's work in March 1914, which was introduced by a quotation from Coburn: "Photography is a medium of expression that requires a dual sort of mentality; it is marriage of art and science."[48]

In a lengthy 1911 essay, possibly used as a lecture, Cunningham praised the work of Edward Steichen and quoted an opinion of the French sculptor Auguste Rodin: "I consider Steichen a very great artist, and the leading, the greatest photographer of the time."[49] The influence on her work of Clarence White, George Seeley, Herbert French, Alice Boughton, and Anne Brigman must also be acknowledged. Cunningham's early pictorialist imagery during the years 1910 to 1915 compares favorably with the best work being done by these Photo-Secession photographers and published in Camera Work, but she risked far more in some of her experimental images. As early as 1911 she tested the latitude possible in one negative by producing two prints of the same self-portrait: a light version titled Morning Mist and Sunshine (pl. 7a), and a darker, moodier variant titled In Moonlight (pl. 7b). She readily accepted the nude as a subject, a natural outcome of her liberal family upbringing, years of life drawing, and probable exposure to Die Brücke artists who were painting and exhibiting in Dresden during Cunningham's stay there. The Brücke theme of the nude in the landscape, of nudist bathing and recreation, was an expression of the original and pristine Being as well as a way of overcoming social restraints. Man and woman became integral parts of nature, liberated and guided by Eros, and physically released from the confinement of hypocritical bourgeois morality.[50] Cunningham's photographs of a nude man, woman, and child grouped on a shore, created about 1910 (one, entitled Reflections [fig. 9], was published in The Town Crier in 1915), are surprisingly direct and unretouched—a marked departure from the veiled chiaroscuro in Adam and Eve by Frank Eugene (fig. 10), the only photograph of a nude male and female couple ever to be published in Camera Work (April 1910). Eugene's negative was reworked with dramatic scratching to impart the quality of an etching—and thereby artistic acceptability—to this potentially risqué subject. In an issue devoted to the nude in photography (Nov. 1914), Platinum Print reproduced a selection of similarly fuzzy, "artistic" images of female nudes by a group of pictorialists including Coburn, E. O. Hoppé, and Paul Anderson.

Cunningham's creative work during this period often involved friends who shared an adjoining studio: John Butler, a mural painter; Clare Shepard, a painter of miniatures; and John's brother, Ben. The three became her models in romantic, mysterious tableaux created for Cunningham's lens. Allegorical studies were commonly staged by Pre-Raphaelite painters and photographers such as Julia Margaret Cameron in the late nineteenth century and

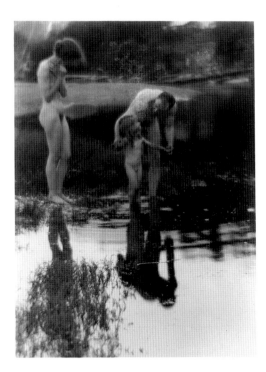

Fig. 9. Imogen Cunningham. *Reflections*, 1910.

Fig. 10. Frank Eugene. *Adam and Eve*, 1898.
Reproduced in *Camera Work* 30 (April 1910).

by scores of turn-of-the-century pictorialists. In period costume, Imogen's friends re-enacted ideas from their favorite works of literature, such as William Morris's *The Wood Beyond the World* or the exotic verse of Yone Noguchi.[51]

Several of these soft-focus images might directly relate to Cunningham's interest in theosophy, whose adherents sought knowledge of God through an intuitive mysticism. Imogen, under Clare Shepard's influence, had begun to read numerous theosophical tracts. Shepard, in fact, believed herself to be clairvoyant. Her persona curiously seemed to translate into her painting technique; her miniatures on ivory were so evanescent in effect that the pigments seemed to have been "breathed upon the ivory."[52] Cunningham's photograph *The Vision* depicts Clare, eyes closed, hand extended, perceiving an unknown force. The astigmatic aura about Clare's person in *The Dream* (pl. 10) can be interpreted as the approximation of an astral body. As noted in *First Steps of Theosophy*, "Those who are *clairvoyant* (clear-sighted), which means that they have developed the power of seeing this finer than physical matter, tell us that when they look at any one of us they see the physical body, the ordinary form, which is all that most of us can see, and that within this, they see a form of finer matter which interpenetrates the denser physical matter, and also stretches beyond the physical form, appearing as a kind of cloudy shell or halo surround-

ing the physical body."[53] Imogen related this interest in a spiritual search to her new correspondent, George Roy Partridge (called Roi), a Seattle artist studying in Paris.[54]

Partridge had met John Butler and Clare Shepard as art students about 1909. The three had banded together to form a mutual interest group, calling themselves "The Triad." Butler and Partridge traveled together to Europe in 1910 for a year of art study in Munich, followed by journeys to Rome and Paris during 1911. While Butler returned to Seattle, Partridge stayed on in Paris to develop his recently acquired etching skills.[55] Shepard, assisted by Cunningham, organized an exhibition of Partridge's etchings and drawings for the Seattle Fine Arts Society in 1913. Imogen and Roi began a correspondence that developed from a discussion of business matters to an exploration of each other's thoughts, values, and dreams. Cunningham seemed to maintain a cordial aloofness from this man she had never met. Roi, however, quickly developed a passion for Imogen through her letters, in which she enclosed newspaper clippings about her career and photographic self-portraits. He wrote: "Imogen, ever since the thrill that your first letter gave me, you have continued to move me. . . . Yes, I confess it, I set out months ago with the deliberate intention of winning your affections because I wanted them, oh, Imogen, so much!!! . . . Underlaying all this, however, is that want, that emptiness, that incompleteness. I

Fig. 11. Roi Partridge. *Imogen Cunningham*, ca. 1915. Platinum print. Collection of Imogen Cunningham Archives, The Imogen Cunningham Trust, Berkeley, California.

Fig. 12. Imogen Cunningham. *Roi Partridge, Etcher*, 1915. Platinum print.

must have my mate. I want her now."[56] He proposed marriage a few months later: "You are the ideal woman for me, and fearing no longer, in all hope, tranquility, and happiness, I ask you if you will be my friend and companion for life—if you will be my wife."[57] Roi implored Imogen to join him in Europe: "Come, sweet, the sun's afire and there are such wondrous lands to explore—Love and Time and Italy!"[58] But the outbreak of the First World War forced Roi to return to Seattle in late 1914, when he finally met the object of his desires (fig. 11). Imogen memorialized her first meeting with Roi by photographing him in hat and cape in front of her ivy-covered entrance. The couple wed on February 11, 1915, in John Butler's studio, and Roi set up a room for etching next to Imogen's studio. She proudly posed Roi in front of his oversize etching *La Petite Reine* (1913) to produce a handsome study of designer and design (fig. 12).

Roi preferred to sketch directly from nature and greatly appreciated the Pacific Northwest landscape (fig. 13); together, he and Cunningham made forays into the local terrain. She engaged him as a model in an extended series of the nude in the wilderness. He remembered: "One of my first appearances in Seattle newspaper columns was because of a photograph Imogen had taken of me in the mountains, running around without any clothes on. Some newspaperman got hold of it, and it made an interesting little item. I had been up at Mount Rainier sketching, and Imogen came up to visit me. She was photographing wherever she was, so she suggested I take my clothes off and pose for her. So there I was, sitting on a cake of ice and getting photographed in the buff. Luckily she was using soft focus lenses in those days, so the identification wasn't very exact."[59] The series includes Roi posing nude as Narcissus at the edge of a pond and in a variety of classical gestures perched atop the mountain amidst blasted pines. Publication of one of these images, *The Bather* (fig. 14), in 1916 in *The Town Crier*[60] created a local scandal and invited so much ridicule that Cunningham retired the negatives for more than fifty years.[61]

Cunningham's use of the nude male figure communing with nature was a daring development within the figure-in-landscape genre. Anne W. Brigman, the only West Coast photographer to be published in *Camera Work*, incorporated rhythmic natural forms with the female nude, often herself, whose angst-ridden postures created a sense of mythic lore (fig. 15). A *Camera Work* commentator, J. Nilsen Laurvik, wrote: "In Mrs. Brigman's work, the human is not an alien, has not yet become divorced by sophistication from

the elemental grandeur of nature; rather it serves as a sort of climactic point, wherein all that nature holds of sheer beauty, of terror or mystery achieves its fitting crescendo."[62] Whereas Brigman shaded her images with allegorical possibilities, Cunningham increasingly presented the body directly and confrontationally. She was not naive about the shock value of the nude in her work. In a 1916 letter to Roi, who was away on a sketching trip, she wrote: "Got an important invitation for exhibit. Amer. Institute of Graphic Arts, N.Y., Chandler Bldg. Ex. to be for one month—from Oct. 4—in Gal. of National Arts Club—& to set forth the development of phot. from 1839 to present day—they suggest my sending at least— Portrait of Mrs. Champney & Pierrot Betrübt [fig. 16]—Back of this I see Clarence White—he thinks I have done nothing else damn him—What else shall I send? I think I'll get busy & do a shocker— Miss C. [Miss Cann, a neighbor] suggests today that I photograph her nude with Tanaka [Yasushi Tanaka, a painter, instructor of life drawing at the Fine Arts Society, and lover of Miss Cann] dressed— I have an idea—guess I'll get busy. Write me as encouragement."[63]

To compare Cunningham's work with that of her Seattle contemporaries crystallizes the significance of her contributions and the sophistication of her concepts. The Fine Arts Society sponsored lectures and discussions on cubism and futurism as early as 1913 (the society even held a futurist party in 1915, possibly inspired by the exhibition in the same year of Italian futurist paintings at the Panama-Pacific International Exposition in San Francisco, which many members had visited), and Marcel Duchamp's *Nude Descending the Staircase (No. 2)* was exhibited in Seattle in 1913, shortly after its purchase from the Armory Show by Frederic C. Torrey of San Francisco, but the general provincial consensus regarding such new painting styles was that "these new eccentricities in art are but an expression of the general lack of discipline in our modern civilization."[64] No Seattle artists, not even Partridge, Butler, or Shepard, seemed to be producing art that veered from safe, acceptable traditions in rendering the figure or landscape. Cunningham's intention to deliberately devise shock value in her art, her willingness to transgress the boundaries of bourgeois morality, indicates a courageous, adventurous talent just beginning to bloom as well as a determination to advance the critical acceptance of photography. Her pronouncement on the subject was didactic: "The useless question—Is it art?—now that the question of what is art has become so important, has grown still more useless. Let us hope that by the time the critics and artists have decided whether there is

Fig. 13. Roi Partridge. *The Marvelous Mountain*, 1915. Etching. Courtesy of Anthony R. White, San Mateo, California.

Fig. 14. Imogen Cunningham. *The Bather*, 1915.

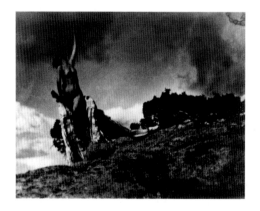

Fig. 15. Anne W. Brigman. *Soul of the Blasted Pine*. Reproduced in *Camera Work* 25 (Jan. 1909).

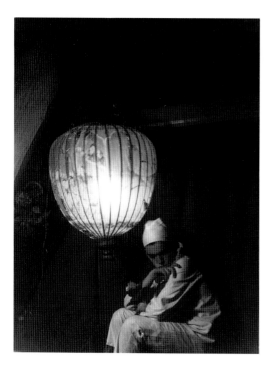

Fig. 16. Imogen Cunningham. *Pierrot Betrübt*, 1910.

such a thing as modern art or not, they will also be calmly content to call the work of the camera by its own rightful name of photography."[65]

Imogen's first son, Gryffyd,[66] was born on December 18, 1915, and she soon returned to work, juggling motherhood and profession. She wrote to Roi, who was back sketching on Mount Rainier in the summer of 1916: "It would have been a great day for photographing Gryff out doors because it is the warmest yet but I have been swamped trying to do the necessary errands, Rosso's packet, your canteen and my prints to the London Salon, together with the attempt to finish the Thomsen order. . . . I engaged the girl whom Mrs. Densmore sent, Rose Tiedemann, and have some hopes of being something more than a bundle of nerves when you return. . . . The eternal little slavy jobs eat up all my energy so that I have not a pleasant idea in my head. . . . Doesn't this sound sordidly domestic? and you are probably soaring in the clouds upon the mountains."[67]

Imogen's letters to Roi during his periods away relate family and neighborly news, tales of her studio business and Roi's etching sales, her inspirations and discouragements, her interest in movies, and her recent passion for a new magazine, *Vanity Fair*. She wrote Roi: "I bought the Aug *Vanity Fair* to send to you, because it has so many ripping things in it. I shall probably send it before I look it over completely so don't throw it away—needless to say to

you about a *Vanity Fair*, isn't it? I have fallen in love with the photograph of Paul Thevenas and I must have it to look at it again.[68] If you were here I am sure I could not have committed such an indiscretion. I am loving you very much—one month is going to seem much longer than the two I spent in California[69] and I am going to be so ready to be good when you come back."[70] In the summer of 1916 she attempted a pictorial depiction of motherhood: "I photographed Gryff with Miss Cann indoors and somewhat nude. . . . At best the proposition of photographing a mother and child is liable to be either sentimental or absolutely unpictorial but what I wanted to get to-day was a portrait of Gryff and something of him nude with a woman as background."[71]

Imogen became increasingly weak during a difficult second pregnancy in 1917, during which Roi was away for up to four months on a sketching trip in Carmel-by-the-Sea, California. At times their letters became strained: "I have spent so much time in the darkroom. Your mother came at 3 & took G. for a little walk. . . . I hardly had time to speak to her because I had to get 2 of my morning prints dry & flat & spotted & get the others finished before an expected caller at 4. If you were sick as a dog in the way I am sick you couldn't think affection—either—I'm sorry but the presence of Gryffydd is the only thing that gets a rise out of me—I haven't cared to love the last two weeks."[72]

Imogen's young housekeeper Rose, who at first seemed caring and trustworthy, was suspected of theft and most probably caused three fires in the cottage, one of which severely damaged Imogen's darkroom and her stored glass-plate negatives. Imogen decided to move to California where her parents could tend to Gryff while she had her second child, and she informed Roi of her decision. He was perturbed that she had not sought his prior approval: "Your telegram reached me just as I was starting for Point Lobos with the Burrs. They are picknicking, but I was going to sketch. I am more distressed than I am able to say by this fresh misfortune. You don't say whether any serious damage was done by this third fire, but that you should so arbitrarily, capriciously give up our little home seems a great misfortune to me. You have no consideration—as usual—for where I come in."[73] Cunningham had the house packed and Roi's etching press and prints stored. She dismantled her studio, smashing the majority of her remaining glass-plate negatives to avoid moving them, and traveled with Gryff to San Francisco, where a disgruntled Roi met them.

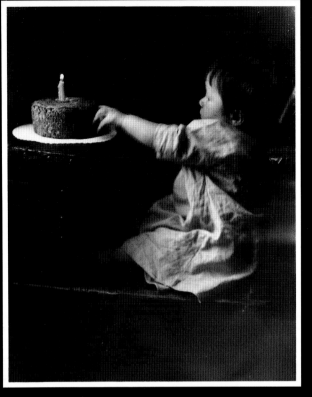

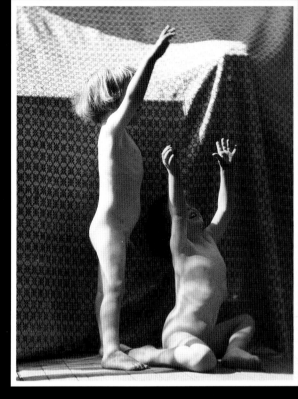

Fig. 17. Imogen Cunningham. *Gryff's First Birthday*, 1916. Fig. 18. Imogen Cunningham. *Rondal and Padraic*, 1919.

Fig. 19. Imogen Cunningham. *4540 Harbor View*, ca. 1920.

California and a New Vision

The family rented a house on San Francisco's Twin Peaks, and on September 4, 1917, Imogen gave birth to twin sons who were named Rondal and Padraic. Roi found employment as a designer with the outdoor advertising company Foster and Kleiser, a job through which he would soon befriend artists Maynard Dixon and Dorothea Lange.[1] Cunningham devoted the years 1917 to 1920 largely to caring for her boys. Although she had no studio or commercial clients, she never ceased photographing her family and intimate surroundings. The images of this period are loving and atmospheric without being sentimental. Imogen captured her three young sons in candid and arranged configurations, often nude, sometimes in their finest attire; birthdays were always significant portrait days (figs. 17, 18). Without her own darkroom, she sent her film to Pillsbury's in the Bellevue Hotel for processing.[2] In 1918 Cunningham briefly worked in the San Francisco studio of Francis Bruguière, helping his assistant Helen Mac-Gregor[3] to spot negatives and prints.[4]

Paralleling trends in art after the Armory Show, a ground swell of nascent experimentation occurred in the photographic world during the late 1910s and early 1920s. Even though Cunningham did little traveling at the time, information on current trends was hardly inaccessible. Through *Camera Work* she was exposed to the aesthetic ideology of figures like the artist and theorist Marius de Zayas as well as to the photographic abstractions of Paul Strand. Cunningham was particularly interested in the Italian futurists, whose work had been exhibited in San Francisco at the 1915 Panama-Pacific International Exposition.[5] Frederic C. Torrey, the San Francisco collector and dealer who had purchased Marcel Duchamp's cubo-futurist *Nude Descending a Staircase (No. 2)*[6] from the Armory Show in 1913, also collected Roi Partridge's prints,[7] and he remained a valuable contact. Cunningham had in fact visited Torrey in 1913 at his Berkeley home, where the Duchamp painting was prominently displayed on the first staircase landing.[8] She recited to friends the cubist prose of Gertrude Stein's "Portrait of Mabel Dodge at the Villa Curonia,"[9] which was published in *Camera Work* (special no., June 1913), and she learned about the possibilities of cubo-futurist or "vorticist" photography through her old acquaintance Alvin Langdon Coburn. He sent Imogen a copy of *Photograms of the Year, 1916*, which contained his seminal article promoting the cause of modernist photography:

> Why should not the camera also throw off the shackles of conventional representation? Why should not its subtle rapidity be utilized to study movement? Why not repeated successive exposures of an object in motion on the same plate? Why should not perspective be studied from angles hitherto neglected or unobserved? Why, I ask you earnestly, need we go on making commonplace little exposures that may be sorted into groups of landscapes, portraits and figure studies? Think of the joy of doing something which it would be impossible to classify, or to tell which was top and which was the bottom! . . . I do not think we have begun even to realize the possibilities of the camera.[10]

Vanity Fair routinely ran novel, photographically illustrated articles on such topics as the cyclograph pictures (time/motion studies) of Frank Gilbreth (August 1916), the use of double-exposure methods in film to create phantoms (April 1920), the vaporous light abstractions produced by Thomas Wilfred's color organ, "a wholly new source of aesthetic impressions" (December 1920), and ectoplasmic spirit photographs that exhibited human apparitions, probably achieved by double exposure (October 1922). Full-page spreads of experimental photographic work more in the mainstream included Ira Martin's astounding light abstractions (July 1921); Margaret Watkins's cubist kitchen-utensil still lifes (October 1921); cubist portraiture acknowledging the influence of German film, specifically *The Cabinet of Dr. Caligari* (December 1921); and a set of four Man Ray rayographs, abstract forms captured on photographic paper without a camera or lens (November 1922). Cunningham herself would soon experiment with light abstraction and multiple exposure, both of which appeared in her work for the rest of her life.

Fig. 20. Imogen Cunningham. *Adolf Bolm Ballet Intime Dancers*, 1921.

In the summer of 1920 the Partridge family moved across the bay to the Fruitvale section of Oakland. The house on Harbor View (fig. 19), located in a remote, rural area of the city, was initially primitive; the well gave out after two days and drinking water had to be carried up the hill.[11] Running water, electricity, and gas arrived only after a year or two. Roi was to begin teaching painting and design that fall at nearby Mills College, a private liberal arts college for women. His new professorial status was undoubtedly enviable to Imogen; she was frustrated by the three-year interregnum in her professional career. Old friend Alan Simms Lee wrote to her:

> Is it too brutal to say that of the two horns of the dilemma that pull you both ways at once—family and art—the youngsters are after all a finer contribution to the community than ever your photographs. It is of course less interesting to the general public and gives them nothing to talk about and it is hard to sacrifice the artist's need for individual praise from an admiring public; but having the family it is difficult as you say to achieve both, at least till the youngsters grow up a bit—you won't be too old then! . . . I think you are rather hard and not quite fair on the achievements of men. Many are very glad to acknowledge the debt they owe to their wives and many do achieve success entailing no sacrifice of others.[12]

Imogen somehow managed to stay creatively active during the first few years of motherhood with, as she wrote, "one hand in the dishpan, the other in the darkroom." Referring to herself in the third person, she noted that she had "a skill with the camera, which she was not willing to sacrifice to maternity, so she turned her camera to use and photographed the things she had around her—her own children of course and plants that she cultivated. It is quite easy to do a bit of gardening work and yet attend children. It is not as easy to do good photographic work, but it can be done. She did both."[13]

In addition to Maynard Dixon and Dorothea Lange, Imogen and Roi began to meet other artists and photographers in the Bay Area. In 1920 they befriended the Los Angeles photographer Edward Weston and his peripatetic colleague Johan Hagemeyer, a Dutch photographer. Cunningham had written Weston to comment on his print of *Ramiel in His Attic*, shown to her by Hagemeyer: "If that doesn't make old near-sighted Stieglitz sit up and look around for and at some one beside the seven constellations, I don't know what could. It has Paul Strand's eccentric efforts, so far as I have seen them, put entirely to shame, because it is more than eccentric. It has all the cubisticly inclined photographers laid low."[14] Discussing photographs of Weston's partner, Margrethe Mather,[15] also shown to her by Hagemeyer, Cunningham regretted her own creative lapse: "Since seeing the work of you two I feel, when I let myself think about it, as if I had a stone in my stomach and my hands tied behind my back. Now aren't you sorry with all your greatness to have elicited such feelings from me. I know why I pour all this in your ear, just as I did when you were here, because like animals and children who intuitively recognize their friends, I felt at once that you understand and appreciate what and why the 'Rune of Women' is. Why is all this as it is and when will it not be so?"[16]

One of Partridge's duties at Mills was the organization of exhibitions for the art gallery, and with Cunningham, he mounted a major exhibition of new photography. Imogen asked Alvin Langdon Coburn to participate, possibly to exhibit his recent abstract vortographs, but his schedule did not permit it.[17] Photographs by Cunningham, Edward Weston, Margrethe Mather, and Anne Brigman were included. The climate at Mills proved agreeable and appropriate for Cunningham. She had studied art, was married to an artist, and gravitated toward artistic friends; Mills was indeed fertile ground. As a liberal arts college specializing in art, music, dance, and literature, the campus routinely was home to a variety of international visiting artists who not only provided inspiration but also became photographic subjects.

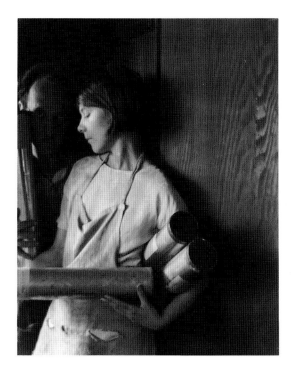

Fig. 21. Imogen Cunningham. *Edward Weston and Margrethe Mather*, 1922.

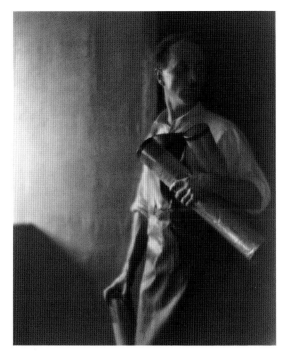

Fig. 22. Margrethe Mather. *Edward Weston*, 1922. Platinum print. Estate of William Justema, Berkeley, California.

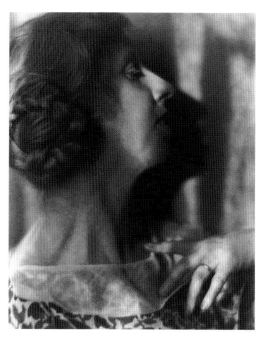

Fig. 23. Edward Weston. *Imogen Cunningham*, 1922. Platinum print. Collection of Imogen Cunningham Archives, The Imogen Cunningham Trust, Berkeley, California. © 1981 Center for Creative Photography, Tucson, Arizona Board of Regents.

Cunningham accepted her first commercial portrait session in years when she photographed the Adolph Bolm Ballet Intime in 1921.[18] She arranged the troupe around the grounds of San Francisco's neoclassical Palace of Fine Arts, an appropriate site to accentuate the toga-clad, spear-bearing dancers (fig. 20). Typical · pictorialist images, the pictures are similar to dance photographs illustrated in *Vanity Fair* by Baron Adolf de Meyer, Maurice Goldberg, and Arnold Genthe. But 1921 was a distinct turning point for Cunningham. As she refined her vision of nature, changing her focus from the long to the near, she sought out detailed pattern and form, evident in studies of bark texture and contorted tree trunks along the Carmel coast (pl. 21), a writhing snake curled on a gnarled Monterey cypress (pl. 51), and the trumpet-shaped morning glory that grew wild in her backyard (pl. 22). A family visit to the zoo about the same year produced a series of zebra studies, one of which precisely defines the natural black and white abstraction of the animal's patterned belly and loin (pl. 20). Her portraits of this period, such as a 1922 series of Edward Weston and Margrethe Mather[19] (pl. 24, fig. 21), and of Roi and John Butler from 1923 (pl. 26), form tightly composed relationships between the sitters within the framework of the plate. The emphasis on clarity, form, definition, and persona displaces her previous use of pictorialist space.[20]

By 1923 Cunningham was breaking new ground in West Coast photography. Her photographs of lunette sunlight patterns diffused through a leafy tree during a solar eclipse might be straightforward documentations of a natural phenomenon,[21] but they are also unusual nonrepresentational abstractions (pl. 30), recalling the strange, stellate light studies of Coburn's vortographs (fig. 24).[22] Possibly in response to Coburn's suggestion to make multiple exposures on one plate, Imogen in about 1923 composed a double-exposure portrait of her mother, her profile veiled by a still life of a pewter pitcher filled with spoons, the utensils virtually forming a shining headdress (pl. 31). The superimposed imagery more likely presents a meaningful personal motif (nine spoons symbolizing Susan's living children, a portrait of mother and children?) than a Picabian mechanomorphic representation or a sociopolitical statement such as those suggested by the Italian futurist Tato in his images of faces overlaid by machinery flywheels. Cunningham's use of pewter as an element in this image might refer to the German mystic and theosophist Jakob Boehme (whom she mentioned in lectures), who in 1600 attained sudden enlightenment from the reflection of sunlight in a pewter dish.

The double image, through either unmanipulated double exposure on the same sheet of film or the superimposition of two negatives, fascinated Cunningham and facilitated her creation of visual metaphors. The mirror image, reflections in water or window glass, the layered multiple image (created in camera or darkroom), the relationship between positive and negative, and the direct photography of duplicates found in nature are a significant leitmotif throughout her work. One might conjecture that bearing identical twins might have created, or at least augmented, this idiosyncrasy. Cunningham's scrutiny of the world might have presented infinite pairings, but once isolated by her camera, their discrepancies, however minor, made them interesting. For example, she photographed her twin sons' ears to compare their similarities as well as to document their different freckle patterns.

Imogen constantly struggled to balance her family life, commercial sittings, and creative work. While the children were still too young for school, she occasionally earned money by photographing some of the young women attending Mills, but she disliked the limitations of these jobs. Alan Simms Lee commiserated: "I can well imagine your distress if you are reduced to photographing 'pretty girls.' Doesn't sound a bit in your line."[23] She occasionally transcended the unchallenging work, however, by following up a

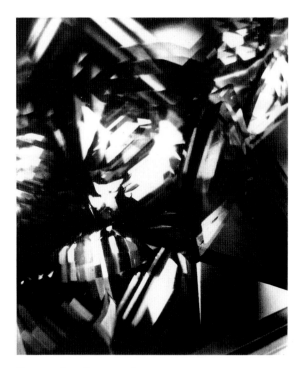

Fig. 24. Alvin Langdon Coburn. *Vortograph*, 1917. International Museum of Photography at George Eastman House, Rochester.

traditional portrait session with nude studies, if the sitters were agreeable. With increasing consciousness of design, she created in 1923 a nude study of a woman whose breasts are crossed by triangles of light and shadow and subtly framed by a nude male figure behind her (pl. 28). The work refers to an often-reproduced image by Weston, *Breast* (1920),[24] but confers more dramatic intrigue to the subject.

Cunningham's concern for purity of image and clarity of detail became increasingly important during the 1920s. She continued to photograph Roi and the boys but became particularly interested in flora, gathering prime botanical specimens from the backyard and elsewhere. She even found the fungus growing on the basement walls near her darkroom to be a suitable subject. Cunningham's fascination with botanical imagery may have been inherent; she had made botanical lantern slides in college and had photographed a strange bonsai arrangement in her Seattle studio before 1915 (pl. 12). But two classic masterpieces of floral still life had been published recently in *Vanity Fair* and could have validated her decision to explore botanical subjects in depth. Charles Sheeler's dignified *Zinnia and Nasturtium Leaves* was reproduced in May 1920, and *Lotus, Mount Kisco, New York* (fig. 25), Edward Steichen's study of an ethereally lit flower suspended in mysterious space,

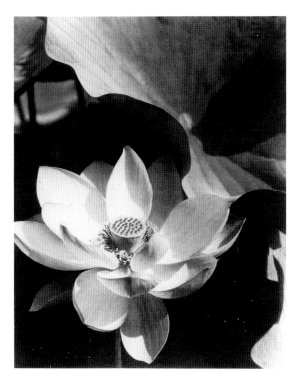

Fig. 25. Edward Steichen. *Lotus, Mount Kisco, New York*, 1915. Reproduced in *Vanity Fair* (July 1923). © Condé Nast Publications, Inc.

was printed in July 1923. The ubiquitous attributions of influence to Georgia O'Keeffe's mid- to late-1920s floral paintings are misdirected; Cunningham stated that she did not see them until visiting New York in 1934.[25]

From 1923 to 1925 Cunningham made an extended series of magnolia flower studies (fig. 26), which became increasingly simplified as she sought to recognize the form within the object. The results are best represented by the well-known *Magnolia Blossom* (pl. 38) and its counterpart, a detail of the magnolia's core, *Tower of Jewels*, the name given to the central wedding cake–like architectural tower at the Panama-Pacific International Exposition in 1915. Cunningham's botanical interests were supported by Johan Hagemeyer, who had been a professional horticulturist (pl. 23).[26] Hagemeyer created a limited body of floral still lifes during the 1920s including the moody, erotic, chalice-like *Calla Lily* (fig. 27), of which Edward Weston wrote: "Rumour has that you, in some God given super moment of creative fury have created for the world's delight a Lily— a real He Lily—grant that I may soon swoon with pleasure in the viewing of it—My own 'Art' has reached such heights that even Eunuchs ejaculate from excitement."[27] Margrethe Mather, too, photographed plant life during the 1920s. Her fluid arrangement of

two calla lilies emerging from perforations in a light-colored board is a characteristically subtle study of the nuances of white and gray (fig. 28).

This modernist vision of nature was not restricted to photography; Canadian-born, California-based painter Henrietta Shore, an important influence on the development of Edward Weston's mature vision, began to paint organic abstractions by 1920. These paintings, which she called "semi-abstractions," were variously interpreted as depictions of the fourth dimension or manifestations of subliminal eroticism. A 1923 comment by Raymond Henniker-Heaton regarding Shore's work can be applied as well to the innovative photographers of the period: "Permanent qualities in art are not obtained by repeating or rehearsing time-honored formulas. They are achieved through sensibility to the dominating spirit of the time, and the creative mind will recast Nature in this mold."[28] One of Shore's intriguing compositions, *Trail of Life* (fig. 29), presents the same sinuous morphology as Cunningham's detailed abstraction of a water hyacinth (pl. 36).[29]

Imogen was also educated in flora by Egon von Ratibor, a German prince who called himself James West and helped to create the University of California Botanical Garden. They met in the late 1920s and went on field trips together to photograph unusual plants and gardens, especially succulents. West occasionally stayed at the Partridge home where a guest bed was always available to him: "He would wander in at ten o'clock at night, talk plants until 3 a.m., then get in bed and chain smoke."[30] Cunningham did not always photograph plant materials straightforwardly or in their natural habitats; her arrangements were often created spontaneously in a spirit of fun, albeit with a solid sense of design (pls. 32, 33). Looking for pattern and design, she found worthy subjects in occasional random artifacts, such as a drawerful of buttons (fig. 30), a drainboard of dishes, or eggs in egg cups (pl. 48). Whereas Edward Weston defined a part of his oeuvre by his preoccupation with the quintessential life force of fruits and vegetables, Cunningham rarely photographed them, although she did make a few attempts with pears and bananas (fig. 31), pineapples, and erotically suggestive carrots and radishes.

Cunningham maintained a considerable interest in German culture. She purchased or read publications such as the annual *Das Deutsche Lichtbild*, which profiled botanical photographs by Albert Renger-Patzsch, volumes from Ernst Fuhrmann's *Die Welt der Pflanze* (1929–31), and Karl Blossfeldt's *Urformen der Kunst*

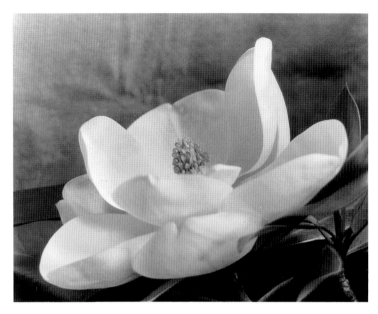

Fig. 26. Imogen Cunningham. *The First Magnolia*, ca. 1923.

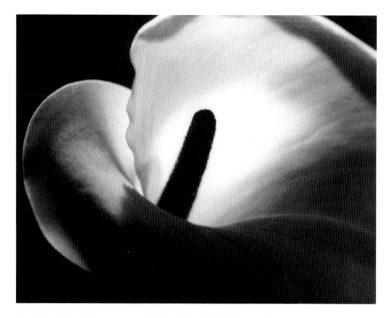

Fig. 27. Johan Hagemeyer. *Calla Lily*, 1926. Center for Creative Photography, Tucson.

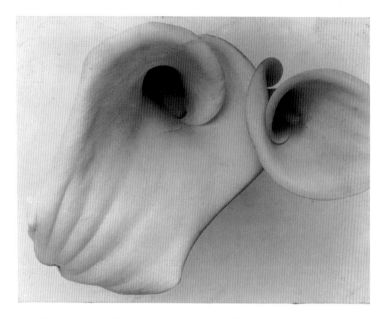

Fig. 28. Margrethe Mather. *Calla Lilies*, ca. 1926. Estate of William Justema, Berkeley, California.

(1928). The comparable plant images of Cunningham and Renger-Patzsch are more likely ascribed to similar concerns than direct influence since Imogen was well into her exploration of the subject before exposure to her German counterpart. Renger-Patzsch was the most notable practitioner of the New Objectivity (Neue Sachlichkeit), Germany's version of modernist or "new vision" photography, a style favoring the pure and objective presentation of visual facts. His formal examinations of specific flora intimately revealed the intrinsic designs of nature and presented analogies between their elemental structures and aspects of industrial design. Believing that the camera perceived natural objects more clearly than the eye, Renger-Patzsch isolated a characteristic fragment from the whole, thereby underscoring its essential elements.[31] The Bauhaus painter, photographer, and teacher László Moholy-Nagy also considered the camera an important tool of the new vision: "In photography we possess an extraordinary instrument for reproduction. But photography is much more than that. Today it is in a fair way to bringing (optically) something entirely new into the world."[32] Cunningham, more than any other West Coast photographer, reflected the objectivity of German and Bauhaus practitioners in her work. Unlike Weston's innate transcendentalism, Cunningham's stoic descriptiveness made her a better candidate for producing superior examples of unsentimental botanical imagery and of precisionist works that glorified machine forms.

One peculiar Cunningham photograph, unique to her work of the time and indeed unique to American photography of the

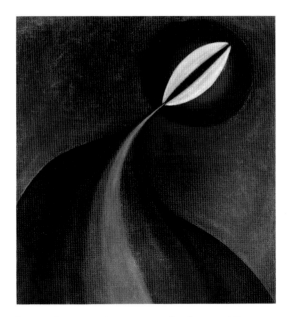

Fig. 29. Henrietta Shore. *Trail of Life*, 1921. Oil on canvas. Collection of Richard Lorenz, Berkeley, California.

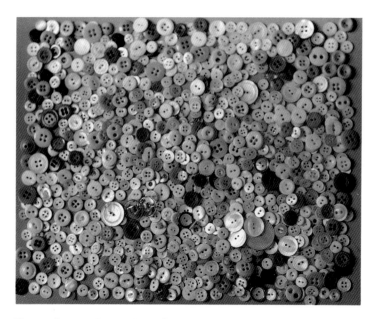

Fig. 30. Imogen Cunningham. *Buttons*, ca. 1925.

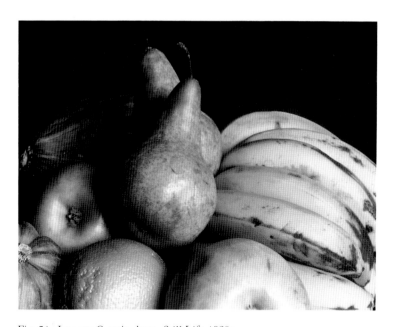

Fig. 31. Imogen Cunningham. *Still Life*, 1920s.

period, is *Snake* (pl. 52), a 1927 image in which she manipulated a 1921 negative to produce a negative print. Drawing on her previous experience with lantern slides, Cunningham produced *Snake* by using the earlier negative to make a glass plate positive, from which she enlarged the final negative print. Having performed this novel inversion once, however, she curiously did not then develop the idea further,[33] unlike Franz Roh, the German experimental photographer and author who created a strong body of negative imagery in the mid-1920s,[34] and Moholy-Nagy, whose pairing of negative and positive images intentionally transposed tonal values and separated optical experience from intellectual association.[35]

During the late 1920s Cunningham flirted with precisionism, the American equivalent of the New Objectivity that with compelling clarity revealed the material properties and geometric volumes of the fabric of industry. She photographed extensively in Los Angeles in 1928, aggrandizing the oil industry in a striking series of oil rigs and tanks at Signal Hill (pl. 49). The idealization of American industry in popular culture became apparent in a 1928 issue of *Vanity Fair*. A Charles Sheeler image of the Ford manufacturing plant at River Rouge, Michigan, was illustrated with the title "By Their Works, Ye Shall Know Them," and the accompanying article reverentially exclaimed that the factory was "the most significant public monument in America . . . America's Mecca, toward which the pious journey for prayer."[36] As a mother putting breakfast on the table each morning, Cunningham (who did not drive) might have been nominating her own choice for America's favorite public

monument when she began an extensive series of industrial land-
scapes around the Nabisco Shredded Wheat factory in Oakland.
Her study of a water tower, unconventionally shot from below
(pl. 50), has a sophisticated European modernist sensibility that is
not found in comparable industrial studies of the same period by
Weston and Hagemeyer. The factory structure looms above, trap-
ping the viewer like a menacing Brobdingnagian creation. The cam-
era angle resembles those of Alexander Rodchenko and that of the
image on the 1929 *Film und Foto* exhibition poster (attributed to
graphic designer Jan Tschichold), in which a towering photographer
shoots directly down on the viewer. Franz Roh remarked about
such newly seen perspective: "Formerly pictures were taken only
in horizontal view-line. The audacious sight from above and below,
which new technical achievement has brought about by sudden
change of level (lift, aeroplane, & c.) . . . is stirring."[37]

Rather than supporting the traditional precept that Edward
Weston was her modernist mentor, Cunningham's work of the late
1920s presents a strong case for her position as the most indepen-
dently sophisticated and experimental photographer at work on the
West Coast. A review of a photography exhibition at the Berkeley
Art Museum in 1929 declared: "Imogen Cunningham . . . is easily
the star of the show. She has struck a beautiful balance between
quality and organization; she has simplified, yet she has not simpli-
fied to the point where her work loses interest. . . . On the other
hand, we see here the work of one who is probably the most ex-
alted of all pictorial photographers: Edward Weston . . . yet, unlike
Imogen Cunningham, Weston has simplified his compositions to a
degree that results in practically no composition at all. There are
not enough elements involved to make his works vitally interesting.
Were it not for Cunningham's revelations of what can be created in
photography, we might appreciate Weston the more."[38]

Richard Neutra was a Viennese architect who emigrated to
Los Angeles in 1925 and worked in the International Style. Acting as
a representative of the German Work Alliance (Deutscher Werk-
bund), an organization that promoted the arts and technology and
sporadically organized international expositions,[39] Neutra invited
Edward Weston to select the West Coast entries for the historic
1929 *Film und Foto*, an exhibition held in Stuttgart that largely de-
fined the nature of avant-garde photography at the end of the dec-
ade.[40] Although Weston asked Cunningham for examples of her
flower forms, the ten images she exhibited at Stuttgart included a
nude and an industrial study as well.[41]

Fig. 32. Margrethe Mather. *Hands of Billy Justema*, ca. 1925.
© 1987 Estate of William Justema, Berkeley, California.

Fig. 33. Edward Weston. *Fragment*, 1927. Reproduced in
Transition 19–20 (June 1930). © 1981 Center for Creative
Photography, Tucson, Arizona Board of Regents.

Weston thought Cunningham's work to be "fine and strong and honest."[42] He had been exhilarated by her print of a glacial lily, or false hellebore (pl. 39), which he had seen at the Los Angeles Museum. Weston wrote her: "I went out to the museum today, primarily to land some work and see Stojana's exhibit, incidentally to see the 'International Salon of Photography.' As usual, most of it was rubbish, though several Japanese had fine things, but I had one thrill and it was your print—Glacial Lily—it stopped me at once, I did not note the signature until I had exclaimed to myself—'this is fine!' It is the best thing in the show, Imogen, and if you keep up to that standard you will be one of a handful of important photographers in America—or anywhere. Thank you for giving me rare pleasure."[43] When he reviewed an exhibition of her work at a Carmel gallery two years later, he was again generous with praise: "She uses her medium, photography, with honesty,—no tricks, no evasion: a clean cut presentation of the thing itself, the life of whatever is seen through her lens,—that life within the obvious external form. With unmistakable joy in her work, with the unclouded eyes of a real photographer, knowing what can, and cannot, be done with her medium, she never resorts to technical stunts, nor labels herself a would-be third-rate painter. Imogen Cunningham is a photographer! A rarely fine one."[44]

As if her botanical interests had largely been expressed by the late 1920s, Cunningham now began to turn from plant to human forms. She ventured into an exploration of body parts, perhaps spurred by several detailed anatomical studies in the *Film und Foto* catalogue and its companion publication *photo-eye* (edited by Franz Roh and Jan Tschichold), such as Max Burchartz's signature New Objectivity image, *Lotte (Eye)*; Herbert Bayer's detail, *Legs*; and the cropped, pursed lips in P. E. Hahn's *The Speaker*. The ears of her twin sons (pl. 61), the right eye of friend Portia Hume (pl. 60), the legs of exotic dancer John Bovingdon (pl. 58), and the feet of her dentist, Paul Maimone (pl. 59), became new props for her photographic agenda.

Weston, Mather, Hagemeyer, and Cunningham influenced one another to varying degrees, and even though each of them found human appendages to warrant photographic examination—either as studies in form or, as in Mather's case, form and emotion—the core idiosyncrasies of each personality inevitably defined each individual's style: Weston, the perfectionist theoretician; Hagemeyer, the sophisticated romantic; Mather, the illusory aesthete; and Cunningham, the novel and prodigious experimenter. Mather's

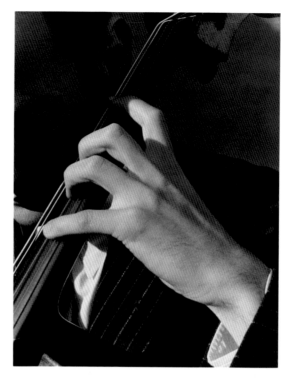

Fig. 34. Imogen Cunningham. *Hand of Gerald Warburg*, 1929.

lyrical picture of Billy Justema's hands in a mudra-like gesture speaks the fey poetry of the young artist's soul (fig. 32); Weston's *Fragment* (fig. 33) stolidly describes the poised athleticism in the knees of dancer Bertha Wardell. Cunningham became fascinated with hands, especially those of artists and musicians.[45] She intricately and intimately wove the art around the artist's hand: sculptors embrace their work, musicians wield their instruments, actors apply makeup. Henry Cowell, an avant-garde composer of dissonant scores and the founder of New Music, with clenched fists performs one of his innovative "tone clusters" on the piano (pl. 45); Gerald Warburg's hand, starkly lit against his dark shoulder, articulates his masterful finesse of the cello (fig. 34).

In 1930 Lloyd L. Rollins became the new director of the sister museums of San Francisco, the M. H. de Young Memorial Museum and the California Palace of the Legion of Honor. Young and energetic, Rollins quickly initiated an adventurous schedule that included regular photography exhibitions. Edward Weston was given a retrospective in November 1931, and Cunningham's retrospective of sixty-three prints opened at the de Young on December 18, 1931. One critic noted that for "those who still think that certain forms of so-called modernistic art have no kinship to nature have but to see such direct photographic studies . . . to learn that a literal

representation of nature may come very near to being an abstraction, for nature itself is capable of a more weird creative imagination than is the mind of man, 'modernist' or otherwise." He added: "Though they are softer and less brutal than Weston's prints, her photographs are equally as direct as are his, and are frequently, in our opinion, finer than some of his."[46]

But another review of the exhibition in *The Fortnightly*, by a young, amateur photographer named Ansel E. Adams, was curiously condescending and sexist in describing the forms that Weston had recently found to be pure, honest, strong, and, one assumes, not conditioned by sex. Adams's perception of "a definitely feminine point of view" in the work seems to indicate some degree of diminishment. He opined that "her work is refreshingly free of propaganda, philosophical and artistic, yet there is a naive devotion to certain traditional conceptions of art which, in a broad sense, is a very safe quality for a photographer to possess. Her prints could have been produced only by a woman, which does not imply, however, a lack of vigor. All her photographs brim with a restrained strength typical of keen decisive feminine energy."[47] A slightly edited version of the same exhibition, billed as *The Seeing Eye*, was shown in the spring of 1932 at the Los Angeles Museum where it was noted: "This exhibit points out in most unmistakable terms how the speeding of modern life seems to have robbed us of the fun of seeing,—but that with such opportunities as this everyone may again develop an intimate contact with the untold beauties to be found in unexpected aspects of nature."[48]

Cunningham, like Albert Renger-Patzsch in Germany, had begun to compartmentalize the visual world, each category as intrinsically interesting as the next. In his landmark book *Die Welt Ist Schön* (The World Is Beautiful), Renger-Patzsch signaled the freeing of photography from the traditions of painting: "The secret of a good photograph, one that possesses esthetic quality of a work of art, lies in its realism. . . . Let us leave art to the artists and let us try by means of photography to create photographs which can stand alone because of their *photographic* quality—without borrowing from art."[49] Cunningham's choice of subject became uniquely photographic and decidedly unpainterly in a 1929 outing to Yreka, California. The dynamically striated shadows of a dilapidated barn, receding in several planes to a small open landscape (fig. 35), present a transitory scene that accords well with the observation of Carl G. Heise, Renger-Patzsch's editor, that "the translation of what the photographer saw in everyday reality into a black-and-white image

Fig. 35. Imogen Cunningham. *Yreka*, 1929.

spurs the viewer on to seek a visual excitement which he previously passed by unaware."[50] The symmetry of an abandoned outhouse seat (pl. 65) and its allusion to Edward Weston's photograph of a Mexican toilet, *Excusado* (1925), inspired Cunningham to make a photograph. She sent Weston a copy with a note: "When I saw this on my wanderings this summer, my thoughts flew at once to you. I realize that it does not have the classic beauty of the 'Greek Urn' of the Mexico City days, but there is something about it which compensates anyway. Perhaps it is the fact that it is so sociable and friendly."[51]

During a dinner party in Santa Barbara in 1931, Cunningham met Martha Graham, a former member of the Denishawn Dancers whose artistic liberation began after seeing paintings by Wassily Kandinsky in New York in the 1920s. Graham, the originator of expressionism in modern American dance, had just achieved a major success in New York with her presentation of "Primitive Mysteries," a dance triptych that reinterpreted the life of the Virgin.[52] Graham found Cunningham to be the first photographer with whom she could comfortably create,[53] and in one afternoon session, Imogen produced ninety Graflex negatives, two of which were the first of her images to appear in *Vanity Fair*, in December 1931.[54] Indicative of Cunningham's objective realism is an image of Graham, nude, framed within an open barn door and brilliantly lit by the

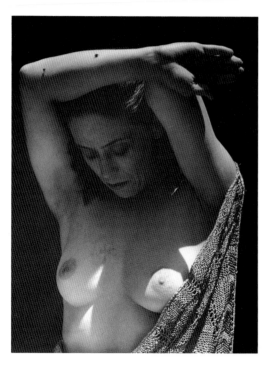

Fig. 36. Imogen Cunningham. *Martha Graham 44*, 1931.

Fig. 37. Imogen Cunningham. *Cary Grant*, 1932.

noon sun against the dense, black interior (fig. 36). The flies alighting on Graham's arm remind the viewer of the gritty circumstances of the picture and validate the integrity and fortitude of this brief collaboration.

Vanity Fair advertised itself as the first and last word on modernism, a forum for a modern point of view with a "sketchy, sophisticated, half gay, half serious outlook on life," and as such it reflected Imogen's interests in popular culture. Published by Condé Nast, the magazine was edited by Frank Crowninshield, who believed in breaking barriers: "For women we intend to do something in a new and missionary spirit. . . . We dare to believe that they are, in their best moments, creatures of some cerebral activity . . . and we hereby announce ourselves as determined and bigoted feminists."[55] Cunningham had submitted to the magazine her portraits of the cellist Gerald Warburg, who was the husband of Natica Nast, Condé Nast's daughter. The materials were returned, but a correspondence between managing editor Donald Freeman and Cunningham led to an assignment to photograph Hollywood personalities.

Imogen began her association with the magazine on a trial basis because of her doubts about the practicality of an Oakland/ Los Angeles train commute and its effect on her family's life, as well as her ideological concern that agents would impede her from tak-

ing fresh, natural, and unglamorous pictures. She wrote Freeman: "I am not certain to what extent it would be possible to pierce the shell of artificiality with which the film stars surround themselves, especially if the photographs would have to please them and their managers first before you could use them. I am presuming that you would wish me to get as far away as possible from the type of portraiture which fills the movie magazines of the day. I should not be interested unless I might be free to try and get more character than this into the work."[56] Freeman responded: "The Hollywood venture, about which we have been corresponding, is in the nature of an experiment. I agree with you that it is indeed almost impossible to pierce the shell of artificiality but our policy has always been to please ourselves, and we emphatically refrain from submitting proofs to managers, press agents, studios, or even to the sitters. You are correct in assuming that we would favor what one does not see in the motion picture magazines."[57]

From 1932 to 1935 Cunningham photographed such personalities as Joan Blondell, James Cagney, Ernst Lubitsch, Spencer Tracy, Warner Oland, Frances Dee, and Cary Grant (fig. 37). Her renegade use of straightforward photography to penetrate the facade of Hollywood stars and to realistically document them off the set coincided with her association in late 1932 with several Bay Area photographers whose shared ideology led to the formation of

Group f.64. The name, derived from the smallest aperture available on a large format camera, implies images with the greatest depth of focus and sharpest detail. The original members were Ansel E. Adams, Imogen Cunningham, John Paul Edwards, Sonya Noskowiak, Henry Swift, Willard Van Dyke, and Edward Weston. Their goal was to produce pure and unmanipulated photographs that utilized the full technical capabilities of the camera and were contact printed, without enlargement or retouching, on glossy paper. Although Group f.64 had only one exhibition, at the de Young museum in 1932,[58] its legend has had a lasting effect. In its assertion of visual reality, the group became a pivotal reference for straight photography.[59]

By 1932 Cunningham and Weston were internationally acclaimed professional photographers; each had already been given a major retrospective at the de Young museum. Cunningham's participation in the Group f.64 exhibition, therefore, was a show of support for the medium as well as an act of encouragement toward young, amateur talent. At the time it seemed a peripheral event, little more than another show on her group exhibition list. In fact, a review in *The Argonaut* failed to individuate the exhibition from the Bay Area's active photography scene: "And sharp focussing happens to be the vogue just now in 'artistic' photography. . . . Such a collection of prints makes us feel that, had we time or money, or both, we would add photography to our list of favorite hobbies."[60]

Cunningham's interests were always too eclectic, her attitude too flexible, to be constricted by Group f.64 definitions, whose manner of realism and choice of subject she later considered a regional West Coast style.[61] Historically categorized as a kindred echo of Weston, the guiding spirit of the short-lived group, Cunningham became rather his antithesis. As a pioneering adventurer, she had the innate curiosity to experiment, to "fool around" as she would often say, and go beyond signature, safe subjects. She exploited serendipity, cropping an image when she felt it necessary, saving a rejected print from the darkroom sink when it became more interesting from accidental solarization, and sandwiching negatives or shooting double exposures when she pleased. Shades of dada and surrealism run through her work, and the conceptual dogma of the pure print with which she had momentarily associated herself was, by then, a foregone consideration; Group f.64 was more a summation of her past endeavors than an indication of future direction.

Fig. 38. Baruch. *Harald Kreutzberg's "Danse Macabre."* Reproduced in *Vanity Fair* (Jan. 1928). © Condé Nast Publications, Inc.

Fig. 39. Imogen Cunningham. *Hands of Laura LaPlante*, ca. 1931.

At about the same time Cunningham exhibited with Group f.64, she was increasingly preoccupied with the multiple image or double exposure. She had produced a glorious example several years before based on a portrait of her mother (pl. 31), and the increased use of this pictorial device by other photographers in the late 1920s possibly encouraged her further experimentation. *Vanity Fair* illustrated the German photographer Baruch's multiple study of Harald Kreutzberg's *Danse Macabre* (fig. 38) in January 1928, and during the following few years a progression of multiple-exposure portraits by Edward Steichen and Cecil Beaton were published in the magazine.[62] The images indicated personality dualities, confused the passage of time, defied representational gravity, and perhaps even manifested a fourth dimension. Cunningham most likely attended the 1932 *Foreign Advertising Exhibition*, a presentation of avant-garde European commercial photography at the de Young museum, where such work as Herbert Bayer's classic photomontage cover for the journal *Bauhaus*, multiple exposures by Germaine Krull, mirror reflection still lifes by Florence Henri, and photomontages by László Moholy-Nagy and György Kepes were displayed.[63] Cunningham incorporated double exposures into her own magazine work, contrasting expression and form, time and space, in a study of Martha Graham (pl. 72) and the private preparations and public presentation of actress Laura LaPlante (fig. 39).

Alan Simms Lee wrote Cunningham in early 1934:

> I am glad to note you are still rebellious. I don't know why I shouldn't be glad, except that if you were otherwise, it would mean that either something devastating had happened to your insides which were deplorable or else you had got beyond esthetic kicks and quaintness in religion which is most unlikely. So your bent now is Realism with a capital R. Is it? You ought to have done that years ago, though I don't know just what the phrase means. I suppose it is an exact and detailed reproduction of the apparent: but as such I don't see that it is any more real than what you used to do and I am very far from assurance that it matters. But I like these photographs, somehow they seem very sane and honest and interesting. But why the devil, if you think realism a good thing in art, don't you think it equally good as applied to Life! There's something wrong with one or the other. What's your scheme of Reality?[64]

Lee was referring to Imogen's critical difficulty in balancing her personal and professional lives. She had been invited to work in New York City by *Vanity Fair*, but Roi insisted that she defer the trip until they could travel together. Imogen would not wait, and she wrote him from Chicago on her way cross-country:

> Why in the world would you think that it puts you in a ridiculous position for me to go away for a time on a working job. . . . I am sure you are bitter about my methods of working my exit, but with your attitude of mind, nothing else was physically possible for me. I begged too many times for co-operation and permission. . . . I cannot get myself straightened out through idleness—I have never really learned to play—and if I did want to play, I could not afford to. The working part only makes the going easier because I will not become involved in debt and it will cost you no actual money. I assure you I do not value myself so highly as a photographer as you seem to think, but neither could I venture afield unless I had some confidence in my ability. Only thru putting myself thru it, as it were, can I really think I am worth anything to you or the family. . . . Try not to forget that I have always really done the essentials, have always been at home after school, when the children came, that my work has not been as distracting as most wives' occupational bridge, that I had always the hope that in place of going down in the scale of worthwhileness and achievement as most hausfraus do that I was going up. . . . I really thought I had the right of an adult to undertake an obligation. I never thought for a moment that a person so liberal in all else would deny me this.[65]

Roi could no longer accept Imogen's assertive independence, and undoubtedly a certain amount of professional rivalry increased the tension. And now that their sons were all old enough to be on their own, the marriage had perhaps lost its last cohesive element. In June 1934 he traveled to Reno, Nevada, to file for divorce,[66] and when Imogen returned from the East Coast to the house on Harbor View, it had become her settlement.

Stolen Pictures

While in New York in 1934 Cunningham visited Alfred Stieglitz at his gallery, An American Place. Stieglitz, now aware of her reputation (unlike her 1910 visit to "291"), submitted to being photographed. Imogen borrowed his 8-by-10-inch view camera and made seven fine portraits of him posed against his most precious Georgia O'Keeffe painting, *Black Iris* (pl. 80).[1] She recalled the experience years later:

> I was afraid of him then [1910] but not in 1934, when I photographed him with his own old 8 × 10 camera with a Goertz lens on it, so corroded that one could not see the markings for the diaphragm. It was operated by a hose with a bulb at the end and as old as I am, I had never used that. He practiced me and was most cooperative. I had no meter and just held the bulb, watching him all the time, as long as I dared to. I made seven exposures and all of them look like him but . . . the one I like best . . . has that skeptical look he could so easily put on.[2]

The few photographs Cunningham made in her month's stay in Manhattan covered a broad spectrum of social strata and pictorial content. She photographed horse-drawn carts in Chinatown (fig. 40), and an advertising agency commissioned her to photograph Mrs. James Roosevelt, Franklin D. Roosevelt's mother, at her home on the Upper East Side. The juxtaposition of extreme wealth and dire poverty in the city ostensibly induced Cunningham to take what she considered her first "stolen picture," a term she used to describe her individual type of documentary street photography.[3] She captured a bum sleeping beneath a "No Thorofare" sign on the sidewalk beneath the Queensboro Bridge, a watchful cat graffito chalked on the wall above him (pl. 77). She sent a note to photographer Ralph Steiner typed on this image, which caused him to ponder: "The picture . . . reminds me of that beautiful saying of Anatole France's to the effect that he admired the 'beautiful impartiality of the Law which permitted the rich as well as the poor to sleep under the bridges at night.'"[4]

Imogen traveled to Washington, D.C., where the Asian art exhibits at the Freer Gallery of Art particularly impressed her, and then continued on to Hume, Virginia, where her Seattle friend John Butler and his wife, Agnes, had bought an old Georgian mansion called the Dell. This Southern respite was a much-needed lull and an opportunity, perhaps, to discuss her marital problems. Assessing life at the Dell, Imogen wrote her son Gryff: "It is impossible to describe their life, in someways not enough of achievement perhaps, and a possible lack of contentment over that but withal a grace and charm and quiet affection for each other and their friends, which all people ought to acquire with maturity. Perhaps this much philosophy will do for the moment and I might get myself down to the realities of life, but the realities in this beautiful place do not seem so real to me."[5]

Imogen photographed "a bit here and there, mostly the natives but there has been a storm every afternoon this week except yesterday."[6] She focused on Butler's rural property, the tradesmen repairing the house, townsfolk lingering about the general store, and especially the members of a black family living nearby. Rebecca (pl. 78) took in wash to support herself and her two sons (pl. 79), and the grace and dignity Cunningham imparts in this series imply her knowingness of a hard life and her admiration for this single mother's fortitude and determination. She wrote her sons: "I will also try to work and earn money when I come back. I have several assignments from *Vanity Fair*. . . . I want so much to do the right thing, if only I can find out what that is . . . and I hope that this great vacation of mine is going to make me a better and more avid mother."[7]

When Cunningham returned to Oakland, she and Roi divorced. Her need to assert herself had become intolerable to him, and she was equally weary of his chauvinistic, dogmatic ways. Their marriage had lasted nineteen years. Cunningham maintained a cordial relationship with Partridge and confessed to friends her sincere love for him, describing him as the only man ever in her life. Gryff

Fig. 41. Imogen Cunningham. *Coon Saw*, 1934.

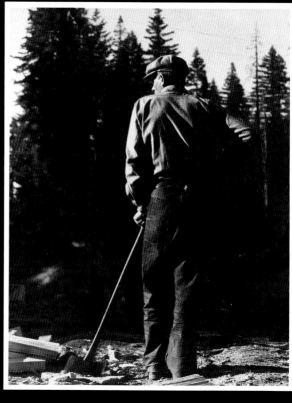

Fig. 42. Dorothea Lange. *Unemployed Exchange Association*, 1934. The Oakland Museum, California.

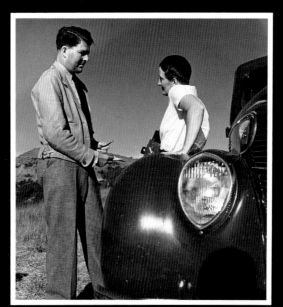

was attending the University of California, Berkeley, and Padraic and Rondal would graduate from high school the following year. Imogen would hereafter remain single, devoted only to her craft.

Imogen's beginnings in the genre of documentary photography coincided with those of her friend Dorothea Lange, who in 1934 began to document the social concerns raised by the great American depression.[8] Paul Taylor, a professor of economics and a specialist in migratory labor at the University of California, Berkeley, invited Cunningham and Lange in 1934 to provide visual documents for his social research. He was studying self-help cooperatives and bartering systems used by the unemployed, particularly the Unemployed Exchange Association (UXA) operating in the foothills near Oroville, which had received a federal grant to convert a failed sawmill into a cooperative.[9] Taylor, Cunningham, Lange, and three other Bay Area photographers, Willard Van Dyke, Preston Holder, and Mary Jeanette Edwards, spent a weekend photographing the cooperative's members and their difficult existence. Taylor considered Lange's working method a search for emotion and story, whereas Cunningham "set up and made a few studied, well-organized, well-executed photographs."[10] Her descriptive portrait of a worker's head is solidly composed with formal architectural elements and relied on the cooperation of her subject (fig. 41), whereas Lange candidly captured nuances of attitude, character, and mood, and her images imply a story (fig. 42). Van Dyke noted that Lange was able to create in each photograph "another climax in the turbulent drama of human relations [by acting] as if she possessed the power to become invisible to those around her. This mental attitude enables her to completely ignore those who might resent her presence."[11] Lange eventually divorced Maynard Dixon and married Taylor in 1935 (fig. 43). Although Cunningham and Lange remained good friends, they never again worked together on a documentary project.

Cunningham would continue to take "stolen pictures" throughout her life, but they would always be more humanistic, environmental portraits than photojournalistic commentaries. She disliked invading people's privacy and interpreting or judging their lives; perhaps, too, her own poor youth made her steer away from depictions of poverty and sadness: "I don't take, for instance, certain miseries of the world, like children that are left behind without parents, and so on. You know, a documentary is only interesting once in a while. If you look at a whole book of Dorothea's where she has row after row of people bending over and digging out carrots—

that can be very tedious. And so it's only once in a while that something happens that is worth doing."[12] Cunningham's background, after all, was in the arts, and her belief in producing works of aesthetic value was a constant. She remarked at a much later date: "I have no ambition, never did have any ambition, to be a reporter. That is something different. I still feel that my interest in photography has something to do with the aesthetic, and that there should be a little beauty in everything."[13] She rationalized her hybridized style of documentary work:

> I am not one of those persons who thinks it necessary to defend my position in regard to straight photography. . . . I had, or so I suppose, a great opportunity to record a place and a time—by this I mean honest documentary when I began as a professional photographer in Seattle in 1910. But photography was to me an expressive art and I left all the documents to the newsmen, of whom there were not as many as now. Since that time, however, I have made things that I thought expressive as well as documentary—see enclosed shot of my father when he was 90 [pl. 88]. . . . I am interested in reading all the ideas and there will always be people who like to write about theories of photography but I still remain the person who likes just to try doing things.[14]

Imogen continued to work occasionally for *Vanity Fair* until the magazine folded in 1936.[15] In 1934 she photographed Upton Sinclair, the author and liberal candidate for governor of California who promised to eliminate poverty in the state, and in 1935 she had a session with Herbert Hoover, shot in Palo Alto, California. Although unnerved by the ex-president, she nevertheless produced a successful group of classic, yet stern, formal portraits taken in his library, as well as several relaxed and affable outdoor images of Hoover and his dog (pl. 84).[16] The Philadelphia bibliophile A. S. Rosenbach hired her to photograph numerous literary figures for publicity and editorial use, including Somerset Maugham, Jules Romains, and John Masefield, poet laureate of England.[17]

Cunningham photographed Gertrude Stein during her American tour to promote a new book, *Lectures in America* (pl. 81),[18] and one of the images, shot atop the balcony of San Francisco's Mark Hopkins Hotel, became an intriguing collaboration. Cunningham produced a slightly time-lapsed double exposure of Stein's head, a neo-cubist chronophotograph of full face and full profile, overlapped with a hint of the movement between poses (fig. 44). A passage of Stein's writing appropriately applies: "The making of a portrait of any one is as they are existing has nothing to do with

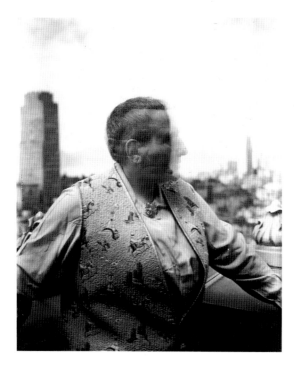

Fig. 44. Imogen Cunningham. *Gertrude Stein, San Francisco 2*, 1935.

Fig. 46. Imogen Cunningham. *Photomontage of Herbert Hoover and Franklin D. Roosevelt*, ca. 1935.

Fig. 45. El Lissitzky. Cover for *Il'ia selvinskii zapiski poeta* (Notes of a Poet), 1928. Courtesy Anacapa Books, Berkeley, California.

remembering any one or anything. . . . You do see that there are two things and not one and if one wants to make a portrait of some one and not two you can see that one can be bothered completely bothered by this thing."[19] The image strikingly resembles El Lissitzky's double-exposure portrait of Jean Arp in front of a dada periodical, used as the cover for a book of Russian poems in 1928 (fig. 45).[20]

Cunningham used the double exposure to complete a portrait by extending it through time, to create, as Stein believed, a more revealing impression. If double exposure was inappropriate for a picture, however, Cunningham substituted place for time, and the sitter's physical environment became the method of revelation. Cunningham rarely went into a photo session with preconceived notions: "Don't think that I have things so perfectly figured out for myself. I have not especially when the work concerns real people whom one wishes to portray with some significance. . . . I like to try all sorts of people but I go at different kinds differently—I have no rules—and if I had, they wouldn't be rules for another person."[21] Unconventional and unpredictable, she created a peculiar photomontage about this time, one of the few overtly political works in her oeuvre—a collage of Herbert Hoover (cut from one of her portraits of him) and Franklin D. Roosevelt (fig. 46).[22]

Cunningham continued to receive commissions from Mills College to photograph visiting artists and instructors such as painters Amédée Ozenfant and Lyonel Feininger, dancer José Limón, and Helena Mayer, a faculty member and Olympic fencer (pl. 83). In 1935 Cunningham's friend from her early years in Seattle, Nellie Cornish, who had founded the Cornish School there, enlisted her help in the production of a sophisticated catalogue to promote the school, a private institution for the study of drama, music, dance, and art.[23] Using the studio and darkroom of Edward Curtis's brother, Asahel, after-hours to carry out the project, Cunningham ambitiously proceeded to document student thespians on stage, set production, marionette practice, art students painting from a nude model, dance classes based on eurythmics, and young musicians playing instruments. Perhaps the open nature of the school caused her to be even more experimental in her technique, because this body of work is defined by a high number of double exposures and photomontages. *Three Harps* (fig. 47) is a tour de force of structured theatricality, with forms as strong, bold, and exciting as Man Ray's inverted composition *Eva* (fig. 48). By 1937, however, Cunningham made her last multiple exposures for many years to come when she photographed the dome of the Mount Hamilton Observatory (pl. 91) and the expansive cloudscape unfurling from the surrounding heights (pl. 90).[24]

The Oakland waterfront became a rich source for industrial still lifes (pls. 82, 89), and local characters squatting in a miserable, makeshift Hooverville engaged Cunningham's attention. One photograph, *Sixes and Sevens*, a tightly composed study of a black man deep in thought over a hand of cards, documents the picturesqueness of the period without eliciting pathos. With her Graphlex, she captured passengers traveling on the five-cent ferry boats from Oakland to San Francisco, sometimes oblivious to her lens but occasionally tacitly cooperative. Well-dressed commuters, businessmen deep in discussion, sailors from the local navy yard, relaxing deckhands (pl. 86), and bindle stiffs carrying their bedrolls (pl. 85) were all unwary subjects.

The bulky 4-by-5-inch Graphlex camera hindered Imogen's pursuit of candid pictures, and in 1937 she experimented with her son Ron's 35mm camera, shooting a few rolls along San Francisco's Embarcadero and Market Street. From the top of the Ferry Building, she made aerial views of pedestrians bustling about the cable-car turnaround, and her studies of store-window reflections achieved in a single release of the shutter the complexity and multi-

Fig. 47. Imogen Cunningham. *Three Harps*, 1935.

Fig. 48. Man Ray. *Eva*, 1932. Reproduced in *Photographs by Man Ray: 1920, Paris, 1934* (1934).

dimensionality of her double exposures (fig. 49). But the reduced negative size did not produce an adequate enlargement, so Cunningham switched to a Zeiss Super Ikonta B and the greater resolution of its 2¼-by-2¼-inch negative, the format she would largely use, with a succession of Rolleiflex cameras, for the rest of her life.[25]

With the advent of *Life* magazine in November 1936, photojournalism found a mass-appeal format of unprecedented power and popularity. Henry Luce's weekly presented intelligent, compelling photography that addressed social and political topics of the times.[26] The cover of the premiere issue displayed Margaret Bourke-White's monumental image, *Fort Peck Dam, Montana*, a celebration of one of Roosevelt's New Deal projects. Possibly inspired by the image as well as by Bourke-White's success in becoming one of *Life*'s first staff photographers,[27] Cunningham during the late 1930s traveled broadly in the West, photographing industrial and architectural subjects for her own enjoyment. She documented the Standard Oil refinery at Richmond Beach, a Weyerhaeuser lumber mill in Washington, the Pondosa Mill and logging operations around McCloud, California, and Boulder Dam, where she made a dramatic composition of the edifice and electrical towers diagonally juxtaposed against the mountainous gorge.

Since she did not drive, Cunningham usually made these trips with other photographers, sometimes her son Ron, other times with friends Alma Lavenson or Hansel Mieth Hagel.[28] The towns of Columbia and Rough and Ready in the Gold Country (pl. 95), architectural ruins in the Sierra foothills, landscapes around Echo Lake and the Napa Valley, the Victorian village of Ferndale, the coast at Point Reyes and the smoothed rocks at Drake's Bay (pl. 97), the rush-filled marshes of Bodega Bay, and the Monterey coast, including Weston haunts like Point Lobos, were favorite destinations.

"Sometimes I wonder," Imogen stated, "what my objectives are, or if I have any objectives." She speculated:

> If one wants to do honest or creative interpretation, one must educate one's audience and one's sitters to help. In a limited way any effort at education must have been going on for some time, but for how many people? . . . The one noticeable bit of progress in the acceptance of reality by the general public has been forced on it by the news reporting magazines, such as *Life*. This we all enjoy when we are not the subject. We love to look into other people's lives and interpret what we think the meaning of the expression on their faces.[29]

As the great flurry of projects and commissions that had occupied Cunningham dissipated with the depression, she actively

Fig. 49. Imogen Cunningham. *San Francisco Window*, 1938.

solicited work and exposure in such magazines as *U.S. Camera, Life, Sunset, House and Garden*, and *Fortune*. She began to photograph for *Sunset*, often in color. Her vivid, brilliantly colorful detail of fuschia flowers graced the cover of the magazine's June 1940 issue. Imogen managed to support herself, and to financially help her grown sons as she could, by taking commissioned portraits, publishing work in magazines as often as possible, and living frugally. She indicated her concern over securing work to Tom Maloney of *U.S. Camera* in a letter regarding her inclusion in the 1942 annual: "What shall I say about such a straight shot, literal Kodachrome, except that it was a JOB and that you might give me a little ad saying that I would like more of the same. . . . And for myself. I am not like a spring morning—fiftyish to be inexact. Still having a good time at it. I have been taken for Mrs. Roosevelt and Peggy Bacon. Perhaps I am a cross between the two, or maybe just a hideous mutation."[30]

As World War II progressed, Cunningham commercially photographed many a serviceman, even though photographic supplies were limited and at a premium. To help economize, she rented her house in Oakland to a Mills instructor in 1942 and moved into a small cottage, which her son Rondal had previously rented, on Colby Street at the edge of Berkeley. She wrote Portia Hume:

> As far as "getting out from under" my old job, as a housekeeper and mother, there is no reason in the world why I cannot leave that completely in my past. I thought that by separating myself physically from the scene of my past crimes, I might the more easily . . . begin an entirely new scheme of living. I am not even thinking what it is or could be. Just different. I am not overly ambitious but still I feel most competent in my own work and have had at least three rewards far

Fig. 50. Imogen Cunningham. *Washington Square*, 1945.

Fig. 51. Imogen Cunningham. *Sailor, Montgomery Street*, 1945.

afield in the last year which ought to encourage me to keep on, as long as I can focus.[31]

Imogen later described the pros and cons of the Colby Street location: "I thought all the time I was there I would do a great deal of listening to lectures at the University, and that I would get myself re-educated and have a very good intellectual time. Actually, I trotted back and forth to San Francisco practically every day, or out to my old lab [on Harbor View] which my tenants didn't use, where I had my darkroom still. That was a pain, just sheer painful. It's a time I just don't want to remember. After I got into Roger Sturtevant's place I commuted there from Colby Street, which was completely convenient."[32]

An old friend from the early 1920s, Sturtevant[33] was primarily an architectural photographer who, along with Imogen, was one of four California photographers included in the 1929 *Film und Foto* exhibition. He had worked with Dorothea Lange and maintained a live/work studio on Montgomery Street, a location convenient to downtown; Imogen would use his studio until 1946. Because of Sturtevant's frequent out-of-town assignments, Imogen occasionally took care of his son, a high-school student. She enjoyed this temporary commuter life: "That was the first and only time that I have ever lived away from my work. It's more convenient to live

where you work, but when you're separated from it, you can't do anything about it, so you have a little more free time. It's quite remarkable. Photographers never have free time."[34]

Working in the city occasioned Cunningham's fresh return to street photography—her "stolen pictures"—and frequent forays with her Rolleiflex into downtown San Francisco yielded admirable rewards: a large woman in clashing prints cleaning bird droppings from the benches in Washington Square (fig. 50), doorways in Chinatown with impish children and fussing mothers, a soldier befriending a group of young Chinese girls playing on the street, lunch-hour sunbathers in Jackson Square, and naval police standing guard outside the infamous Black Cat Cafe (fig. 51). For Cunningham, the aesthetic aspects of this work remained paramount: "If you have a long lens and look in on a group talking on a street, may not the result of such a shot be as graphic a portrait as anything one could get? There are countless illustrations possible, for almost everyone interested in photography today is on the alert for the 'decisive moment' as Cartier-Bresson has named it. . . . I do not pretend to myself that the social document is more important than any other. It is usually judged for what it says, not for the way in which it says it. Perhaps because of my early training, I am still interested in the 'way.'"[35]

Fig. 52. Imogen Cunningham. *1331 Green Street*, 1947.

On Green Street

After the war, Cunningham sold the Oakland house on Harbor View and, in 1946, bought a cottage at 1331 Green Street in San Francisco. She spent almost a year refurbishing it and building a darkroom in the basement; she finally occupied her Russian Hill home in 1947. From the street one could easily miss the house, which sat at the rear of a narrow lot caught between two large buildings; an abundant garden with a palm tree filled all the intervening space (fig. 52).

Located only several blocks from Imogen's new home was the California School of Fine Arts, where in 1946, Director Douglas MacAgy established a department of photography. He appointed Ansel Adams as head of the program for the first year, and in 1947, Minor White, a young photographer and devotee of the work of Edward Weston and Alfred Stieglitz, was invited by Adams to take over his teaching responsibilities at the school.[1] Cunningham, Dorothea Lange, Adams, and Weston all taught specialized subjects as visiting instructors. White noted that "Cunningham works with the portrait class, and many a student finds his way to her house for more of her sharp wit and practical understanding of the problems of a direct approach to portraiture."[2] She confided to White, however, a certain dissatisfaction with teaching: "Probably I am not a good teacher. I cannot put myself in the place of a person not knowing anything and not being of his own will interested in supplying that want. So you can see what I think of the pupils."[3]

Imogen taught at the California School of Fine Arts from 1947 to 1950,[4] and perhaps the most fortuitous occurrence during her tenure was the addition of Evsa Model to the list of visiting instructors. He came to San Francisco from New York with his wife, photographer Lisette Model, in the summer of 1946, when Douglas MacAgy had invited him to teach a summer course in textile design at the school.[5] MacAgy's wife, Jermayne, was a curator at the California Palace of the Legion of Honor, and that August she mounted an exhibition of Model's photographs. Model was a staff photographer for *Harper's Bazaar*, but she avoided glamorous illusions in her creative work. Austrian by birth, she learned photography in France, and her 1930s portraits of bored aristocrats on holiday and of bizarre characters along Nice's Promenade des Anglais became indictments of France's "history of waste and social decay."[6] When Model immigrated to America in 1938, her camera was attracted to derelicts, deformities, and human oddities whose powerful presences she further exaggerated by tightly cropping figures in her prints. Her portraits of the dispossessed and of blind street beggars on New York's Lower East Side, made during the early 1940s, recall Paul Strand's similar subjects published in *Camera Work* in 1917, but Model's studies of "running legs" shot from ground level and of window reflections that overlapped forms and figures are refreshingly unique impressions of her new country. John Gutmann, another European émigré who would become a friend of Cunningham's in San Francisco, came from Berlin in 1933 and viewed America with a fresh, sophisticated photojournalistic style that synthesized social and aesthetic concerns.[7] Model's and Gutmann's innovative work became counterpoints to the formalist traditions intoned by Ansel Adams and adapted by Minor White at the California School of Fine Arts.

Although Cunningham's street portraiture was by no means as sensational or confrontational, she recognized a kindred sensibility in Model's photography, a combination of humanness, environment, and composition. The women became friends and traveling companions, and together during the summer of 1946 they explored the city streets in quest of photo opportunities. On occasion they found mutually agreeable material, such as a sidewalk revival meeting in the Fillmore District where Cunningham photographed Model photographing. In several images of curious or devout onlookers, Cunningham again intuitively captured dualities—a pair of women framing an evangelist, a set of twins (pls. 93, 94). During that same summer, Model documented certain individuals identified as contributing to the "intellectual climate of San Francisco" in the February 1947 *Harper's Bazaar*. Portraits of J. Robert Oppenheimer,

Henry Miller, Robinson Jeffers, Darius Milhaud, Edward Weston, Dorothea Lange, Ansel Adams, Cunningham, and others were accompanied by brief biographies.[8]

Model later taught at the California School of Fine Arts, during the fall semester of 1949, and she frequently conducted her classes as field trips to sites throughout the city.[9] *Woman with Veil* (fig. 53), her satirical study of an elaborately outfitted matron on a park bench in Union Square, suggests an inherent hypocrisy in the sitter and an air of condescension in the photographer. The undercurrent of mean spiritedness in Model's approach is not found in Cunningham's work, although Imogen seems to have emulated Model's style for awhile. Cunningham chose to present her subjects in a lighter, more comic spirit, as in a series of curious and perplexed bargain hunters at a city-sponsored rummage sale (fig. 54), portraits of employees and clowns behind the scenes of the Barnes Circus (fig. 55), and a shot of two nuns attempting to interpret the modern abstractions of Alexander Calder in a Los Angeles gallery (fig. 56).[10] The work of this period by both Cunningham and Model candidly presents found subjects but without being decidedly exploitative, unlike the photographs of Model's future student, Diane Arbus, whom critics in the 1960s would accuse of transgressing the boundary between private and public domains.

Cunningham's urban explorations of the early 1950s reveal a picturesqueness in the decay of the inner city as well as a nobility in its neglected citizens. Susan Sontag's description of the photo-documentarian is apt: "Gazing on other people's reality with curiosity, with detachment, with professionalism, the ubiquitous photographer operates as if that activity transcends class interests, as if its perspective is universal. . . . The photographer is an armed version of the solitary walker reconnoitering, stalking, cruising the urban inferno, the voyeuristic stroller who discovers the city as a landscape of voluptuous extremes."[11] Like the anonymous person she caught along McAllister Street creating magical shadow puppets with the afternoon sun (fig. 57), Cunningham too was a medium of transformation. On walkabouts through the city ghettos she discovered, apart from the inherent social commentary of the scenes, wonderful textures, patinas, and curiosities in the rubble and decay that turned her pictures into part autobiography, part travelogue, and part revelation.[12] Cunningham's attraction to and appreciation of such imagery, her "disposition toward images of decay" may have depended upon aesthetic traditions particular to her education, social position, and cultural sphere.[13]

Fig. 53. Lisette Model. *Woman with Veil, San Francisco,* 1947. De Saisset Museum, Santa Clara University, bequest of Helen Head Johnston.

Fig. 54. Imogen Cunningham. *Discrimination at a Rummage Sale,* 1948.

Fig. 55. Imogen Cunningham. *Clown, Barnes Circus,* 1950s.

Fig. 56. Imogen Cunningham. *Nuns at a Calder Show,* 1953.

Fig. 57. Imogen Cunningham. *On McAllister Street,* ca. 1950.

Exposure to Minor White at the California School of Fine Arts and his philosophy of "equivalents," photographs that transcend their original informational or pictorial purpose by evoking emotion, may have attuned her to the occasional choice of evocative, unpopulated locales. One notes, in fact, a similarity to a Minor White sequence when viewing a contact sheet from an afternoon stroll through the Western Addition, a dilapidated San Francisco neighborhood of abandoned storefronts, during which Cunningham arrived at *Self-portrait on Geary Street* (fig. 58). Like a White series, the photographs function together metaphorically, but Cunningham's sequence is grounded and pragmatic, never suggesting the "life-enhancing," Zen-like mysticism that White sought in his imagery.[14]

Imogen's friendship with Lisette Model reopened some New York channels. The Museum of Modern Art, at Model's suggestion, requested new prints from Cunningham,[15] and Helen Gee, who was opening the Limelight Gallery, a combination coffee house/ art gallery, asked her to exhibit work in the 1954 inaugural group show of contemporary American and European photography. Limelight became the first gallery in the United States devoted exclusively to the exhibition and sale of photography.[16] Gee gave Cunningham a solo exhibition from May 8 to June 16, 1956, and from that time on, Imogen, at the age of seventy-three, experienced an era of new recognition and reevaluation. A review of her show noted: "Miss Cunningham's concern with people, reflected in

Fig. 58. Imogen Cunningham. *Self-portrait on Geary Street* (top center), 1956. Vintage contact sheet.

photographs of Negro children on the streets of San Francisco, is at an opposite pole from Lisette Model's intensity of indignation. Miss Cunningham's orientation toward the alienated person is one of quiet sympathy."[17] The critic for the *New York Times* expressed pleasant surprise at the exhibition's wealth of portraiture, a departure from what he considered the "impersonal" landscapes and clichés of "West Coast photography."[18]

Imogen traveled to New York for the Limelight exhibition and turned her camera to the inhabitants of the city's streets, candidly studying tradespeople, subway travelers, young couples, and mothers and children. The scope and diversity of the hundreds of photographs Cunningham made in New York are remarkable considering her age and probable innocence as a lone traveler in the

tougher parts of the city. An expansive range of emotions covers the faces of her subjects, stolen at a moment's notice: gleeful enjoyment and a sense of participation, especially in children caught fresh on the street (pl. 102); mild amusement or passive permission, as in the portrait of a Wall Street businessman resting during his lunch hour, his hat comically tipped in his lap as if he were a street beggar (fig. 59); surprised disapproval at having one's privacy breached while passing through the public domain, as expressed by the unwary traveler emerging from the subway (fig. 60); and defiant indignation, conveyed by a group of women conferring on a Harlem bench, who might agree with Susan Sontag's opinion that "there is an aggression implicit in every use of the camera."[19]

The 1950s were particularly good years for some of Cunningham's finest portraiture, from the "street stuff" to premeditated and revealing images of artists, poets, and writers. In the most penetrating of these portraits, disclosure of the subject is both physical and emotional, as in Cunningham's haunting, introspective study of Morris Graves (pl. 98), an acclaimed masterpiece of twentieth-century portraiture. Graves, a transcendental Northwest painter, had been denied conscientious-objector status during World War II and was imprisoned for refusing induction into military service. His identification with wounded and reclusive birds became the signature metaphor in his art, and Cunningham's full-day session with him on the grounds of his private retreat outside Seattle left him feeling exhausted and captured, if not tormented.[20]

Imogen's abiding interest in poetry led to a friendship with Ruth Witt-Diamant, the founder in 1956 of the Poetry Center at San Francisco State University. With poet Robert Duncan, Witt-Diamant arranged programs with visiting artists such as Marianne Moore, Stephen Spender (fig. 61), Theodore Roethke, and Muriel Rukeyser (fig. 62), and she invited Cunningham to photograph them. Moore became a case history for Imogen of the difficulties inherent in photographing people who dislike their appearance. The perfectly fine likenesses of the poet elicited Moore's critical comments: "Isn't it a pity that when I have things on my mind and have been up late, I can defeat any camera? . . . I am afraid I can't say use them."[21] Imogen mused to Stephen Spender: "All she wants is to be twenty-five years younger than she is. That's really all she wants. She cannot take time. She can't reconcile herself to her age. Now, you see with me, I don't give a damn."[22] Imogen had always detested vanity and forfeited it herself because of her belief that she lacked physical beauty.

Fig. 59. Imogen Cunningham. *Wall Street, New York City*, 1956.

Fig. 60. Imogen Cunningham. *Transport, New York City*, 1956.

Fig. 61. Imogen Cunningham. *Stephen Spender*, 1957.

Fig. 62. Imogen Cunningham. *Muriel Rukeyser*, 1957.

A resolute sense of feminism surfaced in Cunningham's choice of imagery during the 1950s. Not overtly political, the photographs mirror the concerns and decisions that steered Imogen's life as an artist, a wife, a mother, and later, a single working woman. Her depictions of working mothers and homemakers are celebratory, such as her image of artist Ruth Asawa working on her sculptures surrounded by her active children, or a portrait of an impoverished mother in a Taber Alley tenement proudly displaying her brood. Cunningham's participation throughout the decade in the San Francisco Society of Women Artists, a staunch support group, may have solidified a desire to address women's issues.[23] Cunningham demurred at being labeled a "feminist," but her natural independence and sense of equalness define her as one by default. In a later interview she admitted to being a liberal who fought for women's suffrage and civil rights but stated that she "never set out to make a political statement. It's pretty tough to make anybody change and I'm not one of the persons who's going to do it."[24]

Cunningham's choice of the pregnant nude as a subject—during a decade when the word was not even allowed to be spoken on television—was a refreshingly candid challenge to the societal taboos of the Eisenhower years. Rather than succumb to easy romanticization, when Cunningham photographed her pregnant artist friend Merrie Renk (pl. 105), she made a sunlit image startling in its objectivity. The veracity of this fully descriptive portrait is unduplicated by any other photographer of the period.

Imogen's portrait session with Muriel Rukeyser in 1957 was most likely an agreeable opportunity to bond with a kindred spirit. Rukeyser had become notable for breaking through the self-effacement of women's poetry; she had written, while pregnant with her first child, "Nine Poems for the Unborn Child" (1947), one of the first American poems to speak unsentimentally of pregnancy and birth and to give "form to so crucial a group of meanings and experiences."[25] She wrote to her child, in its "dark lake moving darkly," about to "enter the world where death by fear and explosion" awaits it:

My blood at night full of your dreams,
Sleep coming by day as strong as sun on me,
Coming with sun-dreams where leaves and rivers meet,
And I at last alive sunlight and wave.[26]

Cunningham's East Coast sojourn in 1956 and her success in producing what she called "documents of the street" in new and visually stimulating surroundings whetted her desire to travel abroad. Possibly inspired by Bill Brandt's *Literary Britain* (1951), a book of evocative photographs of landscapes, historic sites, and interiors associated with selected authors and poets, Imogen developed a similar idea for photographing "indications of place"[27]—those locales, unpopulated or abandoned, that suggested human presence without the inclusion of a person (fig. 63), much like the images of the French photographer Eugène Atget, whose work she frequently cited in class lectures.[28] In November 1959 she applied for a Guggenheim Foundation fellowship with the following project statement: "To try, by photographing certain writers, their environments and haunts, to create a mood that will supplement their own verbal expression and be a valuable aesthetic contribution. As a matter of fact, this has been a dream of mine for a very long time, and as a dream it ranges over Ireland, England, Scotland and into present-day Germany. But I propose to confine it to England, where I might have a beginning with the poet Masefield, whom I photographed in San Francisco in the '30s, or with Stephen Spender, whom I photographed this year in Berkeley."[29] Although she was not awarded a fellowship that year, Imogen sailed for Europe with her photographer friend Edgar Bissantz on March 29, 1960. The trip may have been somewhat celebratory, because she had just sold a major retrospective collection of her work to the George Eastman House, a sale arranged by Minor White.[30]

Cunningham's itinerary, after arrival at Bremerhaven, included Berlin, Munich, Paris, and London. Along her journey Imogen frequently made street portraits and focused on referential environments. She sought out respected colleague August Sander[31] in Leuscheid, Germany: "After a very troublesome telephone message to Herrn Sander for directions . . . Ed and I started out on something that should have taken 1 hr. according to the authority but took us over two. . . . We found the place, which had an entrance like a pig stye with stinking water running down a ditch—and plenty of pitfalls for an old man. The old gal who opened the door said he was coming up the road and we went out to meet him. I photographed him approaching [pl. 106]." Imogen seemed disappointed with Sander's disinterest in contemporary techniques and materials, with his old-fashioned chemical stockpiles "that hang over from the past." She concluded: "The greatest value in his stuff it seems to me after some few hours deliberation is the honesty with which he showed these various characters, and the more peculiar they were the more interesting. This does not have too much to do with the

Fig. 63. Imogen Cunningham. *Arata Ranch, Moss Beach*, 1958.

way they were done, but the straight forward honesty of the effort with no fancy lighting is refreshing for our day."[32] While in Germany, Cunningham created a fitting homage to Sander in her portrait of two countryfolk walking along a road, the man's top hat and cigar providing the requisite "peculiar" touch (pl. 108).

Upon arriving in Paris, Cunningham eagerly dashed off to American Express where she was expecting several copies of the magazine *Photography*, which had just published an article on her by Norman Hall.[33] She observed: "I have no real complaint about the selection of things shown but one is so small that it does not count [*Agave Pattern*]. The article is surprisingly good when you consider that the man who wrote it doesn't really know me."[34] Paul and Hazel Strand invited Imogen to tea at their country place at Orgeval, outside Paris, during which Imogen viewed many of Strand's prints from Egypt: "No monuments, just people and scenery. Although it would appear that he does arrange his people, they are the most beautiful even though they sometimes seem studied. He also showed the prints in the book on Italy, where he worked most of the time in one village. His wife helps him in many ways with people, if they are unwilling she gets them to fall in with the idea. I can see how she can do that for she is a very charming and natural person."[35] Imogen sailed home from Southampton on July 13, after photographing Stonehenge and other historic English sites.

The following October Cunningham sailed for Europe again, this time with her friend Florence Alston Swift, an artist and the widow of Henry Swift, and visited Norway, Finland, Sweden, Denmark, Poland, and France. The photographs she made on this trip are an eclectic group, all taken as documents of the street. There are many portraits of idiosyncratic characters at open-air markets, children at play in urban spaces, sad old women stooped over their soup bowls in restaurants, and a set of twins (pl. 110) whose individual nuances are as open to interpretation as those of the pair in Diane Arbus's famous image (shot six years later). In many studies of a more formal purity, Imogen expanded her vision beyond portraiture to the referential sites she called "indications of place," such as picturesque doorways and portals with a bicycle, pram, or motorcycle off to the side; reflections in a rain puddle (pl. 111) and raindrops on a car roof (pl. 112); a vortex of telephone wires; and graffiti and textural deterioration on the walls around Paris's Place des Vosges. Her shot of a dress stall (fig. 64) hung with simple, homespun styles is remarkably reminiscent of an Atget study of a similar display along Rue Mouffetard several decades before (fig. 65). Cunningham often included her mirror image in storefront photographs, and *Self-portrait, Denmark* (pl. 109) is representative of a frequent theme: Cunningham juxtaposing her aged self with the visions of glamour and youth encased in department-store window displays. The contrast extends to imagery of girdling, binding, and controlling the female body and spirit, an imposition that she ostensibly deprecates, her reflected spirit rebelling against the implied restraints.

In Paris for her last time, Cunningham visited Man Ray with her friend Leni Iselin, a French photographer, and made several portraits of him in his studio. This 1961 visit with the twentieth century's supreme experimental photographer seems to have resurrected an attraction for darkroom play and manipulation. Shortly upon her return from the continent, Imogen fabricated a multiple-exposure portrait, *A Man Ray Version of Man Ray* (fig. 66), made from a single straight image of the photographer. Her interest in double exposure also was rekindled in the early 1960s, as in her captivating portrait of James Broughton (pl. 114). She produced results similar to double exposure by printing with sandwiched negatives, as an image of a nude model recontextualized in a forest landscape illustrates (pl. 115). To create these one-of-a-kind fusions, she kept numerous files of generic negatives such as rock walls, abandoned architectural sites, and studies of bomb casings to overlay with a portrait, hand, or mannequin. Imogen, ever experimental, in the 1960s also spontaneously utilized solarization during chemical

Fig. 64. Imogen Cunningham. *Paris*, 1961.

Fig. 66. Imogen Cunningham. *A Man Ray Version of Man Ray*, 1961.

Fig. 65. Eugène Atget. *Rue Mouffetard*, 1926. Museum of Modern Art, New York.

development—perhaps as attributable to Man Ray as to a then-fashionable resurgence of the technique—producing flashes of positive/negative reversal and variable sepia toning in her black and white prints. She interpreted her experiments in relation to the history of the medium in a class lecture:

> Photography has gone back and forth so much that it seems unwise to predict just what it will do next or to say what is better or more lasting. Almost every phase from literal to the photogram has its uses, even distortion by a lens, which was first done by Louis Ducos du Hauron in 1888, and in recent years by Weegee. I must confess that I consider the distortion of the human body by Weegee more a vulgarity than a valuable contribution. When one goes back to early realism, the prints from the huge wet plate negatives of Tim O'Sullivan have not been surpassed. Think what you want of the soft focus lens; it too will be in again, and has been used recently by Avedon. From Rejlander in 1857 to Uelsmann now, someone has always been putting negatives together to form a print. Using a negative as a print is not new but cutting up the image and folding it around a box, might be considered an innovation. . . . Solarization is not new but we have not many people using it effectively today. . . . At the present time, at least among many students I have met, symbols are the thing.[36]

Aperture devoted its entire winter 1964 issue to Cunningham, and she spent more than a year planning the contents of what

would become her first monograph. "Miss Cunningham shows the desirable characteristics of the hardy perennial," remarked Minor White affectionately in his preface to the publication.[37] White's apt analogy of the aged but spirited photographer to her beloved flora connoted the endurance this remarkable woman exhibited during decades of personal and professional endeavor. She experimented endlessly with several new types of Polaroid film to produce the illustration for the publication's back cover, which traditionally displayed a Polaroid print in acknowledgment of the corporation's financial support. As she was previously unfamiliar with the material, her testing was wearisome; she wrote Ansel Adams: "Herewith I am giving you notice that I am practically dropping dead from over exposure to POLAROID. Quite a number of people have seen my tries [fig. 67] and quite a few people like them, so I have decided that I will make you a visit with a pocket full of them. . . . Anyway it is a challenge and I would like to work more on this. I find it so fascinating with people that I run myself ragged and make a shot or two of everyone who comes within my gate."[38] She photographed a young black man, shirtless, lying lasciviously on her deck, and considered it fine enough to become the token Polaroid image, but White, concerned by the subject's "power and arrogance," placed it inside instead, substituting a "safer" portrait of her neighbor José languidly posing from his window.[39] For the front cover, White reproduced Imogen's study of a shrub-like, tied wire sculpture, by Ruth Asawa (fig. 68), a tour de force of line translated into three-dimensional form.[40] White's cover choice undoubtedly reflected his own interest in the inherent mysticism of Asawa's work as well as his appreciation for Cunningham's presentation of an intriguing positive/negative study.

Imogen received great accolades for the *Aperture* issue. Alvin Langdon Coburn offered his congratulations: "I did so enjoy the pictures, especially *Leaf Pattern before 1929* (the one with Gertrude Stein overleaf), *Shen You* [sic] *1938*, and *Snake 1929*, but they are all full of thrills! . . . I read all the letterpress non-stop, and it breathes of your vigorous young self at every age."[41] George Craven, a photography instructor in the Bay Area, had written the biographical essay for the volume, and he praised Cunningham for continuing "to grow in vision, wisdom and love. If one recognizes this love is the matrix from which all her art has developed, the past is clearly revealed and the future can be forecast with lively anticipation. For art, Stieglitz reminded us, is the affirmation of life, and the evidence of life is everywhere, including Imogen."[42]

Fig. 67. Imogen Cunningham. *Still Life*, 1963. Polaroid print.

Fig. 68. Imogen Cunningham. *Ruth Asawa's New Expression with Metal*, 1963. Reproduced on the cover of *Aperture* 11, no. 4 (1964).

Fig. 69. Imogen Cunningham. *Civil Rights March, San Francisco*, 1963.

Fig. 70. Imogen Cunningham. *Hashbury*, 1967.

A principal aspect of Cunningham's work during the turbulent 1960s was a dedication to documentary street photography interwoven with social and political themes. She photographed civil rights marches along Market Street (fig. 69), the hippie counterculture developing in the Haight-Ashbury section of San Francisco (fig. 70), a nude love-in staged by a group of her students at Humboldt State, where she occasionally taught summer sessions (fig. 71), and the ubiquitous peace marches protesting the Vietnam war. Outfitted in her well-known black cape, mirrored Indian hat, Rolleiflex with its neckstrap festooned with peace symbols, and a large silver peace symbol hanging from her neck, Cunningham became an outspoken critic of the war. In a 1968 lecture, she summarized her philosophy:

> Perhaps at this moment many of us are feeling that just being an artist is a selfish thing to do in a world that is destroying itself. Here we are, particularly in the United States standing knee deep in litter and reaching at the same time for the moon. Everything is crazy, disjointed and hectic. No matter what our personal ambitions are, I feel sure that each and every one of us would like to know what can be done to alleviate the sickness, and to create a climate of change. . . . As a people it seems we have made war our way of life. Nationalism and its partner racial prejudice are accepted by the great majority of people, or so it seems to me. Perhaps this is not really admitted but look at us, wallowing in feelings of hate and superiority. It is difficult in the idealistic situation of an art school to talk about racism and prejudice, but if we reach down in ourselves individually, we will probably discover some or even many kinds of prejudice. We seem to be a long way from realizing that people are people regardless of their beliefs or the color of their skin. Our great American nation is destroying itself and is not being improved by the strange efforts of the establishment toward the abolition of poverty. The most affluent country in the world can excuse itself only by employing a quote from the Bible, that the poor are always with us. Is it too bad if I confess that to me the action of our government in Vietnam reminds me of a speech of Edmund Burke, in which he said, "Necessity is the plea of tyrants." So far hope and faith have done little for the world. It is going to take some other kind of effort. . . . Perhaps it is terrible to be a pessimist unless one is also a poet, so I will let Muriel Rukeyser say it for us,

> > Darkness, giving us dream's black unity.
> > Images in procession start to flow
> > among the river-currents down the years of judgment
> > and past the cities to another world.[43]

She provocatively expressed her sentiments in a group of still lifes created with dismembered doll parts, the mutilated heads and limbs connoting the horrors of warfare (pl. 116). A more pointed protest is apparent in a portrait of Louis Roedel, his raised hand signalling "stop," superimposed on the gun emplacements at Point Reyes, and simply titled *Warning* (fig. 72).

Fig. 73. Imogen Cunningham. *My Label*, 1973.

Ideas without End

By 1970 Cunningham became concerned with the distribution and placement of her accumulated life's work: thousands of vintage platinum and silver prints as well as a collection of rare photographs by colleagues such as Weston, Mather, and Weston's mistress of the early 1920s, Tina Modotti. While cataloging it all, she rediscovered a cache of about a hundred early glass-plate negatives, including the early nudes of Roi on Mount Rainier, the symbolist photographs of John Butler and Clare Shepard, and assorted pictorialist images. Her find sparked an idea for a new proposal to the Guggenheim Foundation, to whom she applied for support to reprint all her early negatives: "Since I have worked almost constantly at professional photography since 1910, I would like to have the opportunity to give up the professional side of my work for a year and devote my time to printing my creative work."[1]

To no one's surprise except possibly Imogen's, she was granted $5000 for the period from May 1, 1970, to April 30, 1971. The work soon became overwhelming for a woman of eighty-seven who suffered from severe bouts of vertigo. She wrote to a friend: "I am frightfully frustrated by the whole thing as it is more than I thought it would be. Printing is the hardest and most boring part of photography and I am really in for it."[2] She also conceded the frustration to her son Pad: "My time has been absolutely taken from me. I have not begun in any real way to get on with my job. Sometimes invitations which I cannot refuse, terrible numbers of telephone calls, and even visits and people wanting to study with me or help me do my Guggenheim. Also on my own I am trying to clean up the accumulation of 23 years in this small house. . . . The TV men have been my greatest upheaval as they come here, turn the place inside out, photograph everything including stuff in my files (which I have to put back), and all this means is about 3 min on TV."[3]

The Guggenheim award, the public showing of John Korty's documentary film, *Imogen Cunningham: Photographer*, and the publication of a monograph, *Imogen Cunningham: Photographs* (1970), certified Imogen as a town celebrity. Mayor Joseph Alioto proclaimed November 12, 1970, as "Imogen Cunningham Day" in San Francisco. Cunningham loved the attention, but her elevation to grande-dame status eventually became a great strain. "People are consuming me," she said, "especially the young students and all I can think of answering their wanting to do something for me is 'Please neglect me,' but of course I do not say that and I look over hundreds of photographs that are very uninteresting to me. This has always happened to some extent but now it is almost beyond endurance."[4] She commented to a columnist from the local newspaper when asked about the price of fame: "Fame is what comes after you're dead. When you're alive it's notoriety—and an annoyance. I don't consider myself as having it. I'm just a working woman."[5] Deriding celebrity and its concomitant commercialism, she teased Ansel Adams for having recently allowed Hills Brothers to reproduce one of his Yosemite Valley photographs on its collectible coffee cans. She had a young friend forward one of the cans to Adams, filled with dirt and a marijuana plant, with the following note: "Dear Ansel: With the idea that you might now begin to collect these pots, I am sending you one with a plant often mountain grown. As you must know, pots and potties have always been my specialty. Love, Imogen."[6]

The photographs Cunningham printed during her Guggenheim year were exhibited at the San Francisco Art Institute in August 1971. She introduced the show with a 1923 photograph of her parents (fig. 74), Isaac holding the family cow, Bossy, on a rope and Susan carrying a milking pail. Underneath she installed a panel with a Walt Whitman quotation: "Still there will come a time here in Brooklyn, and all over America, when nothing will be of more interest than authentic reminiscences of the past."

Imogen celebrated her ninetieth birthday in 1973, and hundreds of friends gathered for cake and champagne at an open-air party held on April 14 in the meadow near Stow Lake in Golden

Fig. 74. Imogen Cunningham. *My Father, Mother, and Bossy*, 1923.

Gate Park. Imogen was adorned in a birthday gift, a new Nepalese hat. The event was heralded in New York by major exhibitions at the Metropolitan Museum of Art and the Witkin Gallery. Telegrams and congratulatory messages flooded 1331 Green Street. Rarely had a photographer survived long enough to reap the glory of such a celebration and to become a living legend in her craft. Hilton Kramer reviewed both New York shows:

> She seems always to have been at her best when the subject was given an unquestioned priority over the "idea." Empathy rather than esthetic invention has been her forte, guiding her eye and her lens to her most powerful images. However formal or relaxed or intense her subjects may have been in facing the camera, Miss Cunningham is remarkably generous and searching. She really gives herself to the subject—there is no question of turning the subject into "A Cunningham." . . . Others may have brought a deeper and a more concentrated vision to photography or a more flamboyant sense of drama, but Miss Cunningham brought a love and an appetite for life that are no less rare. Picture by picture, we respond to particular triumphs of the eye and the medium, but we come away from her work as a whole with a sense of her own generous response to life.[7]

Cunningham's effort to organize her life took a new shape on February 14, 1975, when she created the Imogen Cunningham Trust to manage, promote, and market her photographic work, both during her lifetime and after. She described her plans:

> My prints will be numbered with a crossfile, no more just my head for reference and a title. That and a date will be there to be sure but the

file is the thing. The trained archivist comes the day after New Year's and I give up all other activities until all is done and shipped to my partner which is General Graphics Services. My dealer requires that I have an indication on all the prints that I do not personally make and I have ordered and got a Chinese chop, which is a seal. Shen Yao wrote it for me and Benny Chi took it to Hong Kong and had it made. I wanted to have it say: "To Hell with you, this print is as good as if Imogen had made it," but it turns out that that is too long. I will stamp it on your next letter and you can have it translated.[8]

Imogen had originally written to Shen Yao: "I have been reading a kind of naive diary by a Chinese painter Ch'i Pai Shih who died in our lifetime, born in the year of the 'pig' 1864, and some things he said might influence your way of seeing the likenesses of your friends, for instance, 'Too much likeness flatters the vulgar taste; too much unlikeness deceives the world.' He made paintings and seals and I am going to copy his idea of seals and have one made for my work, which will be printed for me after my death. I am now looking for a Chinese who can do this kind of work, so my work will go on being printed for as long as anyone is willing to print it, so like a Chinese philosopher, I will live forever."[9] The chop devised by Shen Yao is composed of four Chinese characters that phonetically spell out "Im-o-gen seal" and translate literally into "ideas without end," a succinct and meaningful signature for a woman of her boundless energy and creativity. This chop mark aside Cunningham's stylized signature would now be embossed into the mount below all her prints.

The affirmation of the past, the condensation of a life as seen in the character of an age-worn face, became Imogen's quest in her self-referential last photographic series, After Ninety. She pursued old friends and acquaintances, trying to find those who would share with her camera either a spirit of contentment, despite the infirmities of old age, or defiance at life's inevitable conclusion.[10] Her photographs recall sculptor Horatio Greenough's idea: "Beauty is the promise of function; character is the record of function."[11] The concept also reflected a favorite truth of the Japanese artist Hokusai, whom she often quoted:

> I have been mad about drawing since I was six years old. By the time I was fifty, I had given the public a vast number of drawings, but nothing of what I did before my seventy-third year is worth mentioning. At about the age of seventy-three I had come to understand something of the true nature of animals, plants, fishes, and insects. It follows that

by the age of eighty I shall have made further progress, by the age of ninety I should see into the mystery of things, and if I live to be one hundred and ten everything I do, even if it is no more than a stroke or a dot, will be alive.[12]

She wrote her friend, the photographer Wynn Bullock: "I am doing a new job now photographing people who are old and calling it 'After Ninety.' I have been given an unfair dosage of years, I say unfair as it is almost more than I can cheerfully endure. I am not cheerfully philosophical but rather overly critical of the things that seem to be happening, not in our work but in the social system. . . . Ever the same old complainer."[13] Cunningham photographed an elderly woman, kerchief covering her well-wrinkled countenance, on the sidewalk along Fillmore Street, subtly catching a mother and child peripherally in the picture. She titled the image *The Three Ages of Woman* (pl. 118), recalling a layered process of aging that Stephen Spender so aptly described:

> Faces we've once loved
> Fit into their seven ages as Russian dolls
> Into one another.[14]

A young nun eagerly soliciting a critique of her work from Imogen was answered with a qualification: "I will make a trade with you, if you find a nun over ninety who is willing to be photographed and take me to her, we might get along very well together. I am very pessimistic, intolerant and full of prejudices. I am ready to leave this world."[15] The trade did happen, and Cunningham spent a day photographing at the Sacred Heart Convent, Oakwood, where she captured one of the nuns, sight-impaired but cooperative (fig. 75).

Cunningham once more sought out the reclusive Morris Graves to include him in the project. He had refused a session just a few years before, claiming, "My ego is of the order of ego which also includes an unalterable feeling that the best part of my life is the intensely personal & private area which for me, is violated (& becomes colored with the phony—the pseudo) if someone is there watching with a camera."[16] He eventually complied, however, and in 1973 Imogen spent a day at his retreat in Loleta, California, photographing his vulnerable, mystic qualities (pl. 117). Influenced by Lillian Hellman's poetic introduction to her just-published book of literary portraits, *Pentimento* (1973), Imogen separately photographed the artist and his landscape, then fused the two in an evocative composition (fig. 76). Like a conjurer of natural forces,

Fig. 75. Imogen Cunningham. *Nun at Sacred Heart, Oakwood*, 1976.

Fig. 76. Imogen Cunningham. *Pentimento*, 1973.

Graves works magic over the lake, and Hellman's description of pentimento as "a way of seeing and then seeing again"[17] beautifully applies not only to Cunningham's personal experience with Graves over three decades but also to her general theme for After Ninety.

At about this time Cunningham appeared in a television commercial for a local cooperative funeral society to which she belonged. Standing in a cemetery, clad in one of her favorite black cape and hat ensembles, she offered, ever the pragmatist: "You do not have to have a tombstone. You can be scattered on the grass. That helps ecology. Or, you can be scattered to the winds. I have a friend who . . . rented a boat and took her husband's ashes. . . . From the prow she threw them to the winds. And they came back in her face. . . . But that's only a representation of the old adage, 'Never give up!'"[18] Her pessimism flaring, however, she photographed the shadows of her caped figure and a street sign, cast against a temporary construction wall, and titled the image My Label (fig. 73), with the annotation, "I could call it 'A Sign of the Future.' Blank."[19] Yet unlike so many other photographers who stop working at some point only to assess, reevaluate, and reprint their work, Cunningham was in control of her creative forces until just a few weeks before her death. Her haunting and brilliantly observant images of invalid "Bobbie" Libarry (pls. 119, 120), a former carnival tattooed lady, were as keenly seen in May 1976 as her portrait studies taken a half century earlier.

Imogen Cunningham died on June 23, 1976. She had been admitted to Saint Francis Hospital almost a week before. Her son Gryff told reporters: "She just died of old age. Her equipment ran down."[20] A public celebration of her life was held in Golden Gate Park's Speedway Meadows, and the San Francisco Chronicle invited everyone to bring picnic lunches, musical instruments, cameras, and Frisbees to the full-day event. Ann Hershey, who had made a film on Imogen, Never Give Up, just two years before, offered a compelling impression of the event:

> As we walked across the grass toward the celebration for Imogen Cunningham held in Speedway Meadows a few weeks ago, I was again impressed with the assortment of friends Imogen had collected through the years: straight, hip, gay—all types, sizes and colors from babies to "senior citizens," a term Imogen loathed ("It offends my soul!" she used to say). We were there to greet each other and try to accept the fact that the ninety-three year old sorceress had dismissed us all and moved on ahead. As usual.

The belly dancers were having at it to the soft ripple of an accordion. Ruth Asawa was busily sketching the folks and urging us to sign her book. Imogen's ex-husband, Roi Partridge, looking Quakerish and dapper in his straw hat and chin-beard, stood straight, posing for photographs alongside their three sons—the twins, Ron and Pad, still lookalikes in blue shirts and brown pants, and the taller, more gentle Gryff in his wide-brimmed hat.

The rest of us meandered around, eating, drinking, taking pictures, all honorary members of the huge Cunningham-Partridge clan. Sitting off to one side was a yellow director's chair with IMOGEN in large letters across the back. . . . It was easy to visualize the tiny figure sitting there, draped in the familiar black cloak, watching us carry on, listening to conversations, keeping us in line.

One woman described Imogen beautifully. "It didn't matter whether you had known her for years or you just met her—Imogen was the same with everyone—right there in the moment."

And that's where she kept us—in the moment. "I don't hang on to the past. I have too much to do today to think about that."[21]

The moving portraits in the book of Cunningham's After Ninety project, published posthumously by the University of Washington Press in 1977, are each accompanied by her chatty commentary transcribed from interviews. She described a handsome woman directly facing her camera: "She was a famous pianist, and she's ninety-some. She had just undergone an operation for cancer, and she refused further treatment. She said, 'I might as well die when I'm supposed to,' and I said, 'You're right.'"[22] About her portrait of Roi Partridge, Imogen, contrary in spirit, said: "Of the group of prints of my ex-husband from this session, the one he liked the least was with the cow's skull, so I decided to include it."[23] The editors, unfortunately, failed to include one of Cunningham's self-portraits. The caption might have read: "She's made her living all her life by photography. She liked to quote Confucius. She told me, 'Photography is as wonderful to me today as it would be if I had never before seen a photograph. Let's keep it so.'"[24]

The following short forms are used throughout the notes:

Cunningham/Daniel = Imogen Cunningham, interview by Edna Tartaul Daniel, June 1959, transcript, Regional Oral History Project, University of California, Berkeley

ICA = Imogen Cunningham Archives, The Imogen Cunningham Trust, Berkeley, California

ICP = Imogen Cunningham Papers, Archives of American Art, Smithsonian Institution. All references are to roll 1633 unless otherwise indicated.

Preface

1. Hilton Kramer, "Imogen Cunningham at Ninety: A Remarkable Empathy," *New York Times*, May 6, 1973, p. 23.

2. "Remarkable American Women, 1776–1976," *Life*, special report, 1976, p. 43. Judy Dater's photograph of *Imogen and Twinka* (1974) is reproduced.

3. "Imogen Cunningham: The Queen," *Newsweek*, Oct. 21, 1974, p. 67.

4. Gene Thornton, "Cunningham: Doing Anything That Pleases Her," *New York Times*, Nov. 15, 1970, sec. 2, p. 20.

5. Shen Yao to Cunningham, Nov. 20, 1974, ICA.

Learning to See

1. Isaac Burns Cunningham (b. Jan. 13, 1846; d. Sept. 7, 1943) was the son of John Hopkins Cunningham and Martha House Johnson who married in Virginia and settled in Missouri. They had five other sons and a daughter. During the Civil War, Isaac ran away to join the Union forces as a flag boy; his brothers all joined the Confederacy.

2. Isaac and Mary's children were named Lilly Lee, Minnie May, and Ernest Dale.

3. Susan Elizabeth Johnson (b. June 15, 1847; d. Feb. 14, 1935), born in Gallatin, Missouri, was the daughter of James Johnson and Mary Ann Fisher.

4. Margery Mann, *Imogen Cunningham: Photographs* (Seattle: University of Washington Press, 1970), n.p. (introduction, p. 4).

5. Isaac and Susan's children were Imogen, Paula, George Burns, Edna, Homer, and Thomas Kenneth.

6. "Imogen Cunningham in Utopia," *Pacific Northwest Quarterly*, April 1983, pp. 88–89.

7. Cunningham/Daniel, pp. 4–10.

8. Jane Margold, "Imogen Cunningham at 91: Still Developing," *Ms.* 3, no. 8 (Feb. 1975), pp. 25–26.

9. Ibid.

10. Rondal Partridge, interview with author, Nov. 10, 1992.

11. Ibid.

12. Cunningham/Daniel, p. 11.

13. Ibid.

14. E. Isabelle Halderman, "Successful Seattle Business Women: Miss Imogene [*sic*] Cunningham," *Seattle Post Intelligencer* (1913), clipping, ICA.

15. Helen Ross, "Coming to the Front, No. 10—Imogen Cunningham," *The Town Crier* (Seattle) 8, no. 15 (April 12, 1913), p. 5. Cunningham's first photograph has traditionally been dated about 1901, but this and many other published dates (now known to be inaccurate) were obtained from interviews conducted with Cunningham when she was already in her seventies. Ross's column is the earliest published reference to Cunningham's ownership of a camera, stating that Imogen "did not care to own a camera and never owned one until she took up the work in earnest in her junior year in college."

Christina Berding, in "Imogen Cunningham and the Straight Approach," *Modern Photography* 15 (May 1951), pp. 36–41, 96–98, seems to be the first person to relate that Cunningham took her first photographs in 1901. Cunningham, a few years later, took exception to Berding's chronology in a letter to Helen Gee: "There are of course some slight discrepancies such as 'began my career in 1901 when I got my first camera from International Correspondence School, at Scranton, PA.' That is a good many years from the truth" (Cunningham to Helen Gee, March 25, 1956, ICA).

16. Cunningham in later years dated this photograph as 1901, but she actually corroborated the later date of 1905–1906 in a note to Minor White: "One thing that I did with the first camera from International Correspondence School, I know is somewhere around but I have not yet found it. I have no [4-by-5 glass] negatives of that time but after I came back from Germany in 1910, I made an enlarged negative from a sharp photograph 4 x 5 and made it soft (damn it) and made a platinum print. Do not think that I like it now—I do not but it is still not as bad as the first Weston or the early Steichen (or so I think)" (Cunningham to Minor White, March 28, 1957, ICP).

17. Walli Zimmerman Curtis, "Women's News: Camera 'Dean' Back in Seattle," *Seattle Times*, May 20, 1965, p. 40.

18. Ross, "Coming to the Front," p. 5.

19. Giles Edgerton (pseud. Mary Fanton Roberts), "Photography as an Emotional Art: A Study of the Work of Gertrude Käsebier," *The Craftsman* 7, no. 1 (April 1907), p. 83. *Blessed Art Thou Among Women* (1899) was published in the 1903 inaugural issue of *Camera Work*. Cunningham always claimed that she first saw the image in *The Craftsman* in 1900, but it did not appear there until 1907. She probably did not see any issues of *Camera Work* until 1907 either.

The Craftsman had profiled photography in previous issues. A September 1903 article titled "Leonardo da Vinci, The Forerunner of Modern Science" surprisingly illustrated an 1880s chronophotograph of a flying pigeon by the experimental French photographer Etienne-Jules Marey. In April 1904, "The Photo Secession, A New Movement" by Sadakichi Hartmann included photographs by Alfred Stieglitz, Käsebier, Edward Steichen, Frank Eugene, and Clarence White. Various 1905 issues profiled the photographic works of Adelaide Hanscom, Frances and Mary Allen, and additional studies by White.

In the July 1907 issue, Mary Fanton Roberts, again writing as Giles Edgerton, promoted photography as a significant art form in the well-illustrated article "Photography as One of the Fine Arts: The Camera Pictures of Alvin Langdon Coburn, A Vindication of This Statement." Coburn's handsome portraits of Stieglitz and Käsebier were reproduced within the discussion of the goals of the Photo-Secession.

20. The photograph is often mistakenly given a religious interpretation because of the title. The title, however, is taken directly from a biblical quotation (Luke 1:28) inscribed around a picture on the background wall; see William Innes Homer, *A Pictorial Heritage: The Photographs of Gertrude Käsebier* (Wilmington: Delaware Art Museum, 1979), p. 22.

21. Edgerton, "Photography as an Emotional Art," p. 80.

22. Cunningham to Minor White, May 20, 1964, ICP, roll 1634.

23. Cunningham claimed that she began a subscription to *Camera Work* after her return from Europe in 1910; see Cunningham/Daniel, p. 79.

24. Cunningham noted: "The most desirable camera was what I had just bought, the 5 x 7 Century View with a Cooke lens. It was a beautiful camera even in that day. It was not a day of little cameras. The only little camera I had heard of at the time was the Eastman Kodak, which was made in various sizes. You just guessed the number of feet from a subject and looked in a little glass finder. There was no precision in the focusing device, and yet people did pretty well with them in a certain way. I never became completely addicted to it. I liked the more exact procedure of looking on ground glass, and focusing exactly. . . . I used the Kodak somewhat in London. . . . The 5 x 7 I used on the Continent. But I was very restricted as to money" (Cunningham/Daniel, pp. 172–73).

25. Cunningham's passport, no. 13166, dated Aug. 21, 1909, lists the following information: "Age: 26; Stature: 5 feet, 4 inches Eng.; Forehead: medium; Eyes: blue; Nose: pointed; Mouth: straight; Chin: receding; Hair: red; Complexion: florid; Face: oval." ICA.

26. Cunningham/Daniel, p. 34–52.

27. Halderman, "Successful Seattle Business Women," p. 2.

28. Cunningham/Daniel, p. 51.

29. Imogen Cunningham, "Über Selbstherstellung von Platinpapieren für braune Töne," *Photographische Rundschau und Photographisches Centralblatt* (Halle, Germany) 24, no. 9 (1910), p. 101–105. Cunningham felt that her contribution was soon forgotten because of the development of fast enlarging photographic paper which did not require contact printing.

30. Cunningham/Daniel, p. 59.

31. Ibid.

32. Cunningham/Daniel, p. 40.

33. Cunningham to White, May 20, 1964, ICP, roll 1634.

34. Cunningham/Daniel, pp. 81–83.

35. Cunningham/Daniel, p. 84a.

36. Ross, "Coming to the Front," p. 5.

37. Cunningham/Daniel, pp. 86–88.

38. Halderman, "Successful Seattle Business Women," p. 2.

39. Flora Huntley Maschmedt, "Imogen Cunningham—An Appreciation," *Wilson's Photographic Magazine* 51, no. 3 (March 1914), pp. 97–98.

40. The Seattle Fine Arts Society exhibition rooms were on the fourth floor of the Baillargeon Building; additional exhibitions were sometimes held in the public library. The society had about 150 members.

41. Ross, "Coming to the Front," p. 5.

42. *The Shipbuilders* was also illustrated in *The Arrow* (29, no. 2 [Jan. 1913]), the publication of Cunningham's university sorority Pi Beta Phi, along with an article by Alan W. S. Lee, "Imogen Cunningham and Her Work," and Cunningham's own essay, "Photography as a Profession for Women."

43. Imogen Cunningham, "Photography as a Profession for Women," *The Arrow* 29, no. 2 (Jan. 1913), p. 203.

44. Ibid., pp. 203–209.

45. Alvin Langdon Coburn to Cunningham, April 14, 1913, ICP, roll 1632. Cunningham had sent Coburn two of her photographs, of which he preferred *Marsh, Early Morning* (fig. 3) because of the luminosity of the sky. He reciprocated Cunningham's gift with a copy of *The Cloud* by Percy Bysshe Shelley which included six platinotypes by Coburn.

46. Clarence White to Cunningham, Nov. 28, 1913, Imogen Cunningham Papers, International Museum of Photography at George Eastman House, Rochester.

47. Edward Dickson to Cunningham, Dec. 9, 1913, Imogen Cunningham Papers, International Museum of Photography at George Eastman House, Rochester. No Cunningham image was ever reproduced in *Platinum Print*.

48. Maschmedt, "Imogen Cunningham," p. 97.

49. Untitled Cunningham paper on the history of photography, (1911?), p. 34, ICA.

50. Wolf-Dieter Dube, "The Artists Group Die Brücke," in *Expressionism: A German Intuition 1905–1920*, exh. cat. (New York: Solomon R. Guggenheim Museum, 1980), pp. 90–102. Members of the Brücke included Ernst Ludwig Kirchner, Erich Heckel, Karl Schmidt-Rottluff, and Otto Müller.

51. Yonejiro (Yone) Noguchi, father of the sculptor Isamu Noguchi, was an internationally known Japanese poet and art critic. His poetry included *Seen and Unseen: or, Monologues of a Homeless Snail* (1897) and *The Pilgrimage* (1912). Cunningham probably was introduced to his works by her friend, the painter Yasushi Tanaka.

52. Adele M. Ballard, "With the Fine Art Folk," *The Town Crier* (Seattle) 10, no. 45 (Nov. 6, 1915), p. 13.

53. Ethel M. Mallet, *First Steps in Theosophy* (London: Lotus Journal, 1905), pp. 42–43.

54. In 1919 Partridge changed his first name to Roi because he believed it to be a stronger, more artistic spelling. See Jennifer Kate Ward, "The Etchings of Roi Partridge," in *The Graphic Art of Roi Partridge: A Catalogue Raisonné*, ed. Anthony R. White (Los Angeles: Hennessey and Ingalls, 1988), p. 8.

55. Ibid., pp. 2–4.

56. Roi Partridge to Cunningham, May 28, 1914, ICA.

57. Roi Partridge to Cunningham, Aug. 13, 1914, ICA.

58. Ibid.

59. Judy Dater, *Imogen Cunningham, A Portrait* (Boston: New York Graphic Society, 1979), p. 29.

60. Cunningham's *The Bather* (fig. 14) and *Pierrot Betrübt* (fig. 16) were both reproduced in the Christmas issue of Seattle's *The Town Crier* (11, no. 51 [Dec. 16, 1916]), along with Roi Partridge's *The Marvelous Mountain* (fig. 13), within Adele M. Ballard's article, "Some Seattle Artists and Their Work," pp. 26–33.

61. Cunningham to Lee Witkin, Aug. 3, 1970, ICP, roll 1636. Cunningham produced in 1918 another extensive series of nudes of Roi along the Dipsea Trail, a stretch of mountainous paths in Marin County, California, not far from her parents' ranch.

62. J. Nilsen Laurvik, "Mrs. Annie W. Brigman—A Comment," *Camera Work* 25 (Jan. 1909).

63. Cunningham to Roi Partridge, Aug. 15, 1916, ICA.

64. "Cubists Get Theirs, Seattle Fine Arts Society Holds Annual Meeting," *The Town Crier* (Seattle) 8, no. 19 (May 10, 1913), p. 11. The quote is attributed to Charles Shepard.

65. Imogen Cunningham Partridge, "Is It Art?," in "What Some Folks Think About Art, A Symposium of Ideas by Seattle Artists Who Speak with Authority," *The Town Crier* (Seattle) 10, no. 14 (April 3, 1915), p. 7.

66. Gryffyd Partridge's first name was originally spelled "Gryffydd"; he dropped the second "d" at a later date.

67. Cunningham to Roi Partridge, Aug. 11, 1916, ICA.

68. Paul Thevenas was a Swiss painter, trained in Paris, who moved to New York in the 1910s. His stylized art deco portraits had cubist overtones. See Marie Louise Van Saanen, "Paulet Thevenas, Painter and Rythmatist," *Vanity Fair* 6, no. 6 (Aug. 1916), p. 49.

69. Imogen's parents had left Seattle about 1910 and bought a farm in Graton, California, a small town near Sebastopol, north of San Francisco.

70. Cunningham to Roi Partridge, Aug. 1916, ICA.

71. Cunningham to Roi Partridge, Aug. 18, 1916, ICA.

72. Cunningham to Roi Partridge, July 6, 1917, ICA.

73. Roi Partridge to Cunningham, July 24, 1917, ICA.

California and a New Vision

1. Jennifer Kate Ward, "The Etchings of Roi Partridge," in *The Graphic Art of Roi Partridge: A Catalogue Raisonné*, ed. Anthony R. White (Los Angeles: Hennessey and Ingalls, 1988), p. 8.

2. Cunningham/Daniel, p. 107.

3. Helen MacGregor was a pictorialist photographer in San Francisco in the late 1910s and moved in the 1920s to England where she set up a studio in Marylebone Mews with Maurice Beck. Specializing in portraits of Bloomsbury personalities, they were the chief British photographers for *Vogue* in the 1920s and also worked for *Vanity Fair*. See David Mellor, *Modern British Photography 1919–39* (Arts Council of Great Britain, 1980), pp. 40–41.

4. Cunningham to Walter Chappell, Sept. 9, 1959, ICP. Francis Bruguière (1879–1945) had been a member of the Photo-Secession, and one of his images was reproduced in *Camera Work*. He published a book entitled *San Francisco* (San Francisco: Crocker, 1918), illustrated with his Secessionist images; he moved his studio to New York in November 1918. During the 1920s he experimented with light abstraction and double-exposure imagery. He moved to England in 1928. See James Enyeart, *Bruguière: His Photographs and His Life* (New York: Alfred A. Knopf, 1977), pp. 19–20.

5. Cunningham had noted on a *Camera Work* mailing box (postmarked, anachronistically, May 18, 1912) to check an article on the Italian futurists by James Huneker. It remains uncertain if she attended the Panama-Pacific International Exposition or the futurist exhibition in 1915. She was in San Francisco during the summer of 1914, and although Roi exhibited forty-two etchings at the PPIE and Imogen showed some photographs, there is no mention of either of them visiting it. Cunningham would have been pregnant at the time.

6. Rondal Partridge remembers that Roi Partridge prominently displayed a framed reproduction or print of Duchamp's *Nude Descending the Staircase (No. 2)* in the family home during the 1920s. Interview with author, May 1991.

7. Ward, "The Etchings of Roi Partridge," p. 6.

8. Cunningham/Daniel, p. 93. The painting, bought by Walter Arensberg in 1919, is now in the Philadelphia Museum of Art.

9. Ibid., p. 80.

10. Nancy Newhall, *A Portfolio of Sixteen Photographs by Alvin Langdon Coburn* (Rochester, N.Y.: George Eastman House, 1962), p. 13.

11. Cunningham/Daniel, p. 106.

12. Alan Simms Lee to Cunningham, Oct. 17, 1920, ICP. Lee had known Cunningham in Seattle, where he had been an officer of the Seattle Fine Arts Society. He corresponded periodically from Wuhu, China, where he was stationed as a missionary.

13. Cunningham lecture note, undated (early 1940s?), ICA. Cunningham compared her approach to career and motherhood with that of Dorothea Lange: "I know of another woman who solved the same problem in an even more practical way. She too was a photographer. She had two children and always made enough money with her photography to replace herself in the household. She is now one of the best known documentary workers in the country."

14. Cunningham to Edward Weston, July 27, 1920, Edward Weston Archive, Center for Creative Photography, University of Arizona, Tucson.

15. Margrethe Mather (ca. 1885–1952) was Edward Weston's partner in his Glendale studio. See William Justema, "Margaret: A Memoir," in *Margrethe Mather*, Center for Creative Photography, University of Arizona, Tucson, no. 11 (Dec. 1979), pp. 5–19. Cunningham remained forever certain of the importance of Mather's work and, in her later years, sold a platinum print by Mather, *Pine Branches* (ca. 1918), to the Metropolitan Museum of Art for $300. She stated: "It is appropriate that Marguerite [sic] be represented in an Eastern Museum. I do not know anyone who has anything of hers. She may not have become well known but she was the first and the best influence on Edward Weston at a time when he was a slick commercial photographer and expert retoucher. Historians seem to try to gloss over this fact and he himself in the Day Books gives little to Marguerite [sic], but I feel that I have seen the whole thing" (Cunningham to Phyllis Masser, Nov. 12, 1970, copy, ICA).

16. Cunningham to Edward Weston, July 27, 1920, Edward Weston Archive, Center for Creative Photography, University of Arizona, Tucson.

17. Alvin Langdon Coburn to Cunningham, Oct. 6, 1921, ICA.

18. Adolph Bolm (1884–1951) was a Russian dancer and choreographer who performed with Diaghilev's Ballets Russes from 1908 to 1910.

19. Cunningham had always dated these photographs as 1923, but she and Roi were house guests of Weston in July 1922. They photographed each other (figs. 21–23), and Roi made etchings of Weston and Mather; see Ward, "The Etchings of Roi Partridge," pp. 12–13. Mather also apparently photographed Weston at the same time.

20. These portraits resemble a selection of double-profile "medallion" portraits of actors, including Nickolas Muray's "Douglas and Mary Fairbanks" and "Alfred Lunt and Lynn Fontaine," published in *Vanity Fair* 19, no. 4 (Dec. 1922), pp. 60–61, but the most likely inspiration of Cunningham's cropped double-head portraits of these years is Mather's masterpiece *Johan Hagemeyer and Edward Weston* (1921), which is largely composed of a dark central space framed by half of each subject's face.

21. A partial eclipse of the sun occurred in the Bay Area on Sept. 10, 1923. The crescents in Cunningham's photos (pl. 30) are those portions of the sun not hidden by the moon. Dr. David Cudaback, professor of astronomy, University of California, Berkeley, kindly researched the date of this eclipse.

22. Coburn's abstractions, dubbed "vortographs" by Ezra Pound, were made in 1917 by photographing into a triangle of inward-facing mirrors on a glass tabletop, much like a kaleidoscope; see Paul Blatchford, *Alvin Langdon Coburn*, exh. cat. (London: Arts Council of Great Britain, n.d.), n.p., and Nancy Newhall, *A Portfolio of Sixteen Photographs by Alvin Langdon Coburn* (Rochester, N.Y.: George Eastman House, 1962), pp. 13–14.

23. Alan Simms Lee to Cunningham, Jan. 19, 1923, ICP.

24. Edward Weston, *The Daybooks of Edward Weston*, vol. 1, *Mexico*, ed. Nancy Newhall (Millerton, N.Y.: Aperture, 1973), pl. 2.

25. An article by Paul Rosenfeld, "The Paintings of Georgia O'Keeffe," appeared in *Vanity Fair* 19, no. 2 (Oct. 1922), p. 56, but reproduced only two abstracted landscapes and a still life of apple forms.

26. For further information, see the essays in *Johan Hagemeyer*, The Archive Research Series of the Center for Creative Photography, University of Arizona, Tucson, no. 16 (June 1982).

27. Richard Lorenz, "Johan Hagemeyer, A Lifetime of Camera Portraits," in ibid., p. 13.

28. Quoted in Richard Lorenz, "Henrietta Shore," *Antiques and Fine Art* 3, no. 1 (Dec. 1986), p. 22. See also *Henrietta Shore: A Retrospective Exhibition*, exh. cat. (Monterey, Calif.: Monterey Peninsula Museum of Art, 1986).

29. The similarities between Shore and Cunningham are noteworthy. Shore had retrospective exhibitions at the Los Angeles Museum (1927), the California Palace of the Legion of Honor (1928), and Mills College (1931), among others. Two Shore paintings of simplified leaf forms, *Envelopment* (1922) and *Two Leaves* (1922), presage Cunningham's study of calla lily leaves, ca. 1930 (pl. 69).

30. Jack Napton, "Incredible, Unforgettable James West, Plantsman (1886–1939)," *California Horticultural Society Journal* 28, no. 3 (July 1967), p. 181.

31. Carl Georg Heise, "The World Is Beautiful," reprinted in *Albert Renger-Patzsch: 100 Photographs, 1928*, exh. cat. (Paris: Créatis; Cologne: Schürmann and Kicken, 1979), p. 10. This catalogue attempts to re-create the original book, *Die Welt Ist Schön* (Munich, 1928).

32. László Moholy-Nagy, "A New Instrument of Vision," in "From the Bauhaus," *Camera* (Switzerland) 46, no. 4 (April 1967), p. 30.

33. Cunningham did produce many more negative prints in the 1950s and 1960s, when she renewed experiments with manipulated printing techniques.

34. For a portfolio of Roh's negative imagery, see Juliane Roh, *Franz Roh: Retrospektive Fotografie* (Düsseldorf: Edition Marzona, 1981).

35. Andreas Haus, *Moholy-Nagy: Photographs and Photograms*, trans. Frederic Samson (New York: Pantheon Books, 1980), pp. 68–69.

36. "By Their Works, Ye Shall Know Them," *Vanity Fair* 29, no. 6 (Feb. 1928), p. 62.

37. Franz Roh, "Mechanism and Expression, The Essence and Value of Photography," in *photo-eye* (Stuttgart: Akademischer Verlag dr. Fritz Wedekind, 1929), p. 17.

38. Florence Lehre, "Artists and Their Work," *Oakland Tribune*, Oct. 27, 1929, p. S-7. The other photographers exhibiting were Brett Weston, Manuel Alvarez Bravo, Tina Modotti, Dorothea Lange, Roger Sturtevant, Anton Bruehl, E. A. Nievera, Ira Martin, and three members of the Japan Camera Club of Los Angeles, T. K. Shindo, R. Itano, and K. Nakamura.

39. For a history of the Deutscher Werkbund, see Ute Eskildsen, "Innovative Photography in Germany between the Wars," in *Avant-Garde Photography in Germany 1919–1939*, exh. cat. (San Francisco: San Francisco Museum of Modern Art, 1980), pp. 35–46.

40. Weston, *The Daybooks of Edward Weston*, vol. 2, *California*, p. 103.

41. Cunningham's photographs, with original German titles and exhibition checklist plate numbers, included: *Akt* (pl. 28); *Wassertank* (pl. 50); *Formen einer Blume* (pl. 38); *Pflanzenform* (pl. 42); *Schwarze und weisse Lilien* (a variant of pl. 41); *Calla*; *Pflanzenform* (pl. 43); *Pflanzenform [Rubber Plant]*; *Eislilie* (pl. 39); and *2 Callas* (pl. 40). Cunningham occasionally used these German titles through the years. For illustrations of the images, see Richard Lorenz, *Imogen Cunningham: Frontiers* (Berkeley, Calif.: Imogen Cunningham Trust, 1987), n.p. For further information on *Film und Foto*, see *International Ausstellung des Deutschen Werkbunds, Film und Foto, Stuttgart 1929*, facsimile exh. cat. (Stuttgart: Deutsche Verlags-Anstalt, 1979).

42. Edward Weston to Cunningham, undated (late 1920s), ICA.

43. Edward Weston to Cunningham, Jan. 12, 1928, ICA. Years later Cunningham sarcastically mentioned this letter, which she considered extremely patronizing since Weston ignored the fact that she had been a working photographer for more than twenty years; see Paul Hill and Thomas Cooper, *Dialogue with Photography* (New York: Farrar, Straus and Giroux, 1979), p. 300.

44. Edward Weston, "Imogen Cunningham, Photographer," *The Carmelite*, April 17, 1930, p. 7.

45. *Vanity Fair* (May 1931) ran an article, "Hands That Rule the World of Art," illustrated with nine photographs of artist's hands. The M. H. de Young Memorial Museum, San Francisco, mounted an exhibition called *A Showing of Hands* in June 1932. Included in the show were photographs by Cunningham, Edward and Brett Weston, Johan Hagemeyer, Consuelo Kanaga, Ansel Adams, Dorothea Lange, Roger Sturtevant, Will Connell, Edward Steichen, Anton Bruehl, and Arnold Genthe.

46. Junius Cravens, "The Art World," *The Argonaut*, Dec. 25, 1931, p. 8.

47. Ansel E. Adams, "Photography," *The Fortnightly* 1, no. 12 (Feb. 12, 1932), p. 26. Adams also criticized Cunningham's use of a matte rather than glossy paper. His harsh comments may have been a somewhat vindictive response to an incident in 1931, described years later in his autobiography: "My first contact with Imogen's wrath was when Albert Bender, with enthusiasm for his newly discovered protégé Adams, secured me an assignment to do a small catalog for Mills. Little did I realize that I had trod upon very sensitive toes; I had violated territory sacred to Imogen, who left no bones unpicked about it. I declined the college catalog and the fires died down in time. We became good friends and mutual admirers and soon were cofounders of Group f.64." See Ansel Adams, *An Autobiography* (Boston: New York Graphic Society, 1985), p. 176.

48. "'Impressions in Silver' by Imogene [sic] Cunningham," *Los Angeles Museum Art News*, April 1932.

49. Albert Renger-Patzsch, quoted in Beaumont Newhall, "Albert Renger-Patzsch," *Image, the Journal of the George Eastman House of Photography* 3 (Sept. 1959), p. 142.

50. Carl Georg Heise, "The World Is Beautiful," reprinted in *Albert Renger-Patzsch*, p. 13.

51. Inscribed on photograph, Cunningham to Edward Weston, undated (1929), Edward Weston Archive, Center for Creative Photography, University of Arizona, Tucson.

52. Agnes de Mille, *Martha: The Life and Work of Martha Graham* (New York: Random House, 1991), p. 177.

53. Anna Kisselgoff, "The Century of Martha Graham," in *La danza moderna di Martha Graham* (Reggio Emilia, Italy: Teatro Municipale Valli, 1987), p. 8.

54. Cunningham apparently had submitted prints to *Vanity Fair* as early as Nov. 1929, when she offered *Hand of Gerald Warburg* (fig. 34). In 1930 she sent for consideration prints of Gertrude Gerrish, Henry Cowell, several studies of snakes, and the images *Leaf Pattern, Banana Leaves,* and *Water Hyacinth;* all were returned unpublished. Even her now well-known portrait of Frida Kahlo (pl. 64) was rejected in 1931. Associate editor Clare Boothe Brokaw noted that they were interested only in prominent persons. The two published Graham photographs were selected from twenty-three images submitted by Cunningham. All *Vanity Fair* letters are ICA.

55. Nicholas Fox Weber, *Patron Saints: Five Rebels Who Opened America to a New Art, 1928–1943* (New York: Alfred A. Knopf, 1992), p. 56.

56. Cunningham to Donald Freeman, Jan. 1931, ICA.

57. Donald Freeman to Cunningham, Jan. 19, 1932, ICA. Freeman died tragically in an automobile accident on Oct. 2, 1932, at the age of twenty-nine. He had been on the editorial staff of the magazine for eight years. See "Donald Freeman," obituary, *Vanity Fair* 39, no. 3 (Nov. 1932), p. 13.

58. The Group f.64 exhibition was held from Nov. 15 to Dec. 31, 1932. Preston Holder, Consuelo Kanaga, Alma Lavenson, and Brett Weston were also invited to show with the group. Nine photographs by Cunningham were included: *Hens and Chickens; Rubber Plant; Leaf Pattern* (pl. 43); *Agave; Water Hyacinth No. 1; Sedum Crestate; Blossom of Water Hyacinth; Umbrella Handle and Hand* (pl. 74); and *Warner Oland.* For illustrations of these images, see Lorenz, *Imogen Cunningham: Frontiers,* n.p. The group's major published statements were printed more than two years later in *Camera Craft* 42, no. 3 (March 1935), pp. 106–113, where Cunningham reproduced a portrait, *Marian Simpson, Painter* (pl. 67), and stated her philosophy: "Photography began for me with people and no matter what interest I have given plant life, I have never totally deserted the bigger significance in human life. As document or record of personality, I feel that photography isn't surpassed by any other graphic medium. The big discussion as to whether it is an art or not was settled for me as well twenty years ago by many writers in Stieglitz' publication "Camera Work" as it is to-day. Lewis Mumford says there are fewer good photographers than painters. There is a reason. The machine does not do the whole thing."

59. For a more complete discussion of Group f.64 and its influence, see the exhibition catalogue for the revival of the original show, *Group f.64* (St. Louis, Mo.: University of Missouri-St. Louis, Gallery 210, 1978), and Therese Thau Heyman, ed., *Seeing Straight: The f.64 Revolution in Photography* (Oakland, Calif.: Oakland Museum, 1992).

60. Junius Cravens, "Sharp Focus," *The Argonaut,* Dec. 2, 1932, p. 18.

61. Cunningham/Daniel, p. 148.

62. The art director of *Vanity Fair* from 1929 through 1943 was Mehemed Fehmy Agha (1896–1978), a young Russian commercial artist who radically changed the look of Condé Nast publications such as American and French *Vogue, House and Garden,* and *Vanity Fair.*

63. Junius Cravens, "The Art World: May at the Museum," *The Argonaut,* May 20, 1932, p. 16. Herbert Bayer's cover for *Bauhaus* (1928, no. 1) was awarded first prize at this juried exhibition, which premiered at the Art Center, New York, in 1931, and was organized by Abbott Kimball, of the New York advertising firm Lyddon, Hanford and Kimball. Bayer's famous design depicts an arrangement of geometric shapes (cube, sphere, and cone), pencil, and drafting triangle above a folded sheet of Bauhaus typography. The original exhibition was reviewed by Margaret Breuning, "Foreign Commercial Photographs Make Brilliant Showing," *New York Evening Post,* March 7, 1931. See also Diana du Pont, *Florence Henri: Artist-Photographer of the Avant-Garde,* exh. cat. (San Francisco: San Francisco Museum of Modern Art, 1990), pp. 33–34.

64. Alan Simms Lee to Cunningham, Feb. 22, 1934, ICP.

65. Cunningham to Roi Partridge, April 8, 1934, ICA.

66. In 1935 Roi married Marion Lyman, who died five years later of lung cancer. In 1941 he married May Ellen Fisher, with whom he lived until his death in 1984 in Walnut Creek, Calif.

Stolen Pictures

1. Stieglitz thanked Cunningham for sending him a group of these portraits: "A moment at last which I can call my own. So I hasten to use it to let you know how delighted both O'Keeffe & I were with the prints you were so kind to send us. I never know about portraits of myself. I always consider them good. Crowninshield is going to use one in the next issue of *Vanity Fair.* I wish you could have seen my show. It attracted 7000 people in 6 weeks. And there wasn't a dissenting voice. There was a finality about every print. This is a mouthful I know but it is true. I often think back to your visit with pleasure. O'Keeffe is somewhat better. As for myself I'm on the job as ever—or more than ever—if that be possible. All single handed. My cordial greetings & thanks" (Alfred Stieglitz to Cunningham, Feb. 3, 1935, ICA).

2. Cunningham to Dr. Stieglitz (niece of Alfred Stieglitz), Dec. 30, 1966, ICA.

3. Cunningham to Franke and Heidecke, an advertising firm in Germany, June 5, 1959, ICP. She wrote: "I am not so much intrigued by landscape—though I have done some. I like to do street shots and what I call 'stolen pictures' such as strange people at rummage sales and in crowds."

4. Ralph Steiner to Cunningham, May 24, 1935, ICA.

5. Cunningham to Gryff Partridge, May 24, 1934, ICA.

6. Ibid.

7. Ibid.

8. Lange's first exhibition was in Willard Van Dyke's gallery "683" on Brockhurst Avenue in Oakland. The gallery had previously been used by Anne Brigman and as the meeting space for Group f.64; see *Celebrating a Collection: The Work of Dorothea Lange,* exh. cat. (Oakland, Calif.: Oakland Museum, 1978).

9. Milton Meltzer, *Dorothea Lange: A Photographer's Life* (New York: Farrar, Straus and Giroux, 1978), pp. 81–87.

10. Ibid., p. 88.

11. Willard Van Dyke, "The Photographs of Dorothea Lange—A Critical Analysis," *Camera Craft* 41, no. 10 (Oct. 1934), pp. 464–65.

12. Paul Hill and Thomas Cooper, *Dialogue with Photography* (New York: Farrar, Straus and Giroux, 1979), pp. 302–303.

13. Cunningham/Daniel, p. 194.

14. Cunningham to George Craven, March 12, 1958, ICP.

15. For a history of *Vanity Fair*, see Diana Edkins Richardson, ed., *Vanity Fair: Photographs of an Age, 1914–1936* (New York: Clarkson N. Potter, 1982).

16. Cunningham wrote: "I have just done Herbert Hoover, and did I sweat. I have no feeling for what I got, since I don't really understand him as a person." Thinking of Edward Weston's 1926 image of Rosa Cavarrubias, a direct head-and-shoulders portrait in strong overhead sunlight, her eyes closed and braids curled on either side of her head, Imogen said: "For me the bisymmetry and the pattern of it does not destroy the lady but if you tried the same thing on a clumsy stoic like Mr. Hoover, the result would be caricature" (Cunningham to Consuela Kanaga, Oct. 2, 1935, copy, ICA).

17. Cunningham/Daniel, pp. 159–60.

18. Cunningham years later wrote to a Stein collector about aspects of the sitting; Imogen's personal interest in sewing (she made her own clothes for many years) is apparent in her detailed description: "She wore something that went nicely with the curtains—a vest of thick tapestry cloth all covered over with people and edged with upholsterer's galloon. Under it was a dull rose beautiful silk blouse, very plain, and at the collar a huge circular broach of dull cut semi-precious stones, like the middle ages in Italy. In fact I am sure it was an old broach. Her skirt was rough brown tweed and afterward when she went out she put on a coat like the skirt and drew, what my young son [Rondal], who was my chauffeur then, called a sock over her head." While Cunningham was photographing Stein on the balcony, her companion Alice B. Toklas made it clear that a strict timetable was in effect: "Miss Cunningham, you have three minutes more." A perturbed Cunningham replied: "Miss Toklas, the sitting is over" (Cunningham to Addison Metcalf, Sept. 22, 1955, copy, ICA).

19. Gertrude Stein, "Portraits and Repetition," in *Lectures in America* (New York: Random House, 1935), pp. 175–76.

20. Peter Nisbet, *El Lissitzky*, exh. cat. (Cambridge: Harvard University Art Museums, Busch-Reisinger Museum, 1987), pp. 152, 193. The actual photograph is dated 1924.

21. Cunningham to Consuela Kanaga, Oct. 2, 1935, copy, ICA.

22. The nature of the piece suggests that it might have been proposed as a cover or illustration for *Vanity Fair*. The photomontage depicts a thunderstorm raging over a Congress divided into black and white sides, Franklin D. Roosevelt ascendant over Herbert Hoover, and prominent references to the Agricultural Adjustment Association, the National Recovery Administration, and the Public Works Administration. As Cunningham supported Norman Thomas, the social reformer and six-time socialist presidential candidate, the photomontage is a curious statement, but it possibly refers to, considering the date of late 1935 or early 1936, the striking down by the Supreme Court of some of Roosevelt's recovery measures, such as the NRA's code system in 1935 and the AAA's processing taxes in 1936.

23. *Catalogue of the Cornish School* (Seattle: Cornish School, 1935?). Photographs by Richard W. Erickson and McBride and Anderson were also included in the glossy, spiral-bound publication.

24. One might conjecture that this cloud study was an homage to Alfred Stieglitz's Equivalent cloud series or to Edward Weston's cloud studies, but Cunningham photographed clouds often over the years, beginning in the early 1920s.

25. Up until about 1935 Cunningham used 8-by-10, 5-by-7, and 4-by-5 negatives; after 1938, she primarily used 2¼-by-2¼ and 4-by-5 negatives but continued to occasionally use the 8-by-10 format through the 1950s.

26. Cunningham kept extensive files with clippings of articles from *Life, Harper's Bazaar*, and numerous other magazines throughout the years. She seemed to especially appreciate stories illustrated by her friends Otto Hagel and Horace Bristol as well as by Ernst Haas, Gjon Mili, Henri Cartier-Bresson, Alfred Eisenstaedt, and Edward Steichen.

27. Jonathan Silverman, *For the World to See: The Life of Margaret Bourke-White* (New York: Viking Press, 1983), p. 81.

28. During the late 1930s a mutual support and promotional organization was formed by a group of Bay Area photographers. Called the Western Photographic Group, its offices were at 173 Market Street, San Francisco. Its members were Ansel Adams, Horace Bristol, Imogen Cunningham, Norman Donant, Mary Jeanette Edwards, Otto Hagel, Dorothea Lange, Hansel Mieth, Rondal Partridge, and Roger Sturtevant.

29. Imogen Cunningham, "Sometimes I Wonder," *Spectator* (Junior League of San Francisco), Feb. 1952, p. 6.

30. Cunningham to Tom Maloney, Sept. 2, 1941, ICP.

31. Cunningham to Portia Hume, March 20, 1942, ICP.

32. Cunningham/Daniel, p. 164. The trip from Colby Street to Harbor View would have been about a ten-mile commute, one way, by bus, trolley, and foot. The trip from Colby Street to Montgomery Street in San Francisco also would have been about ten miles but by a more direct bus and train route.

33. Cunningham photographed Sturtevant around 1922, and it was in his studio in 1931 that she photographed Frida Kahlo (pl. 64). Kahlo's husband, Diego Rivera, was in San Francisco that year executing a fresco, *Allegory of California*, at the Pacific Stock Exchange. He painted another major fresco later in 1931 at the California School of Fine Arts (now the San Francisco Art Institute) titled *The Making of a Fresco, Showing the Building of a City*.

34. Cunningham/Daniel, pp. 164–65.

35. Cunningham lecture notes for San Francisco State College, Dec. 5, 1963, ICA.

Although commonly used in Europe, photomontage was infrequently employed by American photographers of the period. The exhibition and catalogue *Murals by American Painters and Photographers* at the Museum of Modern Art, New York, in 1932 included photomontages by Berenice Abbott, Maurice Bratter, George Platt Lynes, Thurman Rotan, and others. For a discussion of photomontage in America, see Sally Stein, "'Good Fences Make Good Neighbors,' American Resistance to Photomontage between the Wars," in *Montage and Modern Life, 1919–1942* (Cambridge: MIT Press, 1992), pp. 128–89.

On Green Street

1. Peter Bunnell, Maria Pellerano, and Joseph Rauch, *Minor White: The Eye That Shapes* (Princeton, N.J.: Art Museum, Princeton University in association with Bulfinch Press, 1989), pp. 4–5.

2. Minor White, "Photography in an Art School," *U.S. Camera* 12, no. 7 (July 1949), p. 49.

3. Cunningham to Minor White, July 28, 1954, ICP.

4. Cunningham again taught at the school (whose name was changed to the San Francisco Art Institute in 1961) during 1965–67 and in 1973.

5. Ann Thomas, *Lisette Model*, exh. cat. (Ottawa: National Gallery of Canada, 1990), p. 106.

6. Ibid., p. 103.

7. John Gutmann (b. 1905) studied painting with Otto Müller in Breslau, Germany, and was hired by Presse-Foto, Berlin, in 1933 as a foreign correspondent. He settled permanently in San Francisco in 1937 and developed the graduate program in photography at San Francisco State University in 1949. See Maia-Maia Sutnik, *Gutmann*, exh. cat. (Toronto: Art Gallery of Ontario, 1985).

8. "The Intellectual Climate of San Francisco—Nineteen Personalities," *Harper's Bazaar*, no. 2822 (Feb. 1947), pp. 220–23. The entry on Cunningham stated: "Imogene [sic] Cunningham began her career making portraits for *Vanity Fair*. Then, searching for a pattern behind realism, she became interested in abstractions. She is now planning to open a portrait studio in San Francisco."

9. Thomas, *Lisette Model*, p. 112.

10. Cunningham said: "Last July I was at the Perls Gallery in Los Angeles when there were a lot of nuns visiting the Calder show. I assure you that was a sight—so without reading my meter or speaking to anyone, I quickly set my Rollei down on a desk and shot a little unpremeditated scene of one young nun putting a mobile in motion and an old one sitting trying to find out all about it from the brochure" (Cunningham to Minor White, July 7, 1954, ICA).

11. Susan Sontag, *On Photography* (New York: Farrar, Straus and Giroux, 1977), p. 50.

12. Although Cunningham intended for her work to go beyond documentation of social concerns, she did produce, about 1950, a series on minority children playing in South Park and adjacent alleys, titled "Have We Slums in San Francisco," which she directed at the San Francisco Housing Authority.

13. Wolfgang Kemp, "Images of Decay: Photography in the Picturesque Tradition," trans. Joyce Rheuban, *October* 54 (Fall 1990), p. 103.

14. See Minor White and Walter Chapell, "Some Methods for Experiencing Photographs," *Aperture* 5, no. 4 (1957), pp. 156–71. *Aperture* was founded by White, Ansel Adams, Melton Ferris, Dorothea Lange, Ernest Louie, Barbara Morgan, Beaumont Newhall, and Dody Warren in 1952. White became editor and production manager. He left the California School of Fine Arts in 1953 to work at the George Eastman House in Rochester and later taught at the Rochester Institute of Technology; see Bunnell, et al., *Minor White*, p. 7.

15. Anne Armstrong, Museum of Modern Art, New York, to Imogen Cunningham, Oct. 22, 1946, and Cunningham to Armstrong, Oct. 28, 1946, ICP. Armstrong stated that Model had favorably reported on Cunningham and requested that she submit a selection of post-1939 prints for purchase. MOMA had received a substantial collection of Cunningham photographs in 1939–40 through the San Francisco collector Albert Bender. Cunningham told Armstrong that "it was a great stimulus to have her [Model] with us."

16. Helen Gee to Cunningham, 1954, ICP. Those photographers invited to be in the inaugural exhibition included Berenice Abbott, Ansel Adams, Edouard Boubat, Bill Brandt, Brassaï, Manuel Alvarez Bravo, Harry Callahan, Imogen Cunningham, Robert Doisneau, Walker Evans, Robert Frank, Izis, Dorothea Lange, Lisette Model, Gotthard Schuh, Edward Steichen, Eugene Smith, Jacob Tuggener, Edward Weston, Sabine Weiss, and Minor White. For an impression of the gallery and the period, see Helen Gee, *Photography of the Fifties: An American Perspective* (Tucson, Ariz.: Center for Creative Photography, University of Arizona, 1980).

17. John Barkley Hart, *The Village Voice*, June 6, 1956, clipping, ICA.

18. Jacob Deschin, "Portraits on View, From the Human Angle—Other Exhibits," *New York Times*, May 13, 1956. Cunningham's portrait *My Father at Ninety* (pl. 88) was reproduced in the article.

19. Sontag, *On Photography*, p. 7.

20. Robert McDonald, interviews with author, Berkeley, Calif., 1991. McDonald curated exhibitions of Morris Graves's work in 1984 and 1990, and had discussed Cunningham's photographs with him.

21. Marianne Moore to Cunningham, undated (1957), ICA.

22. Cunningham/Daniel, p. 135.

23. The San Francisco Society of Women Artists was founded in 1925 to support and encourage the exhibition of art by women. Cunningham entered works in its annual exhibitions at the San Francisco Museum of Art in 1945, 1947, 1949, 1950, 1952–56, 1959, 1962, 1965, 1966. She juried the photography section in 1952 with Johan Hagemeyer and John Gutmann.

24. Judith Rich, "In Focus with Imogen Cunningham," *Westways* (Automobile Club of Southern California) 68, no. 8 (Aug. 1976), p. 72. Adopted by the women's movement as an example and heroine, Cunningham was critical of militant feminism, stating that "a lot of hate never got anyone anywhere."

25. Muriel Rukeyser, quoted in Kate Daniels, ed., *Rukeyser, Out of Silence, Selected Poems* (Evanston, Ill.: Triquarterly Books, Northwestern University, 1992), p. xvi.

26. Muriel Rukeyser, *Collected Poems of Muriel Rukeyser* (New York: McGraw Hill, 1978), p. 286.

27. One of Cunningham's most evocative indications of place, *The Unmade Bed* (pl. 104), was an inside joke to Dorothea Lange. While teaching at the California School of Fine Arts in 1957, Lange required that her students produce a portfolio of photographs to evoke "a completely personal (symbolical or realistic) interpretation of the theme 'Where Do I Live?'"—an attempt at capturing "the most meaningful and personal place" of their environment without the inclusion of any person. The exercise was meant to express the inner self rather than document the outer world. See Meltzer, *Dorothea Lange*, pp. 304–305.

28. Cunningham was well aware of Eugène Atget's photography. She had probably seen the exhibition of his photographs at the de Young museum in San Francisco in 1931, and she had a copy of the Atget volume published by the Photo League (*Photo Notes*, Fall 1948). She also might have seen the 1956 Atget exhibition at the Limelight Gallery in New York.

29. Application for Guggenheim Foundation fellowship, Nov. 16, 1959, ICP.

30. The bulletin of the George Eastman House (*Image* 10, no. 1 [Jan. 1961]) reported that the museum had purchased seventy-five photographs by Cunningham, some of which were on display in the Masterpiece Gallery. She also donated a collection of books, periodicals, exhibition catalogues, and autograph letters of historical significance.

31. August Sander (1876–1964) produced an extensive body of portraiture in Germany before World War II. His work documented the various social strata of the country in a fresh, straightforward manner. He published *Antlitz der Zeit* (Face of the Time) in 1929, a comparative history of the people of the country, photographed in the new objective style.

32. Cunningham travel journal, "At Haus Baden in Bonn," May 3, 1960, ICA. She remembered that what most interested her during the visit was "a large photo of one eye. It hung over a door. It is not in the book [Sander's *Antlitz der Zeit*]" (Cunningham to Otto Steinert, Dec. 30, 1972, copy, ICA). The image is most probably *My Daughter Sigrid's Right Eye* (1926).

33. Norman Hall, "Imogen Cunningham," *Photography* (London) 15 (May 1960), pp. 20–25.

34. Cunningham travel journal, "Paris," May 7, 1960, ICA.

35. Ibid.

36. Cunningham lecture notes for University of California Extension class, Oct. 27, 1968, ICA.

37. Minor White, ed. "Imogen Cunningham," *Aperture* 11, no. 4 (1964), p. 2.

38. Cunningham to Ansel Adams, Feb. 10, 1964, Center for Creative Photography, University of Arizona, Tucson.

39. Minor White to Cunningham, Feb. 23, 1964, ICP.

40. Ruth Asawa, who had studied with Josef Albers at Black Mountain College, executed her hanging wire basket forms and tied wire sculptures during the 1950s and 1960s. Cunningham took most of the photographs for the catalogue of her retrospective exhibition held at the San Francisco Museum of Art in 1973; see Gerald Nordland, *Ruth Asawa: A Retrospective View* (San Francisco: San Francisco Museum of Art, 1973).

41. Alvin Langdon Coburn to Cunningham, Sept. 10, 1964, ICP, roll 1634.

42. George Craven, "Imogen Cunningham," *Aperture* 11, no. 4 (1964), p. 169.

43. Cunningham lecture notes, May 18, 1968, ICA. The Muriel Rukeyser quote is taken from the opening lines of her "Seventh Elegy. Dream-singing Elegy," originally published in the collection *Beast in View* (Garden City, N.Y.: Doubleday, Doran, 1944).

Ideas without End

1. Application for Guggenheim Foundation fellowship, 1970, ICP, roll 1634.

2. Cunningham to Helen MacDonell, July 19, 1970, ICP, roll 1634.

3. Cunningham to Padraic Partridge, May 16, 1970, ICA.

4. Cunningham to Erwin Falkner von Sonnenburg, Nov. 28, 1970, ICP, roll 1636.

5. Merla Zellerbach, "My Fair City: What Is the Price of Fame?," *San Francisco Chronicle*, Oct. 23, 1972, p. 16.

6. Cunningham to Ansel Adams, June 15, 1970, ICP, roll 1639; see also Adams, *An Autobiography*, pp. 178–79.

7. Hilton Kramer, "Imogen Cunningham at Ninety: A Remarkable Empathy," *New York Times*, May 6, 1973.

8. Cunningham to Padraic Partridge, Dec. 26, 1974, ICP, roll 1637.

9. Cunningham to Shen Yao, July 14, 1974, ICA.

10. Lisette Model began an old-age photo project in late 1968, and she photographed extensively at a nursing home in the early 1970s; see Ann Thomas, *Lisette Model*, exh. cat. (Ottawa: National Gallery of Canada, 1990), pp. 155–57. Model most probably discussed the project with Cunningham when they both taught at the San Francisco Art Institute during the summer of 1973.

11. Horatio Greenough, quoted in Alfred Frankenstein, "A Retrospective of the Cunningham Mastery," *San Francisco Chronicle*, Oct. 8, 1977, p. 38.

12. Cunningham lecture note, undated, ICA.

13. Cunningham to Wynn and Edna Bullock, Nov. 2, 1975, ICA.

14. Stephen Spender, "From My Diary," in *Collected Poems, 1928–1985* (New York: Random House, 1986), p. 162.

15. Cunningham to Carlota Duarte, Feb. 15, 1976, ICA.

16. Morris Graves to Cunningham, April 22, 1969, ICA.

17. Lillian Hellman, *Pentimento: A Book of Portraits* (Boston: Little, Brown, 1973), p. 3. Hellman more fully states: "Old paint on canvas, as it ages, sometimes becomes transparent. When that happens it is possible, in some pictures, to see the original lines: a tree will show through a woman's dress, a child makes way for a dog, a large boat is no longer on an open sea. That is called pentimento because the painter 'repented,' changed his mind. Perhaps it would be as well to say that the old conception, replaced by a later choice, is a way of seeing and then seeing again."

18. Jane Margold, "Imogen Cunningham at 91," *Ms.* 3, no. 8 (Feb. 1975), p. 25.

19. Imogen Cunningham, *Imogen! Imogen Cunningham Photographs, 1910–1973* (Seattle: University of Washington Press, 1974), p. 105.

20. Kevin Leary, "Imogen Cunningham, Famed Photographer, Dies Here at 93," *San Francisco Chronicle*, June 25, 1976.

21. Ann Hershey, "Remembering Imogen," *San Francisco Examiner and Chronicle*, magazine suppl., Sept. 26, 1976, p. 60.

22. Imogen Cunningham, *After Ninety* (Seattle: University of Washington Press, 1977), p. 51. The portrait of Martha Ideler was taken in 1975.

23. Ibid., p. 58.

24. Cunningham lecture notes, undated (1960s), ICA. The quotation was also used as her statement in the catalogue for the group exhibition *Six Photographers 1965* (Urbana, Ill.: University of Illinois, College of Fine and Applied Arts, 1965). The other photographers included were Alice Andrews, Jerry Uelsmann, Ruth Bernhard, Paul Caponigro, and Minor White.

Plates

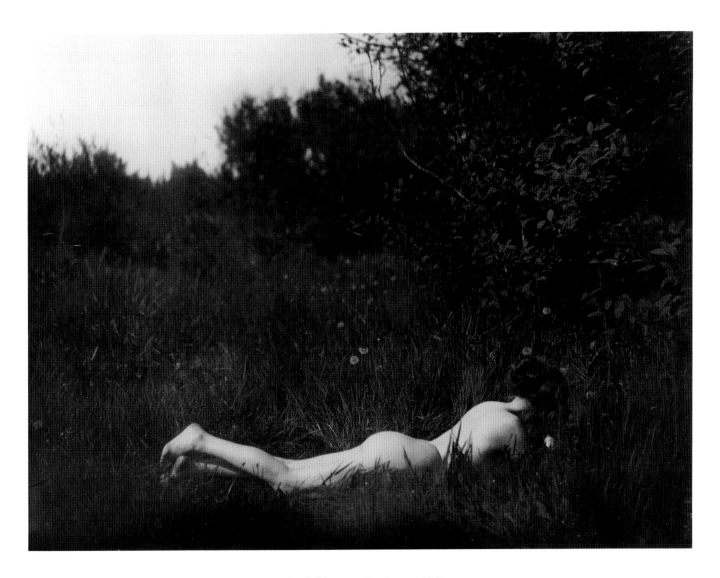

1. *Self-portrait*, about 1906

2. *Maryla Patkowska, Dresden, 1909–10*

3. *Children with Birdcage, 1909–10*

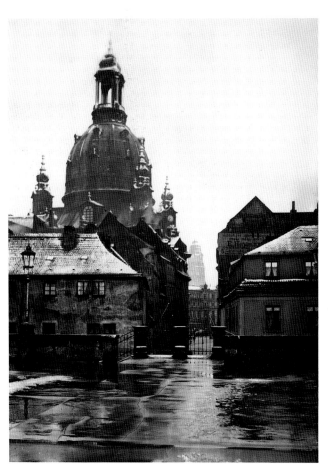

4. *The Dom, Dresden,* 1909–10

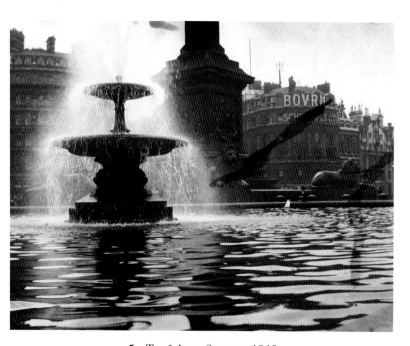

5. *Trafalgar Square,* 1910

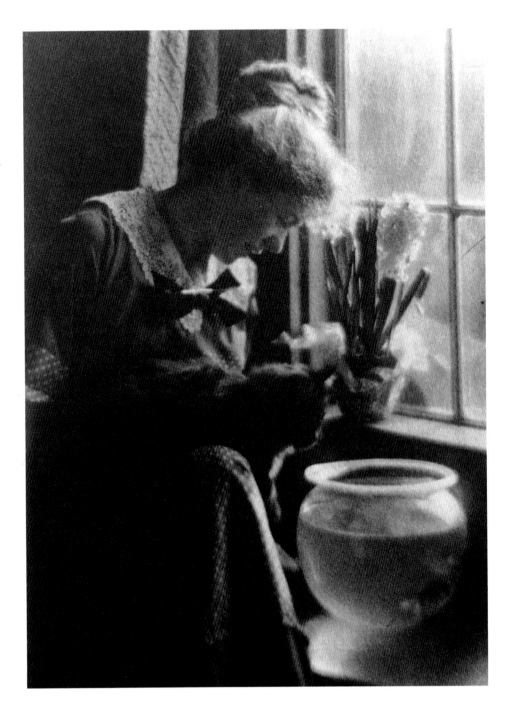

6. *Mrs. Herbert Coe, Seattle,* 1910

7a. *Morning Mist and Sunshine*, 1911 7b. *In Moonlight*, 1911

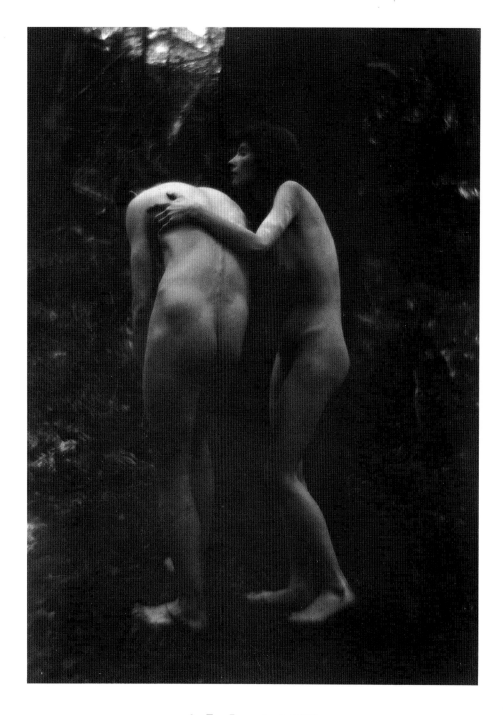

8. *Eve Repentant,* 1910

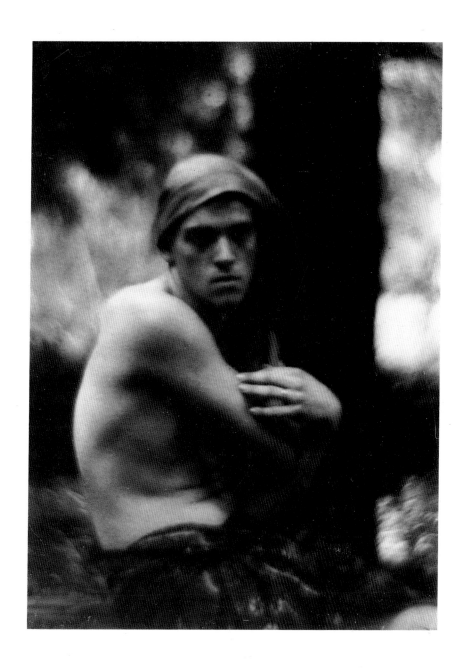

9. *Ben Butler*, 1910

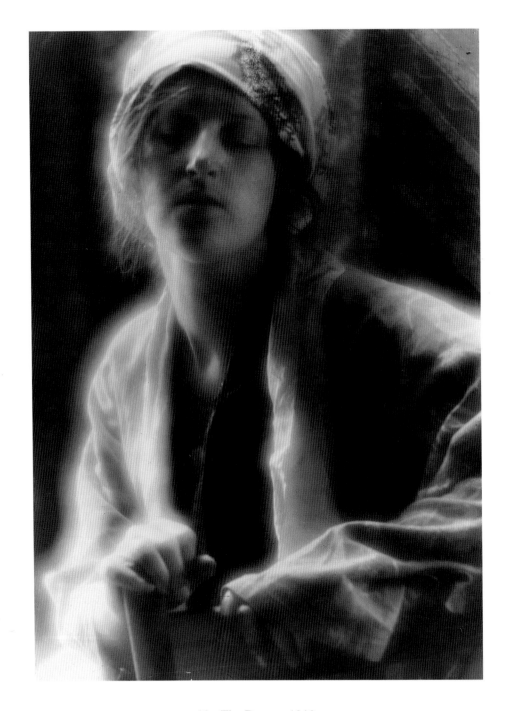

10. *The Dream*, 1910

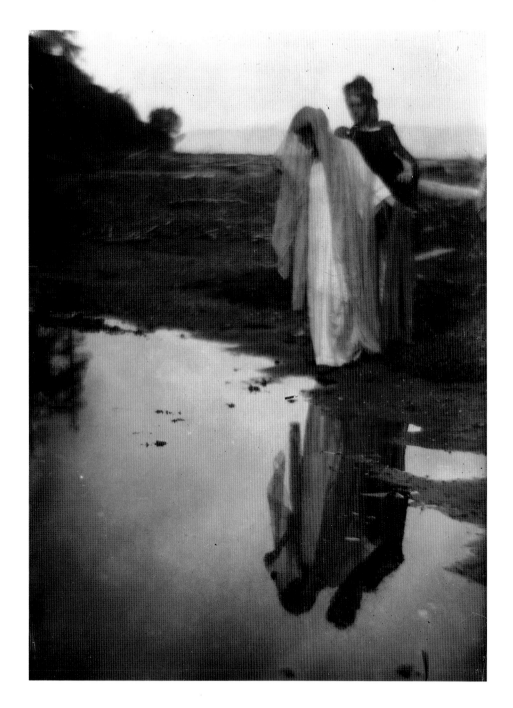

11. *By the Waters*, 1912

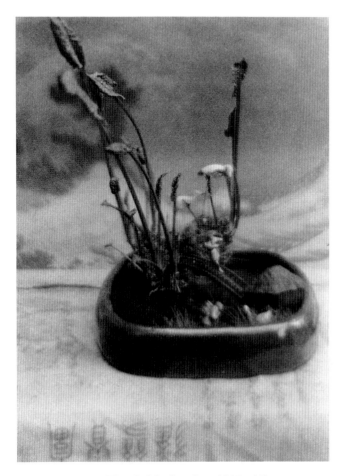

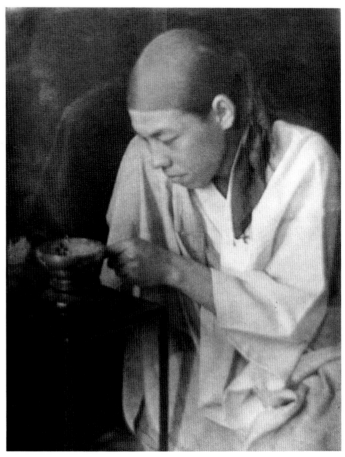

12. *This Is My Garden*, 1910–15

13. *Boy with Incense*, 1912

14. *On Mount Rainier*, 1912

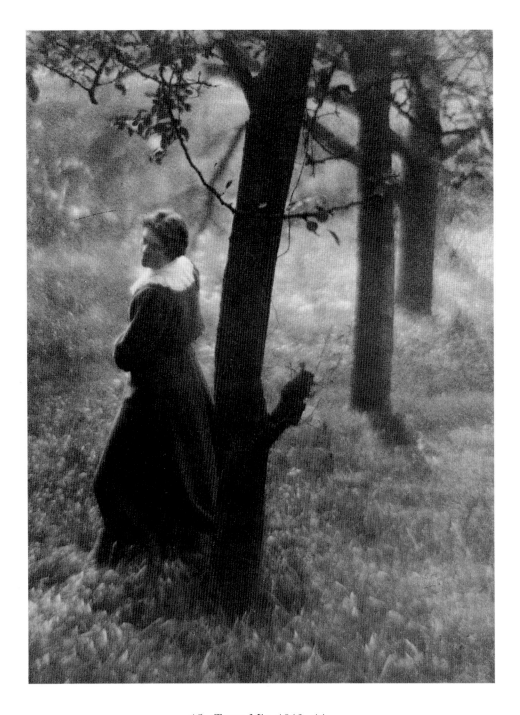

15. *Tante Mia*, 1912–14

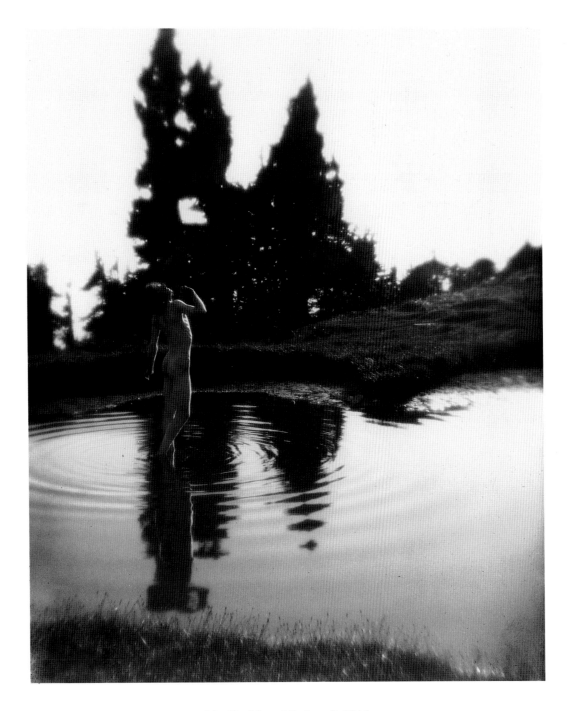

16. *On Mount Rainer 8*, 1915

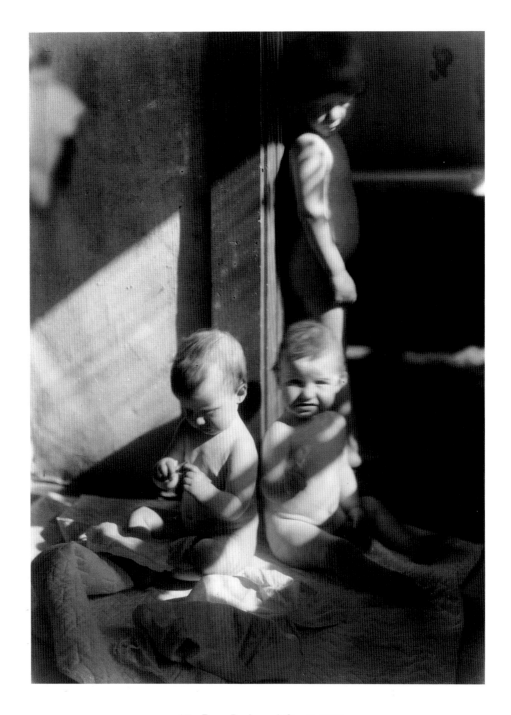

17. *Ron, Pad, and Gryff,* 1919

18. *Birdcage and Shadows,* 1921

19. *Mills College Amphitheater*, about 1920

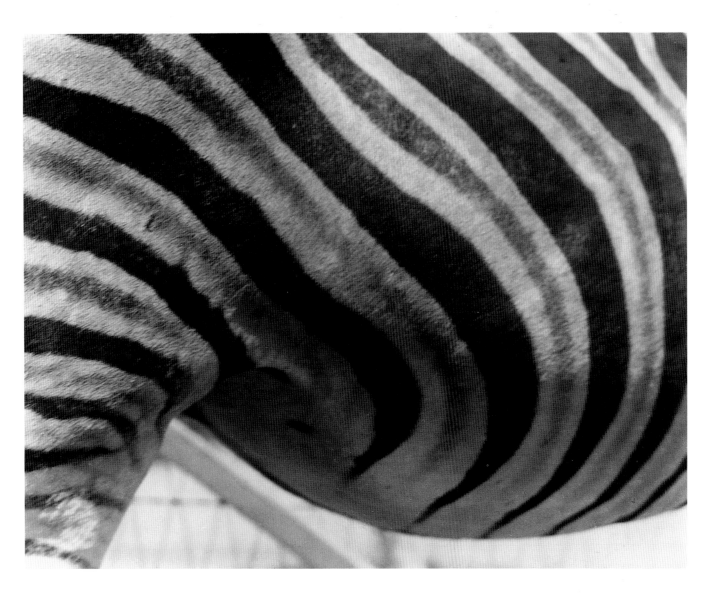

20. *Zebra*, about 1921

21. *At Point Lobos,* 1921

22. *Morning Glory*, about 1921

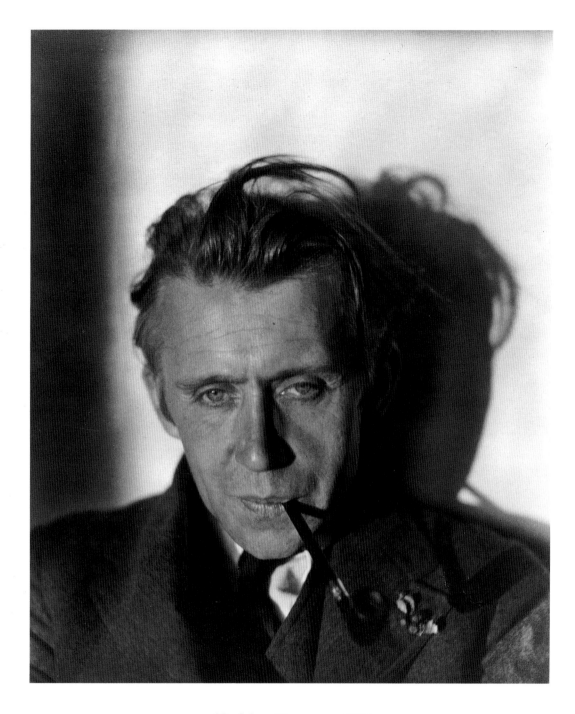

23. *Johan Hagemeyer, 1922*

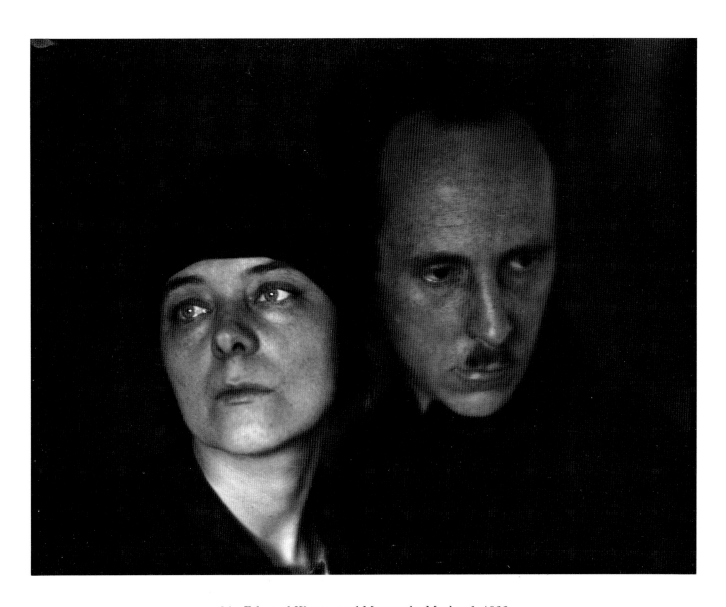

24. *Edward Weston and Margrethe Mather 3*, 1922

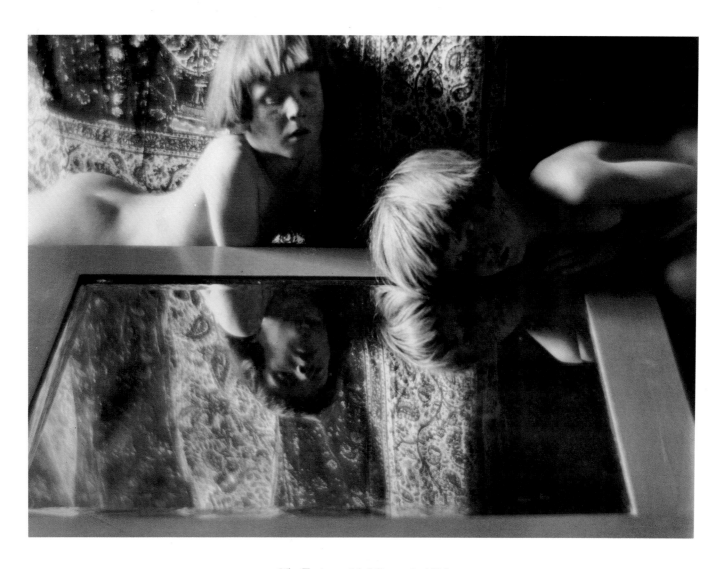

25. *Twins with Mirror 2,* 1923

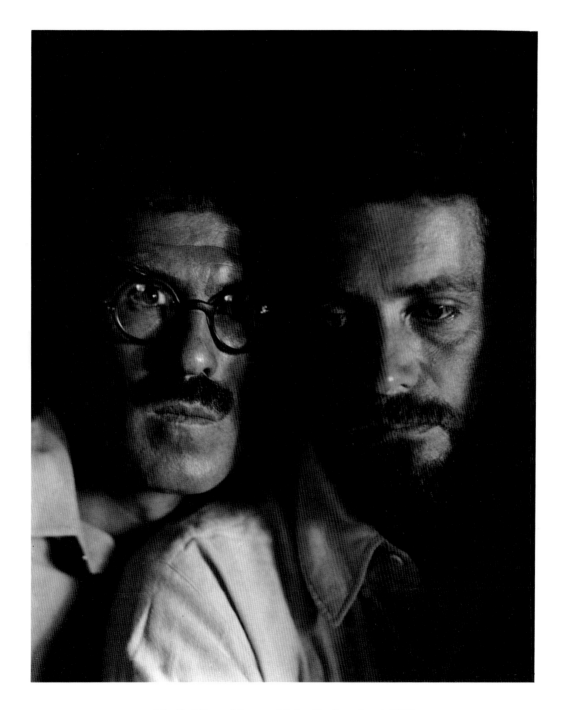

26. *Roi Partridge and John Butler,* about 1923

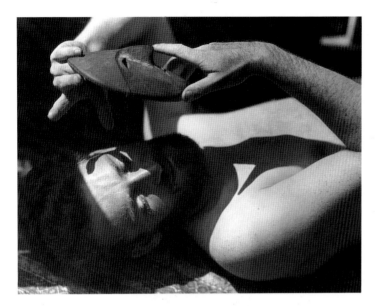

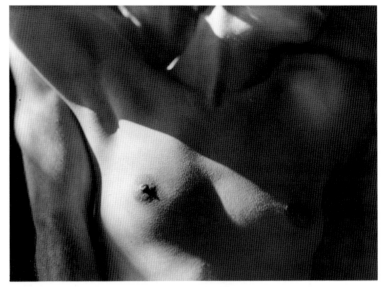

27. *John Butler with Mask,* about 1923 28. *Nude,* 1923

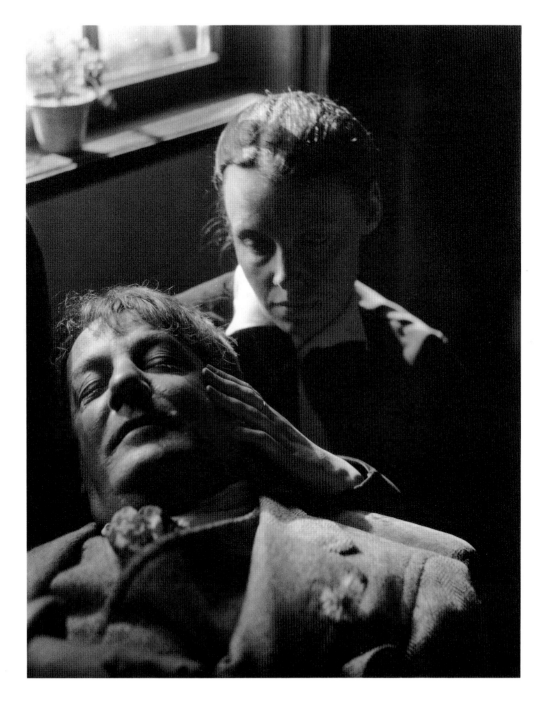

29. *Sherwood Anderson and Elizabeth Prall 2,*
about 1923

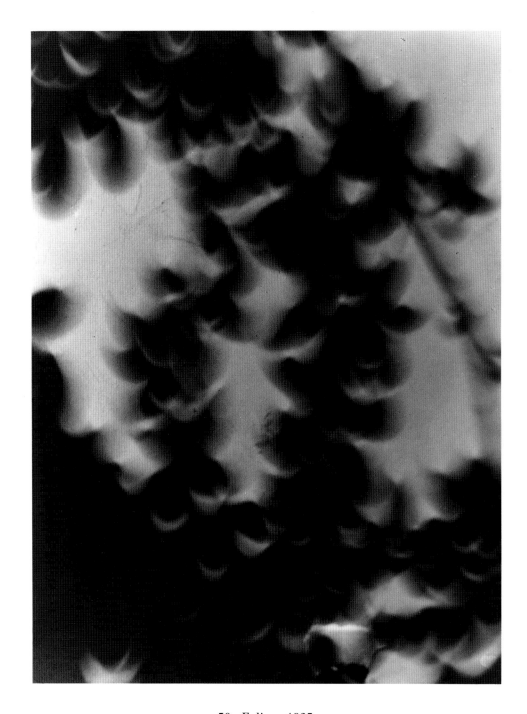

30. *Eclipse*, 1923

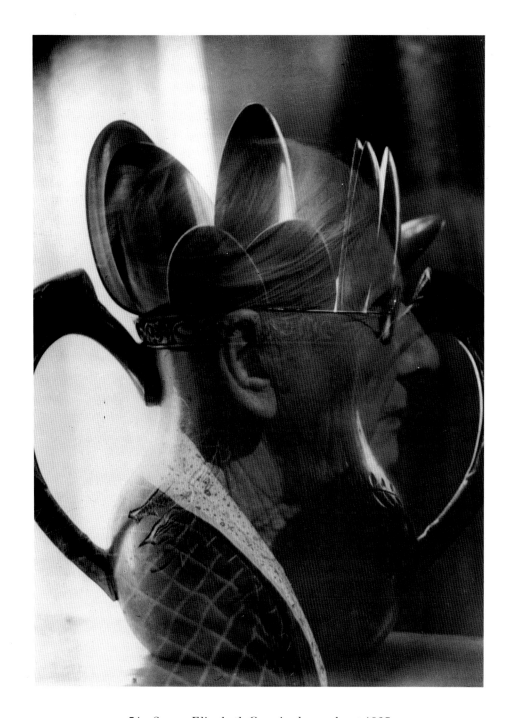

31. *Susan Elizabeth Cunningham,* about 1923

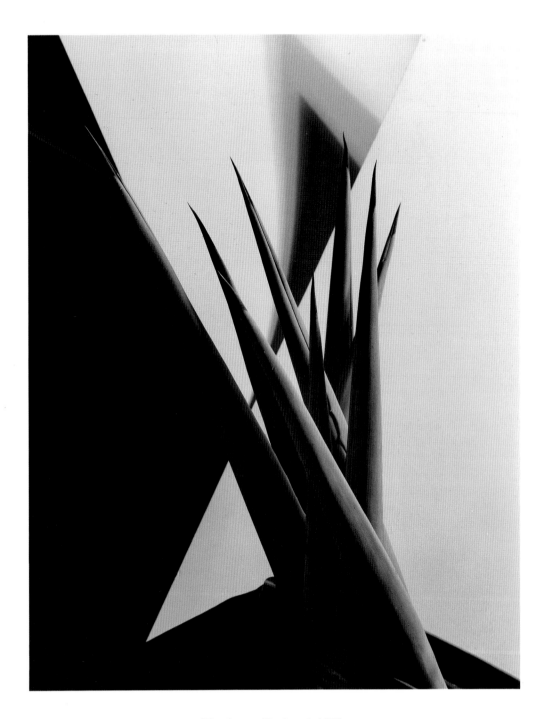

32. *Agave Design 1*, 1920s

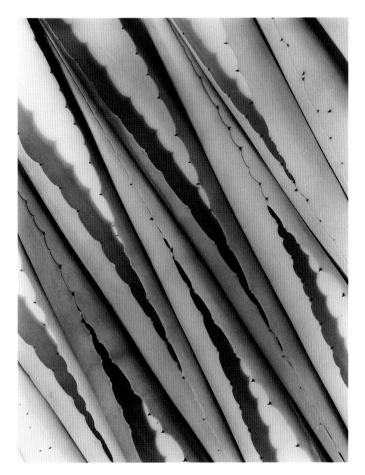

33. *Agave Design 2,* 1920s

34. *Spines,* about 1925

35. *Aloe*, 1925

36. *Water Hyacinth*, 1920s

37. *Flax*, 1920s

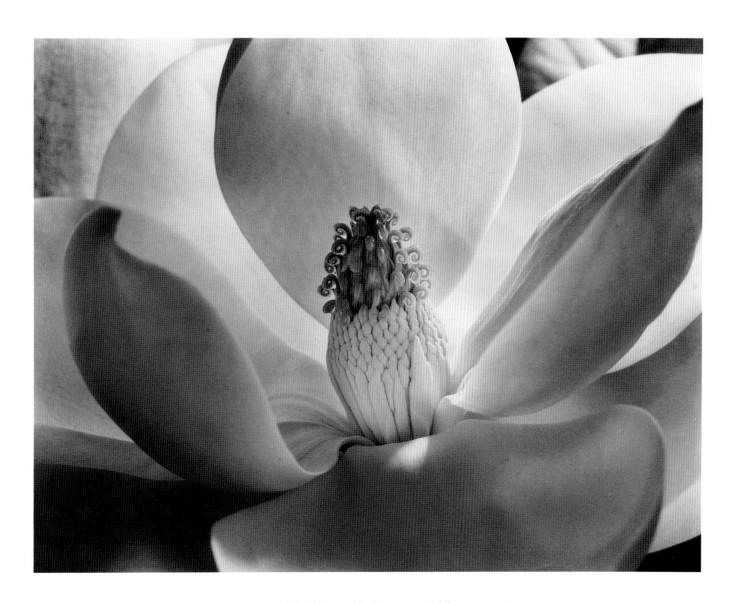

38. *Magnolia Blossom*, 1925

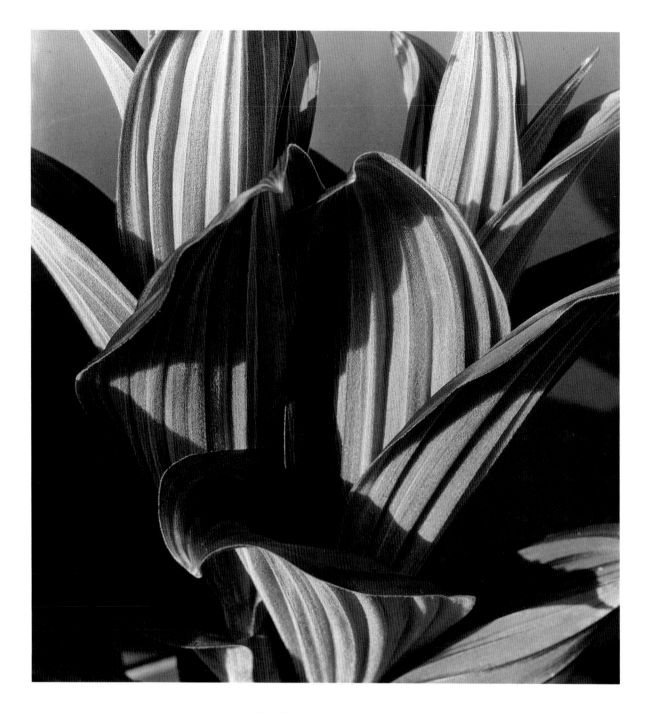

39. *False Hellebore*, 1926

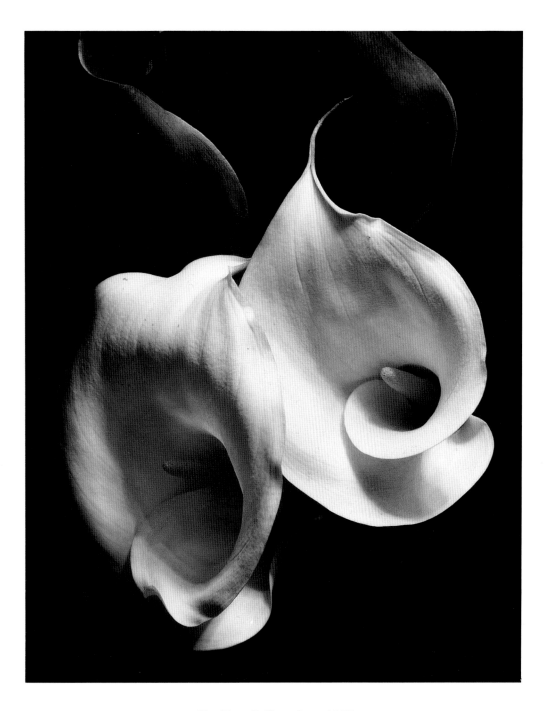

40. *Two Callas*, about 1925

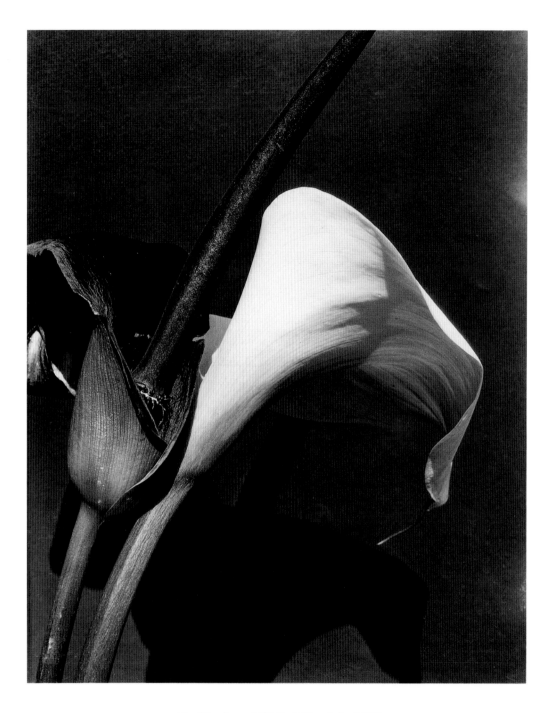

41. *Black and White Lilies*, late 1920s

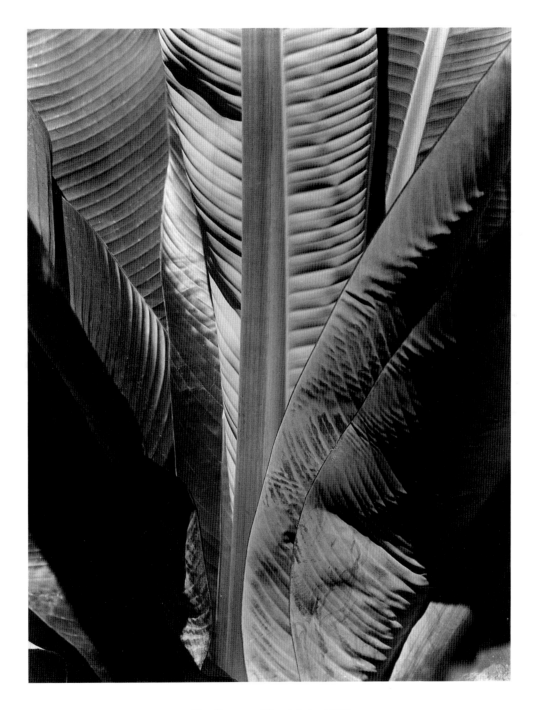

42. *Banana Plant*, late 1920s

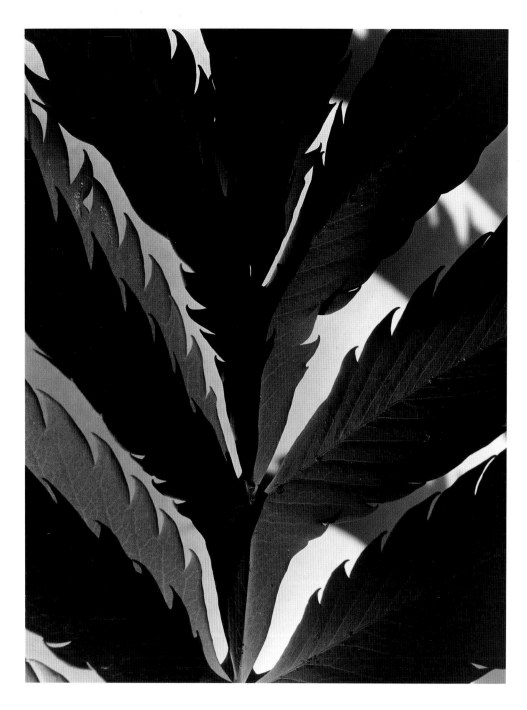

43. *Leaf Pattern*, late 1920s

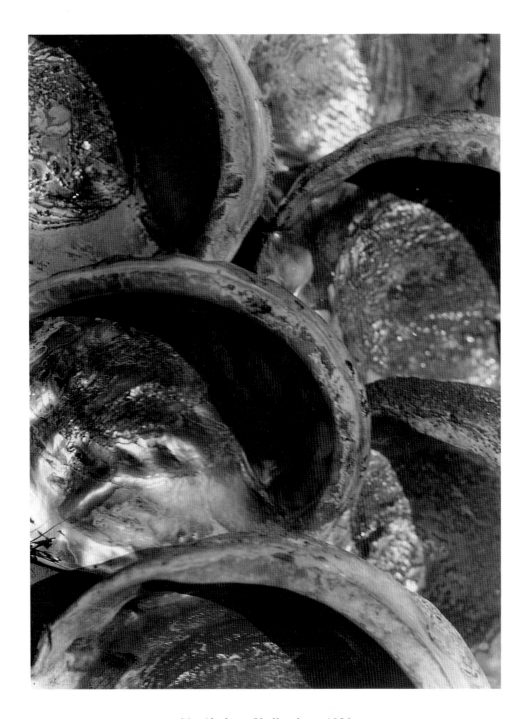

44. *Abalone Shells*, about 1926

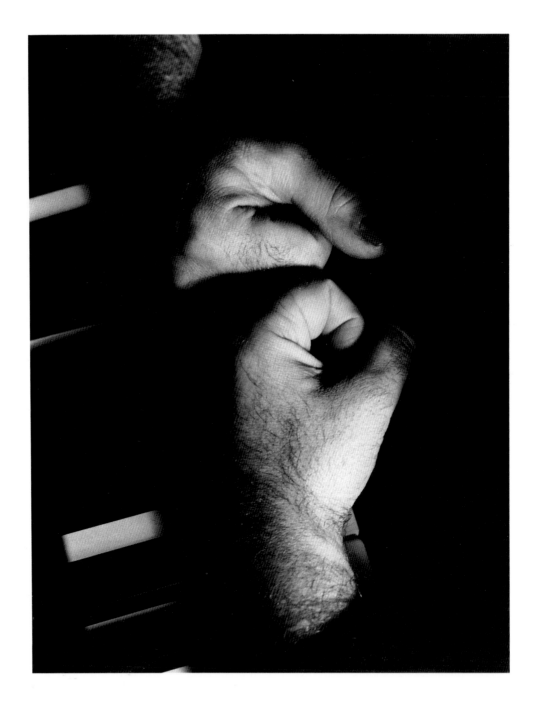

45. *Hands of Henry Cowell,* 1926

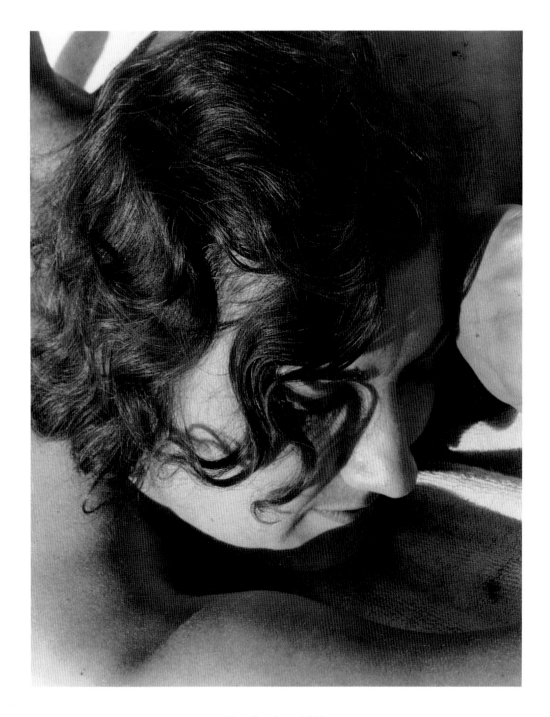

46. *Alta*, late 1920s

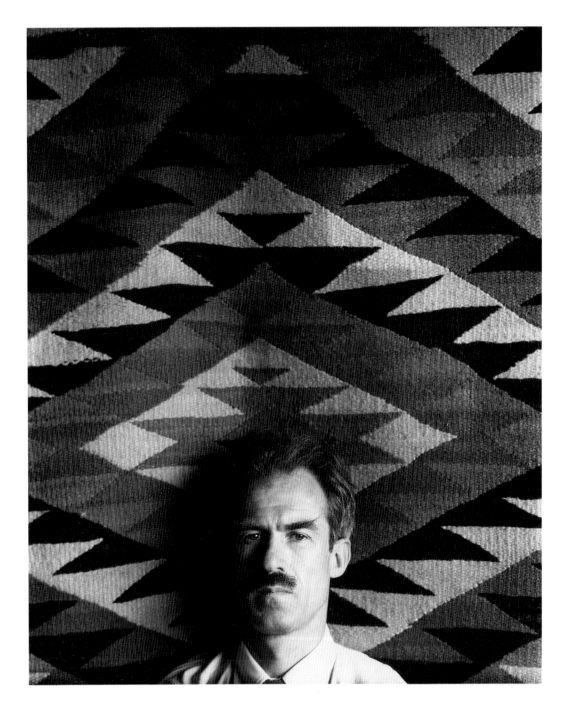

47. *Roi Partridge with Navajo Rug*, about 1927

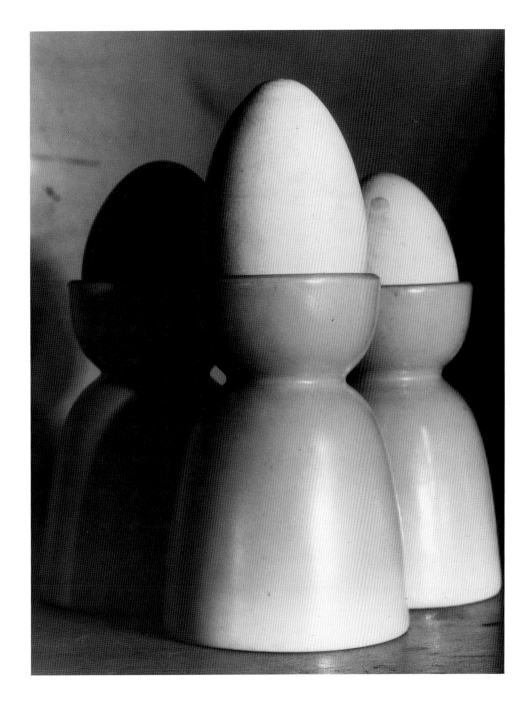

48. *Three Eggs,* about 1928

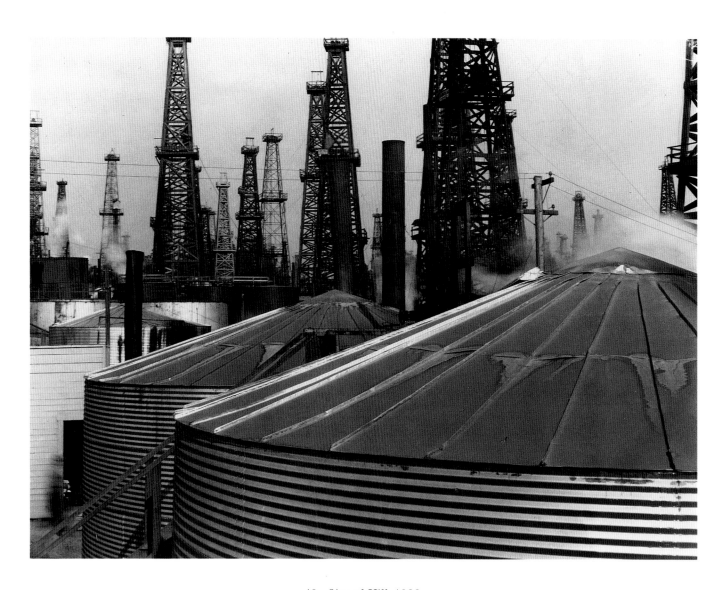

49. *Signal Hill*, 1928

50. *Shredded Wheat Water Tower*, 1928

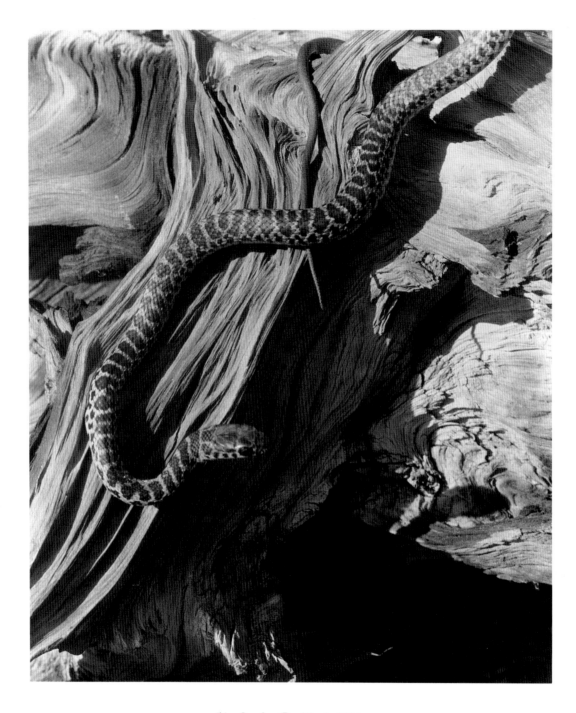

51. *Snake (Positive)*, 1921

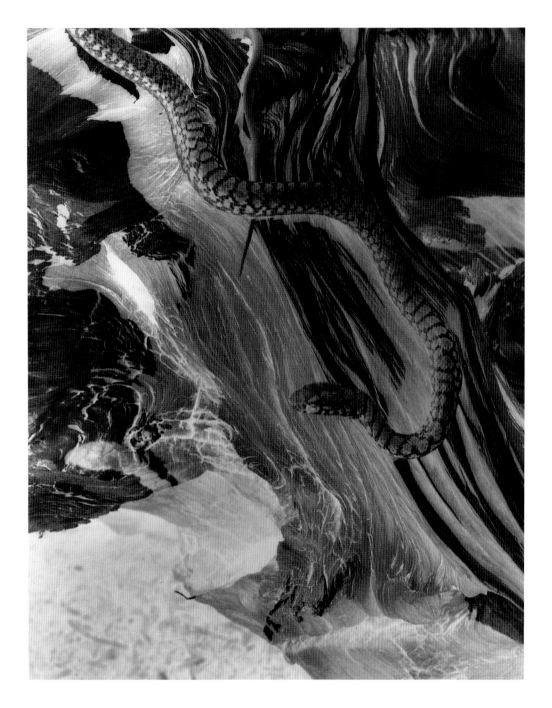

52. *Snake (Negative)*, 1927

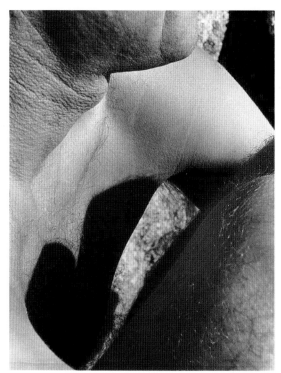

53. *Triangles*, 1928 54. *Roi Partridge*, about 1927

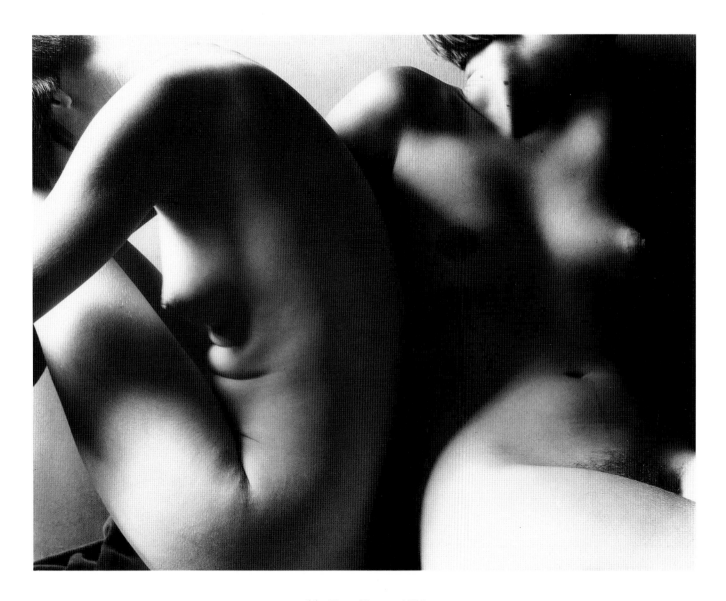

55. *Two Sisters,* 1928

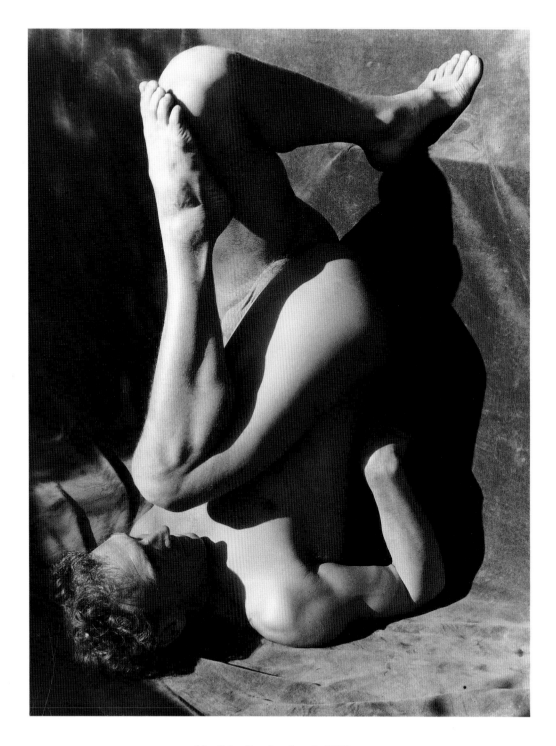

56. *John Bovingdon 2*, 1929

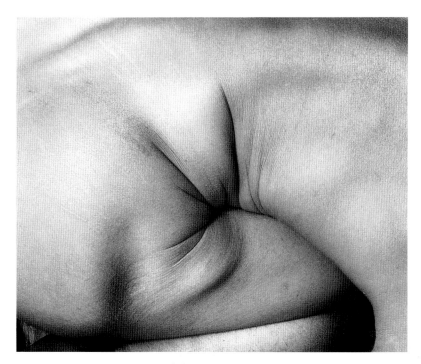

57. *Side*, 1929

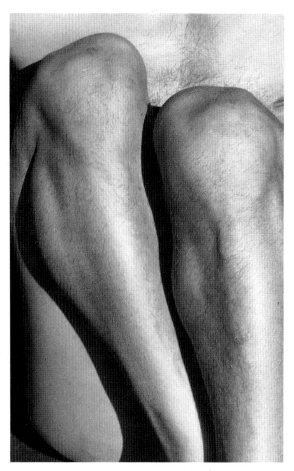

58. *John Bovingdon*, 1929

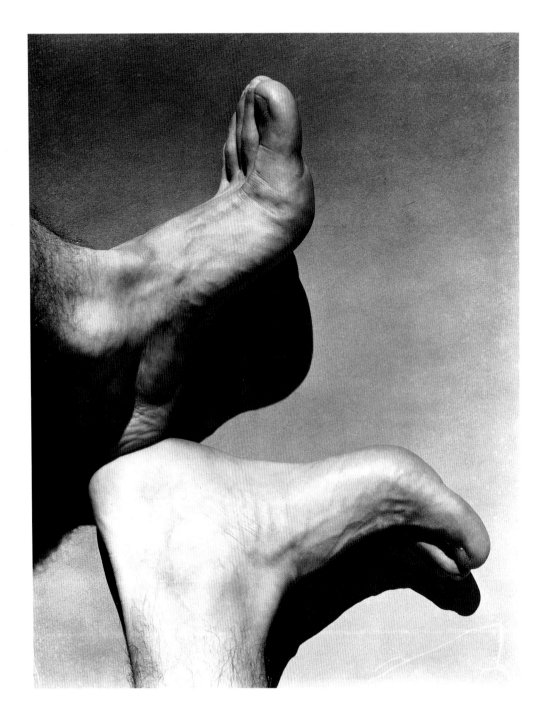

59. *Feet of Paul Maimone 2*, late 1920s

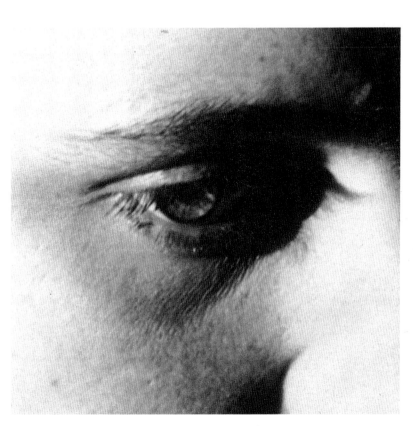

60. *Eye of Portia Hume,* about 1930

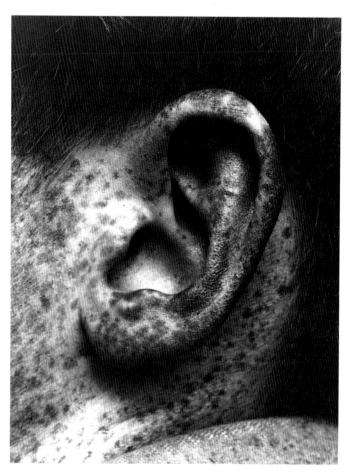

61. *Ear,* 1929

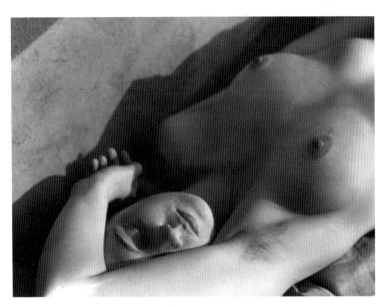

62. *Portia Hume 2*, about 1930

63. *Twins Facing Left*, about 1930

64. *Frida Kahlo*, 1931

65. *Two Holer, Yreka,* 1929

66. *Shells, 1930*

67. *Kelp*, about 1930

68. *Tree,* 1932

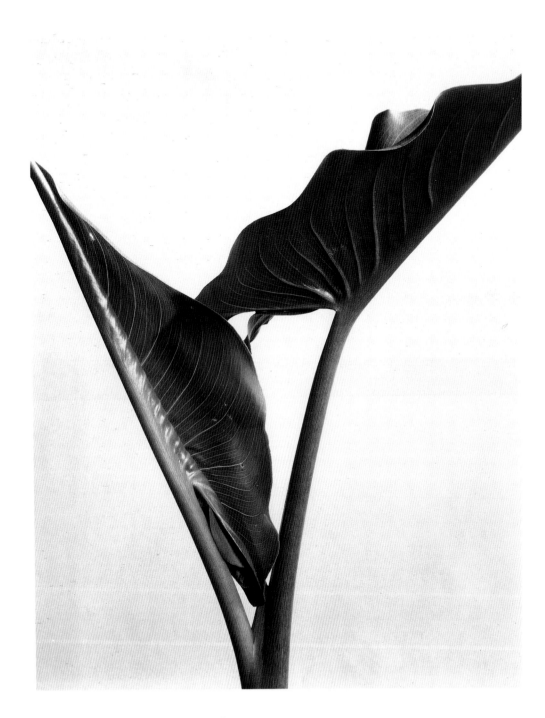

69. *Calla Leaves*, about 1930

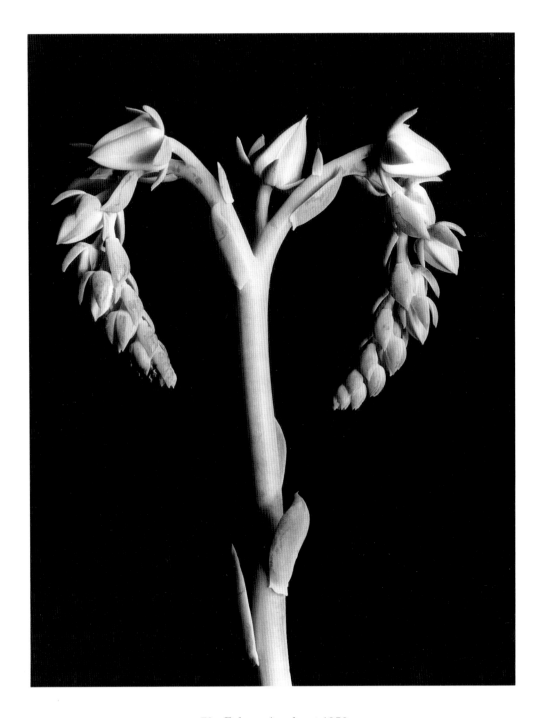

70. *Echeveria*, about 1930

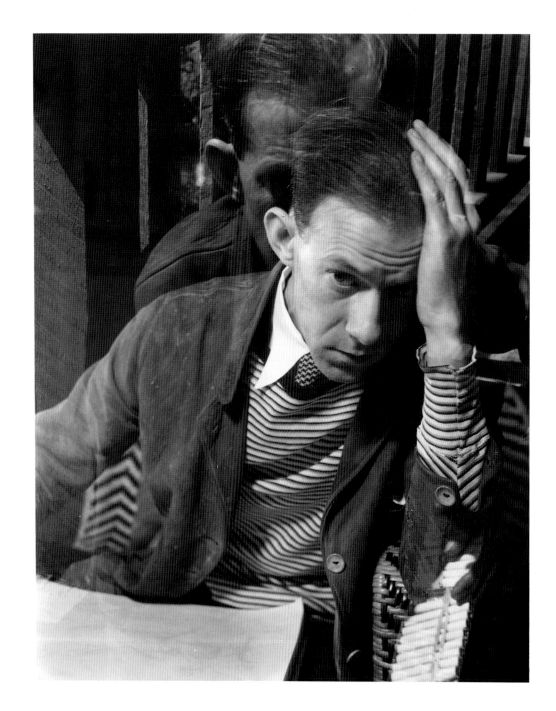

71. *Joseph Sheridan, Painter,* 1931

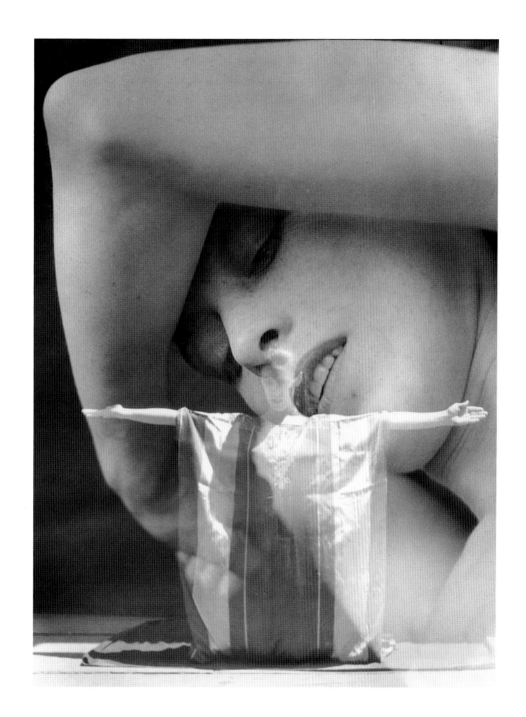

72. *Martha Graham 2*, 1931

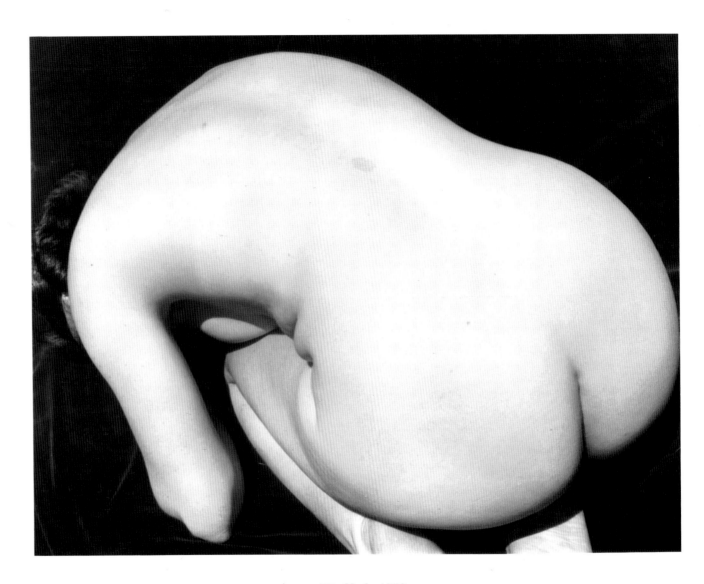

73. *Nude*, 1932

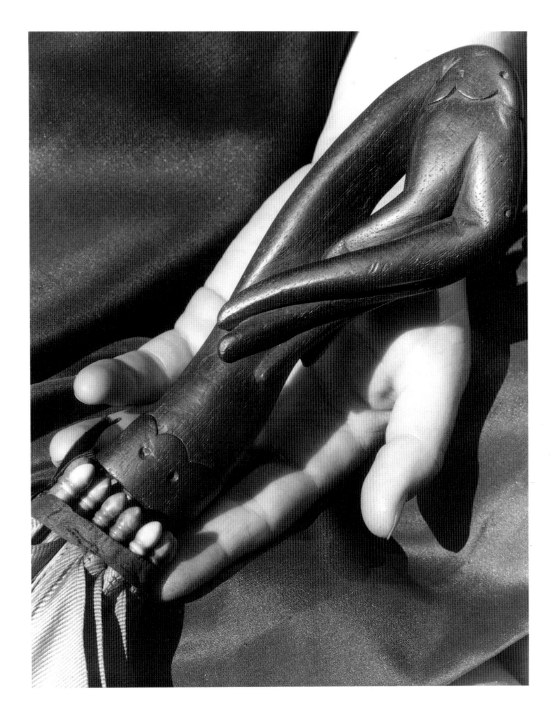

74. *Umbrella Handle and Hand,* 1932

75. *Robert Irwin, Executive Director of American*
Foundation for the Blind, 1933

76. *Marian Simpson, Painter*, 1934

77. *Under the Queensboro Bridge, 1934*

78. *Rebecca, Hume, Virginia 2*, 1934 79. *Rebecca's Boys, Hume, Virginia*, 1934

80. *Alfred Stieglitz 3*, 1934

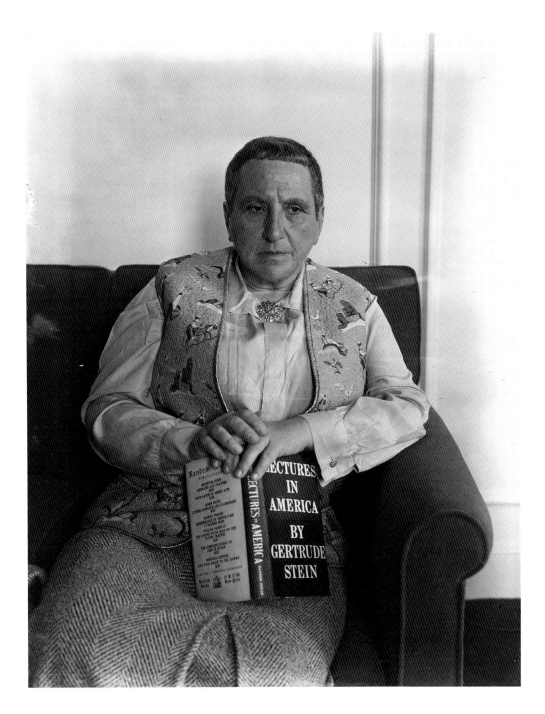

81. *Gertrude Stein, 1935*

82. *Fageol Ventilators*, 1934

83. *Helene Mayer, Fencer, 1935*

84. *Herbert Hoover with His Dog*, 1935

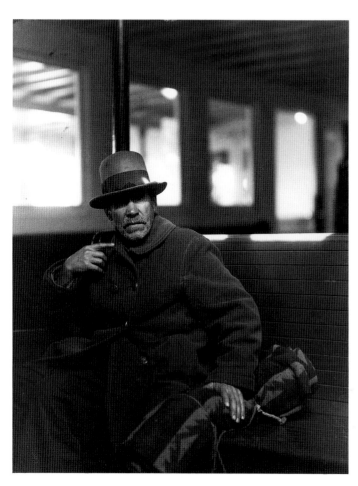

85. *On the Nickel Ferry,* about 1935

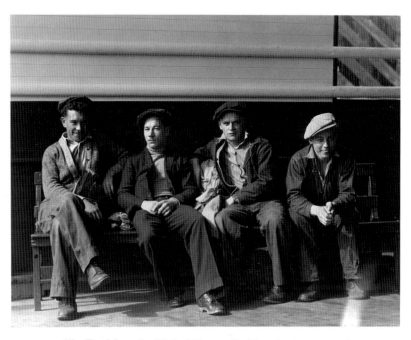

86. *Deckhands, Nickel Ferry, Oakland,* about 1935

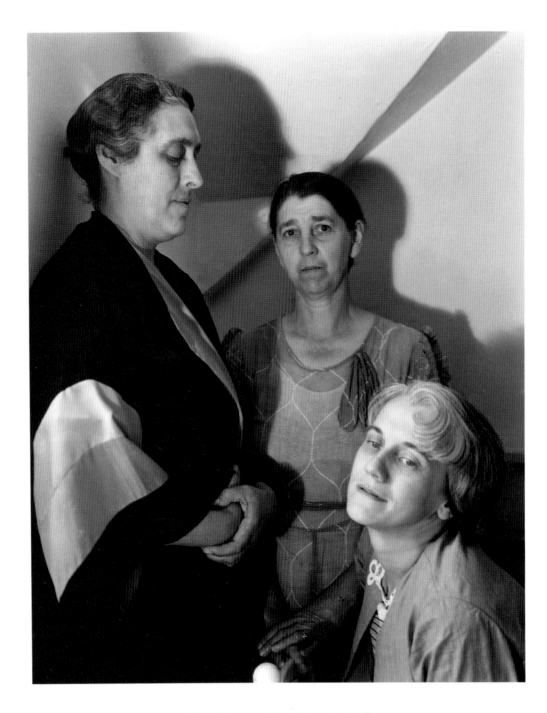

87. *Alida and Her Friends*, 1935

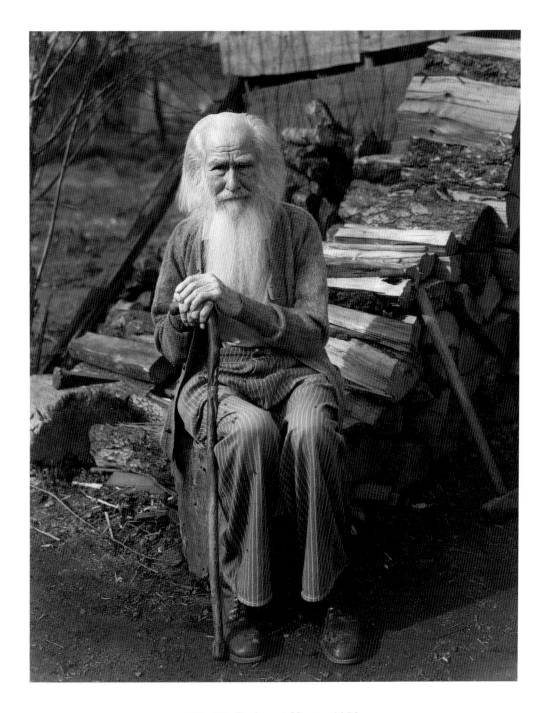

88. *My Father at Ninety*, 1936

89. *Junk*, 1935

90. *Clouds, Mount Hamilton Observatory*, 1937

91. *Mount Hamilton Observatory*, 1937

92. *Tea at Foster's*, 1940s

93. *San Francisco Evangelist Gathering the Crowd*, 1946

94. *Watchers of the Evangel Meeting, San Francisco*, 1946

95. *Pattern of Stone and Stucco, near Rough and Ready,* 1947

96. *Log on Beach*, 1948

97. *Rock, Drake's Bay*, 1955

98. *Morris Graves, Painter,* 1950

99. *Ansel Adams, Yosemite Valley,* 1953

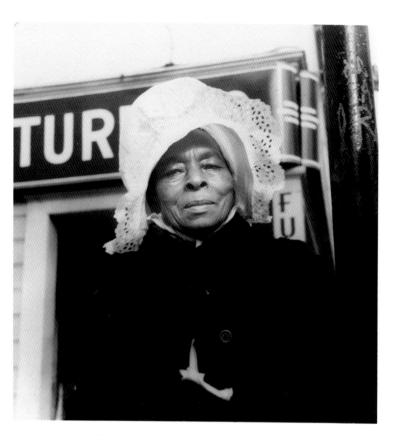

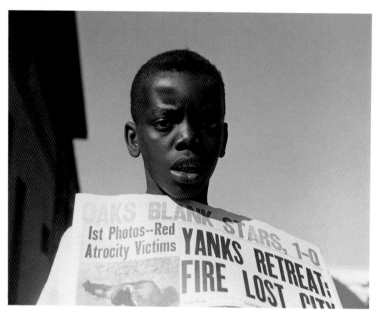

101. *Boy Selling Newspapers, San Francisco,* about 1950

100. *Sunbonnet Woman,* about 1950

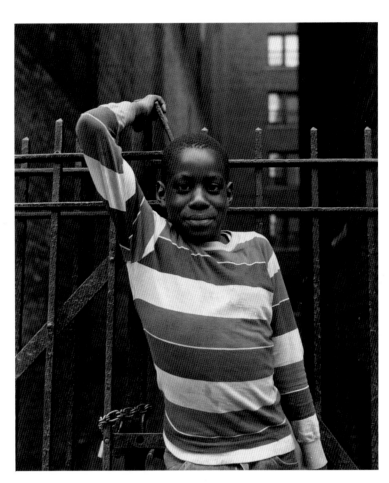

102. *Boy in New York*, 1956

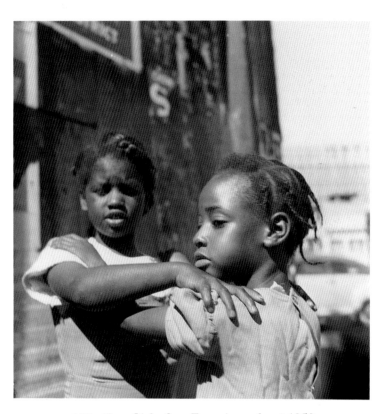

103. *Two Girls, San Francisco*, about 1950

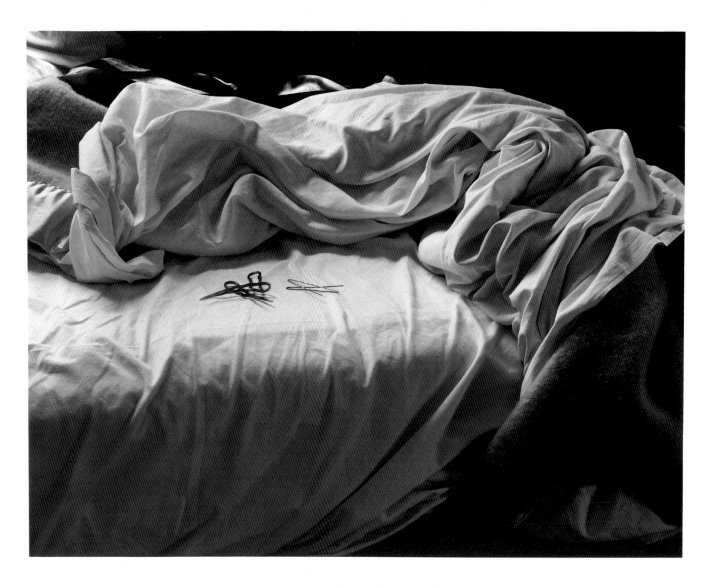

104. *The Unmade Bed*, 1957

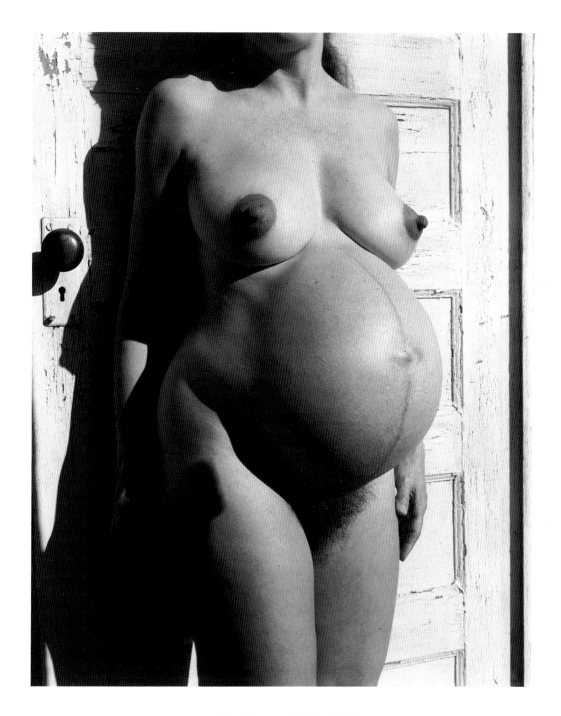

105. *Pregnant Nude,* 1959

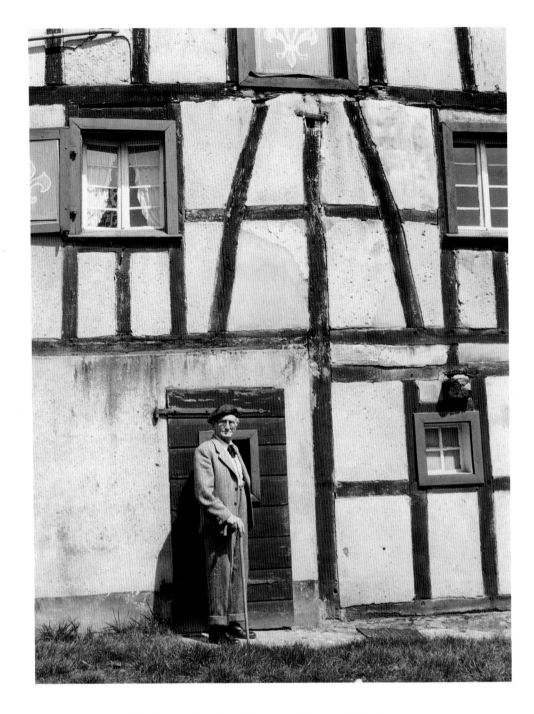

106. *August Sander, Photographer, and His House,*
Leuscheid, Germany, 1960

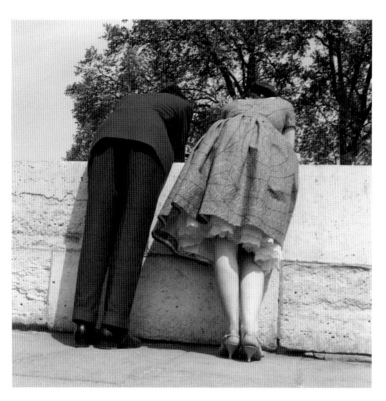

107. *Paris Street*, 1960

108. *People on the Road, Germany*, 1960

109. *Self-portrait, Denmark*, 1961

110. *Twins, Poland,* 1961

111. *Reflection at Sudbury Hill, England, 1960*

112. *Cars with Raindrops, Holmen Kollen, Norway, 1961*

113. *Self-portrait, Mendocino, 1965*

114. *The Poet and His Alter Ego (James Broughton, Poet and Filmmaker),* 1962

115. *Dream Walking,* 1968

116. *Doll with Head between Legs*, about 1970

117. *Morris Graves 2*, 1973

118. *The Three Ages of Woman*, 1972

119. *Irene "Bobbie" Libarry, 1976*

120. *Feet of Irene "Bobbie" Libarry, 1976*

Chronology

1883 Born on April 12 in Portland, Oregon, to Isaac and Susan Cunningham.

ca. 1889 Moves to Seattle, Washington, with her family. Lives at 505 Ward Street until 1909.

1903–07 Studies at the University of Washington, Seattle. Majors in chemistry.

1905–06 Acquires a 4-by-5-inch format camera from a mail-order correspondence school. Takes first photographs on University of Washington campus, including a nude self-portrait out-of-doors.

1907 Writes thesis, "Modern Processes of Photography." After seeing the photographs of Gertrude Käsebier in *The Craftsman*, decides to pursue photography as a career. Graduates from University of Washington.

1907–09 Works in Seattle portrait studio of Edward S. Curtis. Learns to retouch negatives and print with platinum paper.

1909 Awarded a fellowship by her university sorority, Pi Beta Phi, to study abroad. Travels to Dresden to study photographic chemistry with Robert Luther at the Technische Hochschule. Visits the International Photographic Exposition in Dresden.

1910 Publishes her research on the substitution of lead salts for platinum in photographic printing paper in *Photographische Rundschau und Photographisches Centralblatt*. Visits Paris and London and meets Alvin Langdon Coburn. In New York, visits Alfred Stieglitz's gallery, "291," and meets Gertrude Käsebier. Returns to Seattle and opens portrait studio at 1117 Terry Avenue.

1913 Publishes "Photography as a Profession for Women" in Pi Beta Phi's journal, *The Arrow*. Corresponds with Alvin Langdon Coburn and Clarence White.

1914 One-person exhibitions at the Brooklyn Institute of Arts and Sciences and at the Portland Art Museum, Oregon. Included in the International Exhibition of Pictorial Photography, New York. Illustrated review of her work published in *Wilson's Photographic Magazine*.

1915 Marries Roi Partridge on February 11. Son, Gryffyd, born December 18. Two nude male and female studies, *Reflections* and *Eve Repentant*, reproduced in the Christmas issue of *The Town Crier*. Exhibits at Fine Arts Society, Seattle, with Roi Partridge, John Butler, and Clare Shepard. Included in Panama-Pacific International Exposition, San Francisco; Pittsburgh Salon of National Photographic Art; and Philadelphia Salon.

1916 Her nude study of Roi Partridge, *The Bather*, published in the Christmas issue of *The Town Crier*, causes sensation.

1917 Moves to San Francisco. Twin sons, Rondal and Padraic, born September 4. Family resides at 42 Lower Terrace.

1918 Works in San Francisco studio of Francis Bruguière. Meets Maynard Dixon and Dorothea Lange.

1920 Moves to 4540 Harbor View Drive, Oakland, when Roi begins teaching at Mills College. Meets Edward Weston and Johan Hagemeyer.

1921 Resumes commercial portrait business. Photographs Adolph Bolm Ballet Intime. Creates first sharp-focus nature studies, at Point Lobos, and begins to photograph plant forms.

1922 Joins the Pictorial Photographers of America.

1923 Photographs light abstractions and begins series of magnolia studies.

ca. 1923 Makes first double-exposure photograph.

1927 Creates the negative image *Snake*.

1928 Included in Pictorial Photographic Society exhibition, California Palace of the Legion of Honor, San Francisco.

1929 Exhibits at Berkeley Art Museum. Ten of her photographs included in *Film und Foto* exhibition, Stuttgart.

1931 Photographs Martha Graham in Santa Barbara and Frida Kahlo in San Francisco. *Vanity Fair* reproduces two of her Graham studies and hires her to photograph Hollywood personalities. One-person exhibition at the M. H. de Young Memorial Museum, San Francisco. Exhibits at Julien Levy Gallery, New York.

1932 One-person exhibition at the Los Angeles Museum. Exhibits with Group f.64 at the M. H. de Young Memorial Museum, San Francisco, where she was also included in *A Showing of Hands* exhibition.

1933 One-person exhibition at The Forum, Hotel Oakland, Oakland.

1934 Included in *Leading American Photographers* exhibition, Mills College Art Gallery, Oakland. Marriage to Roi Partridge ends in divorce in June. Travels to New York for *Vanity Fair*. Photographs Alfred Stieglitz and begins documentary street photography. Works with Dorothea Lange and Paul Taylor on documentary project in Oroville, California.

1935 One-person exhibition at the Dallas Art Museum. Photographs Gertrude Stein in San Francisco. Photographs for Cornish School catalogue in Seattle. Her Group f.64 statement published in *Camera Craft*.

1936 One-person exhibition at the E. B. Crocker Art Gallery, Sacramento, California.

1937 Beaumont Newhall includes her in *Photography 1839–1937* exhibition at the Museum of Modern Art, New York. Photographs with 35mm camera.

1938 Begins photographing with 2¼-by-2¼-inch format cameras.

1940 Included in *A Pageant of Photography*, Golden Gate International Exposition, Treasure Island, San Francisco.

ca. 1940 Begins photographing in color for *Sunset* magazine.

1941 Included in *Photographers Exhibition* at Mills College, Oakland.

1943 Moves to 6454 Colby Street, Berkeley, and uses Roger Sturtevant's photographic studio on Montgomery Street in San Francisco.

1946	Meets Lisette Model.
1947	Moves to 1331 Green Street, San Francisco, where she builds a darkroom and offers portrait sittings.
1947–50	Teaches at California School of Fine Arts, San Francisco.
1951	One-person exhibition at San Francisco Museum of Art.
1952	KRON-TV, San Francisco, produces documentary on Cunningham photographing blind children.
1953	One-person exhibition at Mills College Art Gallery, Oakland.
1954	Included in inaugural exhibition at Limelight Gallery, New York, and *Perceptions* at San Francisco Museum of Art.
1955	Included in Bay Area Photographers *San Francisco Weekend* exhibition at San Francisco Museum of Art. Interviewed by Herm Lenz, along with Dorothea Lange and Ansel Adams, in *U. S. Camera* article, "Interview with Three Greats."
1956	One-person exhibitions at Cincinnati Art Museum and at Limelight Gallery, New York. Photographs extensively in New York.
1957	One-person exhibition at Oakland Art Museum.
1959	Included in *Photography at Mid-Century*, George Eastman House, Rochester, New York; group exhibition at Oakland Public Museum; and *The Photograph as Poetry*, Pasadena Art Museum. Edna Tartaul Daniel interviews her for the Regional Oral History Project of the University of California, Berkeley.
1960	International Museum of Photography at George Eastman House, Rochester, New York, acquires large collection of her photographs. Travels to Berlin, Munich, Paris, and London. Meets August Sander and Paul Strand.
1961	Travels to Norway, Finland, Sweden, Denmark, Poland, and Paris. Meets Man Ray. One-person exhibition at George Eastman House, Rochester, New York.
1964	One-person exhibitions at Chicago Art Institute and San Francisco Museum of Art. Becomes honorary member of American Society of Magazine Photographers. Experiments with Polaroid film. *Aperture* devotes its winter issue to her work. The Library of Congress acquires a large collection of her photographs.
1965	One-person exhibition at Henry Art Gallery, University of Washington, Seattle. Included in *Six Photographers 1965* at the College of Fine and Applied Arts, University of Illinois, Urbana.
1965–67	Teaches at San Francisco Art Institute.
1966	Featured in Fred Padula film, *Two Photographers: Imogen Cunningham and Wynn Bullock*.
1967	Elected a fellow of the American Academy of Arts and Sciences. One-person exhibition at Stanford Art Gallery, Stanford University, California. Appears in James Broughton's film, *The Bed*.
1968	Receives honorary Doctor of Fine Arts degree from California College of Arts and Crafts, Oakland. One-person exhibitions at Museum of History and Technology, Smithsonian Institution, Washington, D.C.; Carl Siembab Gallery, Boston; and California College of Arts and Crafts, Oakland. Included in *North Beach and the Haight-Ashbury* exhibition, Focus Gallery, San Francisco. Teaches summer session at Humboldt State College.
1970	One-person exhibitions at M. H. de Young Memorial Museum, San Francisco, and Witkin Gallery, New York. Receives a Guggenheim Fellowship to print her early negatives. John Korty films *Imogen Cunningham: Photographer*. University of Washington Press publishes *Imogen Cunningham: Photographs*. The Smithsonian Institution purchases a major collection of her work. San Francisco Mayor Joseph Alioto proclaims November 12 "Imogen Cunningham Day." *Album* magazine publishes a portfolio of her images.
1971	One-person exhibitions at Atholl McBean Gallery of the San Francisco Art Institute; 831 Gallery, Birmingham, Michigan; and Seattle Art Museum. *Creative Camera* publishes a portfolio of her images.
1972	Included in Group f.64 exhibition at University Art Museum, University of New Mexico, Albuquerque. One-person exhibition at Ohio Silver Gallery, Los Angeles.
1973	Teaches at San Francisco Art Institute. San Francisco Art Commission declares her "Artist of the Year." One-person exhibitions at Metropolitan Museum of Art, New York; Witkin Gallery, New York; and San Francisco Art Commission "Capricorn Asunder" Gallery. Included in International Exhibition of Photography, Arles, France. *Images of Imogen* exhibition at Focus Gallery, San Francisco. Begins After Ninety project on old age.
1974	Receives University of Washington's Alumnus Summa Laude Dignatus award. University of Washington Press publishes *Imogen!* Cunningham donates selected papers to the Archives of American Art, Smithsonian Institution. One-person exhibitions at Henry Art Gallery, University of Washington, Seattle, and Oakland Museum. Profiled on KRON-TV "30 Minutes Assignment Four" program.
1975	Creates the Imogen Cunningham Trust on February 14 to continue the preservation, exhibition, and promotion of her work. *Camera* magazine issues "Homage to Imogen" in October. One-person exhibitions at John Berggruen Gallery, San Francisco; Chevron Gallery, San Francisco; and Occidental Center Gallery, Los Angeles. Included in *Women of Photography* exhibition at San Francisco Museum of Art. Receives honorary Doctor of Fine Arts degree from Mills College, Oakland.
1976	Appears on Tonight television show with Johnny Carson and is profiled in CBS documentary. One-person exhibitions at Stanford Art Gallery, Stanford University, California; Strybing Arboretum, San Francisco; and Grapestake Gallery, San Francisco. Dies on June 23.

Selected Bibliography

I. Archival Material

Major Collections

Imogen Cunningham Archives, The Imogen Cunningham Trust, Berkeley, Calif. Includes Cunningham's original photographs and negatives; correspondence; lecture notes and unpublished writings, including a 1911 history of photography as an art form; scrapbooks and memorabilia; business records; books, exhibition catalogues, and periodicals; audio tapes of interviews and transcripts; photographs of Cunningham by others; fine photographs by others.

Imogen Cunningham Papers, Archives of American Art, Smithsonian Institution, Washington, D.C. Includes correspondence, biographical material, interview transcripts.

Other Collections

Center for Creative Photography, University of Arizona, Tucson. Material relating to Cunningham can be found in the papers of Ansel Adams, Wynn Bullock, George Craven, Helen Gee, Edward Weston, and Lee Witkin.

International Museum of Photography at George Eastman House, Rochester, N.Y.

Margery Mann Papers, Archives of American Art, Smithsonian Institution, Washington, D.C.

Mills College Art Gallery, Mills College, Oakland, Calif. Exhibition files.

Roi Partridge Collection, The Bancroft Library, University of California, Berkeley, Calif.

II. Writings by Imogen Cunningham

"Modern Processes of Photography." Thesis, University of Washington, 1907.

"Über Selbstherstellung von Platinpapieren für braune Töne." *Photographische Rundschau und Photographisches Centralblatt* (Halle, Germany) 24, no. 9 (1910), pp. 101–105.

"Photography as a Profession for Women." *The Arrow* (Pi Beta Phi) 29, no. 2 (Jan. 1913), pp. 203–209.

"Is It Art?" In "What Some Folks Think about Art, A Symposium of Ideas by Seattle Artists Who Speak with Authority." *The Town Crier* (Seattle) 10, no. 14 (April 3, 1915), p. 7.

"Imogen Cunningham" (statement). In John Paul Edwards, "Group f.64." *Camera Craft* (San Francisco) 42, no. 3 (March 1935), p. 113.

"Sometimes I Wonder." *Spectator* (Junior League of San Francisco), Feb. 1952, pp. 6–7.

III. Monographs and Books of Photographs by Imogen Cunningham

White, Minor, ed. "Imogen Cunningham." *Aperture* 11, no. 4 (1964).

Imogen Cunningham: Photographs. Seattle: University of Washington Press, 1970.

Imogen! Imogen Cunningham, Photographs 1910–1973. Seattle: Henry Art Gallery and University of Washington Press, 1974.

After Ninety. Seattle: University of Washington Press, 1977.

Dater, Judy. *Imogen Cunningham: A Portrait.* Boston: New York Graphic Society, 1979.

Campbell, John Carden. *2 Dogs +.* Sausalito, Calif.: Deer Creek Press, 1984.

Rule, Amy, ed. *Imogen Cunningham, Selected Texts and Bibliography.* Essay by Richard Lorenz. Oxford: Clio Press, 1992.

IV. Exhibition Catalogues

Internationale Ausstellung des Deutschen Werkbunds: Film und Foto. Stuttgart, 1929.

"'Impressions in Silver' by Imogene [*sic*] Cunningham." *Los Angeles Museum Art News*, April 1932.

A Pageant of Photography. San Francisco: Golden Gate International Exposition, 1940.

Photography at Mid-Century: 10th Anniversary Exhibition. Rochester, N.Y.: George Eastman House, 1959.

Craven, George. *The Group f/64 Controversy: An Introduction to the Henry F. Swift Memorial Collection of the San Francisco Museum of Art.* San Francisco: San Francisco Museum of Art, 1963.

Doty, Robert M., ed. *Photography in America, 1850–1965.* New Haven, Conn.: Yale University Art Gallery, 1965.

Six Photographers 1965: An Exhibition of Contemporary Photography. Urbana, Ill.: College of Fine and Applied Arts, University of Illinois, Urbana, 1965.

Imogen Cunningham, Photographs 1921–1967. Foreword by Beaumont Newhall. Stanford, Calif.: Stanford Art Gallery, Stanford University, 1967.

Lyons, Nathan. *Photography in the Twentieth Century.* New York: Horizon Press and George Eastman House, 1967.

Women, Cameras, and Images I: Imogen Cunningham. Washington, D.C.: Museum of History and Technology, Smithsonian Institution, 1968.

Photo Eye of the '20s. Introduction by Beaumont Newhall. Rochester, N.Y.: George Eastman House and the Museum of Modern Art, 1971.

Group f/64. Albuquerque, N.M.: Fine Arts Center, University of New Mexico Art Museum, 1972.

Imogen Cunningham: Recent Photographs. San Francisco: Art Commission "Capricorn Asunder" Gallery, 1973.

Massar, Phyllis Dearborn. *Photographs by Imogen Cunningham.* New York: Metropolitan Museum of Art, 1973.

Doty, Robert, ed. *Photography in America.* Introduction by Minor White. New York: Whitney Museum of American Art and Random House, 1974.

Imogen Cunningham: Photographs 1910–1973. San Francisco: Chevron Gallery, 1975.

Imogen! Imogen Cunningham, Photographs 1910–1973. Los Angeles: Occidental Center Gallery, 1975.

Women of Photography: An Historical Survey. San Francisco: San Francisco Museum of Art, 1975.

American Photography: Past into Present. Prints from the Monsen Collection of American Photography. Seattle: Seattle Art Museum, 1976.

Campbell, Sara, ed. *The Blue Four: Galka Scheyer Collection*. Pasadena, Calif.: Norton Simon Museum of Art, 1976.

Travis, David. *Photographs from the Julien Levy Collection, Starting with Atget*. Chicago: Art Institute of Chicago, 1976.

Brown, Milton. *The Modern Spirit: American Painting 1908–1935*. Arts Council of Great Britain. Edinburgh: Royal Scottish Academy; London: Hayward Gallery, 1977.

Photographs from the Julien Levy Collection. New York: The Witkin Gallery, 1977.

Tucker, Jean S., ed. *Group f.64*. St. Louis: University of Missouri-St. Louis, 1978.

Photography Rediscovered: American Photographs, 1900–1930. New York: Whitney Museum of American Art, 1979.

Haenlein, Carl. *1920 Amerika Fotografie 1940: Zwischen Hollywood und Harlem*. Hannover: Kestner-Gesellschaft, 1980.

Southern California Photography 1900–65, An Historical Survey. Los Angeles: The Photography Museum, 1980.

West-Coast Pictorialism: Etchings and Photographs by Roi Partridge and Imogen Cunningham. Laguna Beach, Calif.: Laguna Beach Museum of Art, 1980.

American Photographers and the National Parks: A Catalog of the Exhibition. Washington, D.C.: National Park Foundation, 1981.

A Show of Hands: Photographs from the Keoshian Collection. San Francisco: San Francisco Museum of Modern Art, 1981.

Travis, David. *Photography in Chicago Collections*. Chicago: Art Institute of Chicago, 1982.

Tsujimoto, Karen. *Images of America: Precisionist Painting and Modern Photography*. San Francisco: San Francisco Museum of Modern Art, 1982.

The Photography of Imogen Cunningham: A Centennial Selection. New York: American Federation of the Arts, 1983.

Ackley, Clifford S. *Photographic Viewpoints: Selections from the Collection, Museum of Fine Arts, Boston*. Boston: Museum of Fine Arts, 1984.

Imogen Cunningham. Santa Cruz, Calif.: Art Museum of Santa Cruz County, 1984.

Billeter, Erika, ed. *Self-portrait in the Age of Photography: Photographers Reflecting Their Own Image*. Bern: Benteli Verlag, 1985.

Modernist Masterworks to 1925. From "the deLIGHTed eye," a Private Collection. New York: International Center of Photography, 1985.

A Personal View: Photography in the Collection of Paul F. Walter. New York: Museum of Modern Art, 1985.

Signs of the Times: Some Recurring Motifs in Twentieth-Century Photography. San Francisco: San Francisco Museum of Modern Art, 1985.

Coke, Van Deren, and Diana C. du Pont. *Photography: A Facet of Modernism*. New York: Hudson Hills Press and San Francisco Museum of Modern Art, 1986.

Lingwood, James, ed. *Staging the Self: Self-portrait Photography 1840s–1980s*. London: National Portrait Gallery, 1986.

Botanica: Photographies de végétaux aux XIXe et XXe siècles. Paris: Centre National de la Photographie, 1987.

La danza moderna di Martha Graham. Reggio Emilia, Italy: Teatro Municipale Valli, 1987.

Garner, Gretchen. *Reclaiming Paradise: American Women Photograph the Land*. Duluth, Minn.: Tweed Museum of Art, University of Minnesota, Duluth, 1987.

Lorenz, Richard. *Imogen Cunningham, Frontiers: Photographs 1906–1976*. Berkeley, Calif.: Imogen Cunningham Trust and United States Information Agency, 1987.

Of People and Places: The Floyd and Josephine Segel Collection of Photography. Milwaukee, Wis.: Milwaukee Art Museum, 1987.

Weiermair, Peter. *Il nudo maschile nella fotografia del XIX e del XX sec.* Ravenna, Italy: Edizioni Essegi and Pinacoteca Communale, 1987.

After the Manner of Women: Photographs by Käsebier, Cunningham, and Ulmann. Malibu, Calif.: J. Paul Getty Museum, 1988.

American Photographers: Loan Exhibition from The National Museum of Modern Art, Kyoto. Shibuya: Shoto Museum of Art, 1988.

Foster, Alasdair, with Roberta McGrath. *Behold the Man: The Male Nude in Photography*. Edinburgh, Scotland: Stills Gallery, 1988.

Lorenz, Richard. *Imogen Cunningham, Fronteras: Fotografías 1906–1976*. Madrid: Círculo de Bellas Artes, 1988.

Parallels and Contrasts: Photographs from the Stephen White Collection. Beverly Hills, Calif.: Stephen White Editions, 1988.

Vintage Photographs by Women of the '20s and '30s. Chicago: Edwynn Houk Gallery, 1988.

Focus: Photographs from the Collection of Helen Johnston. Santa Clara, Calif.: De Saisset Museum, Santa Clara University, 1989.

Greenough, Sarah, Joel Snyder, David Travis, and Colin Westerbeck. *On the Art of Fixing a Shadow: One Hundred and Fifty Years of Photography*. Washington, D. C.: National Gallery of Art, 1989.

Hambourg, Maria Morris, and Christopher Phillips. *The New Vision: Photography between the World Wars. Ford Motor Company Collection at the Metropolitan Museum of Art*. New York: Metropolitan Museum of Art and Harry N. Abrams, 1989.

Heyman, Therese Thau. *Picturing California: A Century of Photographic Genius*. San Francisco: Chronicle Books and Oakland Museum, 1989.

Lorenz, Richard. *Imogen Cunningham, Grenzen: Fotografien 1906–1976*. Berlin: Zentrum für Kunstausstellungen der DDR, 1989.

The Eclectic Spirit: Imogen Cunningham. Glasgow: Glasgow Museum, Kelvingrove, 1990.

Heyman, Therese Thau, ed. *Seeing Straight: The f.64 Revolution in Photography*. Oakland, Calif.: Oakland Museum, 1992.

Watkins to Weston: 101 Years of California Photography 1849–1950. Santa Barbara, Calif.: Santa Barbara Museum of Art and Roberts Rinehart Publishers, 1992.

V. Interviews

Lenz, Herm. "Interview with Three Greats: Lange, Adams, Cunningham." *U. S. Camera* 18 (Aug. 1955), pp. 84–87.

Daniel, Edna Tartaul. "Imogen Cunningham: Portraits, Ideas, and Design" (transcript of 1959 interview). Berkeley, Calif.: Regional Cultural History Project, General Library, University of California, Berkeley, 1961.

Diamondstein, Barbaralee. *Open Secrets: Ninety-four Women in Touch with Our Time*. New York: Viking Press, 1972. Pp. 79–84.

Jacobs, Mimi. "Imogen." *Pacific Sun*, Aug. 23–29, 1973, pp. 9–10.

Hill, Paul, Thomas Cooper, Diane Wiseman, and Judy Dater. "Homage to Imogen." *Camera* 54, no. 10 (Oct. 1975), pp. 5–44.

Leeson, George. "An Exclusive Interview with Imogen Cunningham." *Second Spring* (Aug.–Sept. 1975).

Conrad III, Barnaby. "Photography: An Interview." *Art in America* 65 (May 1977), pp. 42–45.

Danziger, James, and Barnaby Conrad III. *Interviews with Master Photographers*. New York: Paddington Press, 1977. Pp. 38–54.

Hill, Paul, and Thomas Cooper. *Dialogue with Photography*. New York: Farrar, Straus, Giroux, 1979. Pp. 293–311.

VI. Articles

Halderman, E. Isabelle. "Successful Seattle Business Woman: Miss Imogene [sic] Cunningham." *Seattle Post-Intelligencer* (date unknown, 1913), p. 2.

Lee, Alan W. S. "Imogen Cunningham and Her Work." *The Arrow* (Pi Beta Phi) 29, no. 2 (Jan. 1913), pp. 199–202.

Raftery, John H. "An Artist of the Camera: A Brief Account of the Work of Imogen Cunningham of Seattle." *Seattle Post-Intelligencer Magazine*, May 11, 1913, p. 6.

Ross, Helen. "Coming to the Front, No. 10: Imogen Cunningham." *The Town Crier* (Seattle) 8, no. 15 (April 12, 1913), p. 5.

Maschmedt, Flora Huntley. "Imogen Cunningham—An Appreciation." *Wilson's Photographic Magazine* 51, no. 3 (March 1914), pp. 96ff.

Ballard, Adele M. "Seattle Artists and Their Work." *The Town Crier* 9, no. 51 (Dec. 19, 1914), pp. 23–31.

———. "With the Fine Art Folk" (review). *The Town Crier* 10, no. 45 (Nov. 6, 1915), p. 13.

———. "Some Seattle Artists and Their Work." *The Town Crier* 10, no. 51 (Dec. 18, 1915), pp. 25–36.

———. "Imogen Cunningham Partridge, An Appreciation." *The Town Crier* 11, no. 1 (Jan. 1, 1916), p. 13.

———. "Some Seattle Artists and Their Work." *The Town Crier* 11, no. 51 (Dec. 16, 1916), pp. 26–37.

Cravens, Junius. "Art in Photography" (review). *The Argonaut*, Oct. 12, 1929, p. 16.

Lehre, Florence. "Artists and Their Work" (review). *Oakland Tribune*, Oct. 27, 1929.

Weston, Edward. "Imogen Cunningham, Photographer." *The Carmelite*, April 17, 1930, p. 7.

Cravens, Junius. "The Art World" (review). *The Argonaut*, Dec. 25, 1931, p. 8.

Adams, Ansel E. "Photography" (review). *The Fortnightly* 1, no. 12 (Feb. 12, 1932), p. 26.

Cravens, Junius. "The Art World: Hands Up!" (review). *The Argonaut*, June 10, 1932, p. 14.

———. "The Art World: Sharp Focus" (review). *The Argonaut*, Dec. 2, 1932, p. 18.

"Camera Art" (review). *The Piedmonter* 18, no. 4 (Jan. 27, 1933), p. 1.

"The Intellectual Climate of San Francisco." *Harper's Bazaar*, no. 2822 (Feb. 1947), pp. 220–23.

Berding, Christina. "Imogen Cunningham and the Straight Approach." *Modern Photography* 15, no. 5 (May 1951), pp. 36ff.

Frankenstein, Alfred. "The Local Art Galleries" (review). *San Francisco Chronicle*, May 6, 1951.

Deschin, Jacob. "Portraits on View: From the Human Angle" (review). *New York Times*, May 13, 1956.

Hart, John Barkley. Review. *Village Voice*, June 6, 1956.

Baker, George. "Photography: The Cunningham Magic on Display" (review). *San Francisco Chronicle*, Nov. 17, 1957.

White, Minor. "An Experiment in 'Reading' Photographs: A Consolidation of Readings by Students at the Rochester Institute of Technology." *Aperture* 5 (1957), pp. 51ff.

Review. *Aperture* 7, no. 3 (1959), pp. 128–30.

Hall, Norman. "Imogen Cunningham: Sixty Years in Photography." *Photography* (London) 15 (May 1960), pp. 20–25.

Latour, Ira. "West Coast Photography: Does It Really Exist?" *Photography* (London) 15 (May 1960), pp. 26–45.

Seidkin, Phyllis. "Remarkable Imogen Cunningham." *San Francisco Examiner, People, The California Weekly*, Sunday, July 5, 1964, pp. 8–10.

M[anning], H[arvey]. "Imogen Cunningham—Photographer." *Alumnus* (University of Washington Alumni Association) 55, no. 3 (Spring 1965), pp. 28–33.

Mann, Margery. "Imogen Cunningham." *Infinity* 40, no. 11 (Nov. 1966), pp. 4ff.

Adams, Gerald. "85 and Where It's At." *San Francisco Sunday Examiner and Chronicle, California Living*, March 23, 1969, pp. 6–8.

Borden, Elizabeth. "Imogen Cunningham." *U. S. Camera World Annual 1970* (1969), pp. 60ff.

"Famed Photographer, Octogenarian, Has Poetic Approach with Camera." *The Arrow* (Pi Beta Phi) 86, no. 4 (Summer 1970), pp. 9–11.

Frankenstein, Alfred. "Imogen Cunningham's Career: A History of Photography." *San Francisco Chronicle*, Nov. 19, 1970.

Hamilton, Mildred. "The Prestigious Guggenheim Awards: The Winning Women." *San Francisco Examiner*, Sunday, May 3, 1970, Women section.

"Imogen Cunningham at De Young." *Artweek* 1, no. 41 (Nov. 28, 1970), p. 7.

Jay, Bill. "Imogen Cunningham." *Album* (London) 5 (June 1970), pp. 22–38.

Alston, Elizabeth. "Imogen Cunningham: Portrait of a Candid Cook." *Look*, Feb. 9, 1971, pp. 36–37.

Frankenstein, Alfred. "'The History of My Life': Romanticism to Reality" (review). *San Francisco Chronicle*, Aug. 19, 1971.

Murray, Joan. "History of a Life." *Artweek* 2, no. 29 (Sept. 4, 1971), p. 9.

[Osman, Colin]. "Photographs by Imogen Cunningham." *Creative Camera* (London), no. 85 (July 1971), pp. 222–31.

"Imogen Cunningham." *Modern Photography Annual 73* (1972), pp. 150–55.

"Photographs of Women." *Camera* (Switzerland) 51 (Feb. 1972), p. 31.

Zellerbach, Merla. "What Is the Price of Fame." *San Francisco Chronicle*, Oct. 23, 1972.

Coleman, A. D. "Photography: Cunningham—Still Going Strong." *New York Times*, Sunday, May 6, 1973, sec. 2.

Crawford, Mary. "Clicking Along with Candid Imogen." *San Francisco Examiner*, Aug. 16, 1973.

Frankenstein, Alfred. "Photography's Great Lady." *San Francisco Chronicle*, April 12, 1973.

Humphrey, John. "The Henry Swift Collection of the San Francisco Museum of Art." *Camera* (Switzerland) 52, no. 2 (Feb. 1973), p. 4ff.

K[inzer], H. M. "Imogen Cunningham." *Photography Annual 1974* (1973), pp. 60–65.

Kramer, Hilton. "2 Displays Honor Photographer, 90." *New York Times*, April 28, 1973.

———. "Imogen Cunningham at Ninety: A Remarkable Empathy." *New York Times*, Sunday, May 6, 1973, sec. 2.

Murray, Joan. "Happy Birthday, Imogen!" *Artweek* 4, no. 14 (April 7, 1973), p. 9.

P[orter], A[llan]. "Group f/64." *Camera* (Switzerland) 52, no. 2 (Feb. 1973), pp. 3ff.

Coleman, A. D. "Abigail Heyman and Imogen Cunningham." *New York Times*, June 30, 1974.

Como, William. "The Golden Gait: The People Who Set the Pace." *After Dark* 7, no. 4 (Aug. 1974), p. 34.

Emery, Julie. "Some Libbers Develop Early . . ." *Seattle Times*, June 13, 1974.

Frankenstein, Alfred. "The Images of Imogen—And the Prints of a Purist." *San Francisco Examiner and Chronicle*, May 26, 1974, This World section.

"Imogen Cunningham: The Queen." *Newsweek*, Oct. 21, 1974, p. 67.

"Imogen! Imogen Cunningham Photographs." *Artweek* 5, no. 22 (June 1, 1974), p. 14.

McAllister, Susan. "Imogen Cunningham: Artist of the F-Stop." *Seattle Post-Intelligencer*, April 7, 1974.

Murray, Joan. "Imogen Cunningham." *Artweek* 5, no. 35 (Oct. 19, 1974), p. 11.

Newton, Dwight. "Profiles of Two Giants." *San Francisco Examiner*, Nov. 7, 1974.

Review. *Art News* 73 (Dec. 1974), p. 36.

Tarshis, Jerome. "West Coast Photography." *Studio* 187 (Jan. 1974), p. 36.

Torvik, Solveig. "Portrait of an Artist: Imogen Cunningham at 91." *Seattle Post-Intelligencer*, June 13, 1974.

"U.W. Honors 1907 Alumna." *Seattle Times*, April 21, 1974.

Anspacher, Carolyn. "Imogen Cunningham: A Portrait of the Photographer at 92." *San Francisco Chronicle*, March 31, 1975.

Baccari, Alessandro. "Imogen at 91." *California Professional Photographer*, Jan. 1975, pp. 16–17.

Forgey, Benjamin. "A Half Century of Photos." *Washington Star*, Oct. 10, 1975.

"Imogen Cunningham Is Still Busy at 92." *Independent Journal* (Marin Co., Calif.), May 10, 1975.

Margold, Jane. "Imogen Cunningham at 91: Still Developing." *Ms.* 3, no. 8 (Feb. 1975), pp. 25–26.

Callahan, Sean. "Photography: Two Deaths in the Family." *Village Voice*, Aug. 2, 1976.

Davis, Douglas. "The Ten 'Toughest' Photographs of 1975." *Esquire* 85, no. 2 (Feb. 1976), pp. 108ff.

Hershey, Ann. "Remembering Imogen." *San Francisco Examiner and Chronicle, California Living Magazine*, Sept. 26, 1976, pp. 6–10.

"Imogen Cunningham, Noted Photographer" (obituary). *San Francisco Examiner*, June 25, 1976.

"Imogen Cunningham Tribute." *American Society of Magazine Photographers—NC Newsletter*, no. 5 (July–Aug. 1976), pp. 2ff.

Kramer, Hilton. "Remembering Cunningham and White." *New York Times*, Aug. 1, 1976.

Leary, Kevin. "Imogen Cunningham, Famed Photographer, Dies Here at 93." *San Francisco Chronicle*, June 25, 1976.

McFadden, Robert D. "Pictures in 75-Year Career Display Wit and Fresh Outlook" (obituary). *New York Times*, June 26, 1976.

"No funeral, But a Celebration Will Be Imogen's Last Farewell." *San Francisco Examiner*, July 8, 1976.

"Remarkable American Women 1776–1976." *Life*, special report, 1976, p. 43.

Rich, Judith. "In Focus with Imogen Cunningham." *Westways* 68, no. 8 (Aug. 1976), pp. 18ff.

Wiseman, Diane. "Imogen Cunningham, 1883–1976." *Popular Photography* 79, no. 4 (Oct. 1976), p. 51.

Albright, Thomas. "An Insider's View of Aging: Every Picture Tells a Story" (review). *San Francisco Chronicle*, Sept. 1, 1977.

Badger, Gerry. "Viewed: Imogen Cunningham and Mario Giacomelli at the Photographer's Gallery." *British Journal of Photography* 124, no. 27 (July 8, 1977), pp. 566–69.

Frankenstein, Alfred. "A Retrospective of the Cunningham Mastery" (review). *San Francisco Chronicle*, Oct. 8, 1977.

Murray, Joan. "On the Myth of Imogen Cunningham." *Artweek* 8, no. 35 (Oct. 22, 1977), p. 11.

Smith, Patrick. Review of *After Ninety: Imogen Cunningham. San Francisco Review of Books* 3, no. 6 (Oct. 1977), pp. 19–21.

Cooper, Thomas Joshua, and Gerry Badger. "Imogen Cunningham: A Celebration." *British Journal of Photography Annual 1977* (1978), pp. 126–39.

Symmes, M. F. "Important Photographs by Women." *Detroit Institute of Arts Bulletin* 56, no. 2 (1978), pp. 146–48.

Trojan, Judith. "Imogen Cunningham: A Remembrance." *Mass Media Newsletter* 15, no. 6 (Sept. 11, 1978), pp. 1ff.

Blythe, Ronald. "Living to be Old." *Harper's* 259, no. 1550 (July 1979), pp. 35–54.

Murray, Joan. "Remembrances of Cunningham." *Artweek* 10, no. 42 (Dec. 15, 1979), p. 11.

Mozley, Anita Ventura. "Imogen Cunningham: Beginnings." In "Discovery and Recognition." *Untitled* 25 (1981), pp. 41–45.

Albright, Thomas. "The Cunningham Paradox" (review). *San Francisco Chronicle*, March 6, 1983.

Damsker, Matt. "Cunningham Goes Inside Plant Life" (review). *Los Angeles Times*, Dec. 30, 1983, sec. 6.

"Imogen." *San Francisco Examiner and Chronicle, California Living Magazine*, April 10, 1983, pp. 10–11.

Murray, Joan. "Looking at Imogen: Two Perspectives (Part II)." *Artweek* 14, no. 15 (April 16, 1983), pp. 1ff.

Phillipps, Donna Lee. "Looking at Imogen: Two Perspectives (Part I)." *Artweek* 14, no. 14 (April 9, 1983), pp. 11–12.

Marinovich, Mark. "Cunningham: Life through a Lens" (review). *Santa Cruz Sentinel*, May 4, 1984.

Moreau, Dan. "A Collectible Comes of Age." *Changing Times* 41, no. 9 (Sept. 1987), pp. 67–71.

Edwards, Owen. Review. *American Photographer* 23 (Nov. 1989), p. 32.

Immisch, T. O. "Imogen Cunningham: Grenzen-Fotografien 1906–1976." *Bildende Kunst* 37, no. 7 (1989), pp. 37–40.

"Imogen Cunningham: Eine Fotografin gibt Auskunft." *Fotografie* 43, no. 12 (Dec. 1989), pp. 442–47.

Kohler, M. "Wie Frauen Körper sehen." *Pan* 2 (1989), pp. 96–99.

Hansen, Henning. Review. *Katalog*, June 1991, pp. 53–54.

VII. Other Sources

Adams, Ansel, with Mary Street Alinder. *An Autobiography*. Boston: New York Graphic Society, 1985.

Beaton, Cecil, and Gail Buckland. *The Magic Image: The Genius of Photography from 1839 to the Present Day*. Boston: Little, Brown, 1975.

Diverse Images: Photographs from The New Orleans Museum of Art. Garden City, N.Y.: Amphoto, 1979.

Duval, Jean-Luc. *Photography: History of an Art*. Geneva: Skira; New York: Rizzoli, 1982.

Ewing, William A. *Flora Photographica: Masterpieces of Flower Photography 1835 to the Present*. New York: Simon and Schuster, 1991.

———. *The Fugitive Gesture: Masterpieces of Dance Photography*. London: Thames and Hudson, 1987.

Gee, Helen. *Photography of the Fifties: An American Perspective*. Tucson: Center for Creative Photography, University of Arizona, Tucson, 1980.

Graham, Martha. *Blood Memory*. New York: Doubleday, 1991.

Green, Jonathan, ed. *Camera Work: A Critical Anthology*. Millerton, N.Y.: Aperture, 1973.

Gruber, Renate, and L. Fritz. *The Imaginary Photo Museum*. New York: Harmony Books, 1981.

Hively, William. *Nine Classic California Photographers*. Berkeley, Calif.: Friends of the Bancroft Library, 1980.

Homer, William Innes. *Alfred Stieglitz and the Photo-Secession*. Boston: New York Graphic Society, 1983.

Katzman, Louise. *Photography in California 1945–1980*. New York: Hudson Hills Press and San Francisco Museum of Modern Art, 1984.

Köhler, Michael. *Ansichten vom Körper: Das Aktfoto 1840–1985*. Schaffhausen: Edition Stemmle, 1986.

Language of Light: A Survey of the Photography Collection of the University of Kansas Museum of Art. Lawrence: University of Kansas Museum of Art, 1974.

Lechat, Marie. *Imogen Cunningham: Le portrait dans la photographie*. Thesis, Université Libre de Bruxelles, Faculté de Philosophie et Lettres, 1978.

Lemagny, Jean-Claude, and André Rouillé. *A History of Photography*. Trans. Janet Lloyd. Cambridge: Cambridge University Press, 1986.

The Male Nude. Tokyo: Treville, 1991.

Mann, Margery. *California Pictorialism*. Exh. cat. San Francisco: San Francisco Museum of Modern Art, 1977.

Modern Photography and Beyond: Photographs in the Collection of The National Museum of Modern Art, Kyoto. Kyoto: National Museum of Modern Art, 1987.

Nordland, Gerald. *Ruth Asawa: A Retrospective View*. Exh. cat. San Francisco: San Francisco Museum of Art, 1973.

Photography as a Fine Art. New York: E. P. Dutton, 1983.

Portraits. London: Thames and Hudson, 1983.

Pultz, John, and Catherine B. Scallen. *Cubism and American Photography, 1910–1930*. Exh. cat. Williamstown, Mass.: Sterling and Francine Clark Art Institute, 1981.

The Quillan Collection of Nineteenth and Twentieth Century Photographs. New York: Quillan Company, 1991.

Ratcliff, Carter. "Tableau Photography: From Mayall to Rodan, Its Roots and Its Reason." *Picture* 18 (1981), pp. 4–47.

Richardson, Diana Edkins, and John Russell. *Vanity Fair: Photographs of an Age 1914–1936*. New York: Clarkson N. Potter, 1982.

Rosenblum, Naomi. *A World History of Photography*. New York: Abbeville Press, 1984.

Sandweiss, Martha A. *Masterworks of American Photography: The Amon Carter Museum Collection*. Birmingham, Ala.: Oxmoor House, 1982.

Sobieszek, Robert A. *Masterpieces of Photography from the George Eastman House Collection*. New York: Abbeville Press, 1985.

Sullivan, Constance. *Legacy of Light*. New York: Alfred Knopf, 1987.

———. *Nude Photographs, 1850–1980*. New York: Harper and Row, 1980.

———. *Women Photographers*. New York: Harry N. Abrams, 1990.

Szarkowski, John. *Looking at Photographs: 100 Pictures from the Collection of The Museum of Modern Art*. New York: Museum of Modern Art, 1973.

Thornton, Gene. *Masters of the Camera: Stieglitz, Steichen and Their Successors*. New York: Holt, Rinehart and Winston, 1976.

U. S. Camera 1939 (statement by Cunningham). New York: William Morrow, 1939.

Weston, Edward. *The Daybooks of Edward Weston*. Vols. 1–2. Ed. Nancy Newhall. Millerton, N.Y.: Aperture, 1973.

White, Anthony R. *The Graphic Art of Roi Partridge: A Catalogue Raisonné*. Los Angeles: Hennessey and Ingalls, 1988.

Witkin, Lee. *A Ten Year Salute*. Danbury, N.H.: Addison House, 1979.

Witkin, Lee, and Barbara London. *The Photograph Collector's Guide*. Boston: New York Graphic Society, 1979.

Index